HOME FRONT
The Government's War on Soldiers

HOME FRONT

The Government's War on Soldiers

by

Rick Anderson

*A report on how America's weapons,
medicines, and bureaucracies of mass destruction
harm our troops and veterans*

CLARITY PRESS, INC.

© 2004 Rick Anderson

ISBN: 0-932863-41-8

In-house editor: Diana G. Collier

Cover photo: Arlington Cemetery, Chris Gregerson, 2002
George W. Bush, Jr., AP/Wide World Photos

Library of Congress Cataloging-in-Publication Data

Anderson, Rick, 1941-
Home front : the government's war on soldiers / by Rick Anderson ; foreword by Francis A. Boyle.
p. cm.
Includes bibliographical references and index.
ISBN 0-932863-41-8
1. Soldiers—Health and hygiene—United States. 2. Soldiers—Civil rights—United States. 3. Soldiers—Medical care—United States. 4. Veterans—Health and hygiene—United States. 5. Veterans—Civil rights—United States. 6. Veterans—Medical care—United States. 7. United States—Armed Forces—Personnel management. I. Title.
 UH603.A83 2004
 355.3'45—dc22 2004006755

CLARITY PRESS, INC.
Ste. 469, 3277 Roswell Rd. NE
Atlanta, GA. 30305

http://www.claritypress.com

For Monica

*Dedicated to those who died in war
and to those who died from it*

"Years from now I don't want to see books about `The Gulf War Generation' exposing how we betrayed veterans—twice—by exposing them to a toxic battlefield that created vast numbers of illness and even death."

Robert L. McMahon, President
Soldiers for the Truth Foundation, 2002

"Why should we hear about body bags and deaths and how many [and] what day it's gonna happen? It's not relevant. So why should I waste my beautiful mind on something like that?"

George W. Bush's mother, Barbara, on
ABC's *Good Morning America*, March 18, 2003

Table of Contents

Foreword

I was first approached by Clarity Press, Inc. to write a Foreword to Rick Anderson's remarkable book on the dismal treatment of American GIs by their own government because of my expertise related to American research and development of biochemical weapons of mass destruction and the shipment of same by the U.S. to the regime of Saddam Hussein in the 1980s—the very weapons which ostensibly occasioned the Bush administration's war on Iraq in 2003—as recounted in my lecture on "BioWarfare, Terror Weapons and the U.S.: Home Brew?", published by *Counterpunch.org* on 25 April 2002. Previously, I had drafted the Biological Weapons Anti-terrorism Act of 1989, the U.S. domestic implementing legislation for the Biological Weapons Convention of 1972, that was passed unanimously by both Houses of the United States Congress and signed into law by President Bush Sr. In the fall of 1990, I served as Counsel for the successful defense of U.S. Marine Corps Lance Corporal Jeff Paterson, the first military resister as a matter of principle and conscience to Bush Sr.'s Gulf War I. Then I represented U.S. M.C. Lance Corporal David Mihaila in a successful effort to obtain his discharge from the Marine Corps during Bush Sr.'s Gulf War I as a Conscientious Objector. Corporal Mihaila was the Clerk of the Court for the Paterson court-martial proceeding and was motivated to apply for CO status as a result of my oral argument for Corporal Paterson.

Then at the start of 1991 I served as Counsel for the defense of Captain Dr. Yolanda Huet-Vaughn, who was court-martialed by the U.S. Army in part because of her refusal to administer experimental vaccines to soldiers destined to fight in the Bush Sr. Gulf War I. Later on, I served as Counsel for the defense of U.S. Army Captain Lawrence Rockwood, who was court-martialed for his heroic efforts to stop torture in Haiti after the United States government had invaded that country in 1994. So Clarity felt I had the practical experience and professional expertise required to comment upon the significance of what Rick Anderson had to say.

But as I read *Home Front: The Government's War on Soldiers*, I was deeply moved instead to approach the subject in a more personal manner relating to my own experience as the son of an American Marine who fought valiantly against the Japanese Imperial Army during the Second World War, because my father's life influenced not only my appreciation of the heroism and sacrifices of U.S. Marines, soldiers, sailors, airmen and now airwomen, but also my

understanding and apprehension of its dreadful realities, and the after effects upon those who must bear its brunt, and carry its memories throughout the rest of their lives.

After the Japanese attack on Pearl Harbor on 7 December 1941, my father, Francis Anthony Boyle, after whom I am named (being the oldest of my parents' eight children), applied for admission to Officer Candidate School for the United States Marine Corps. After an extended period of investigation, he was eventually rejected—telling me it was the most disappointing day of his entire life. He was not given the reason for this rejection. But as a child he had rheumatic fever, meningitis, and polio. As a boy he had to walk around with crutches and only gradually managed to wean himself from them. The rejection by the Marine Corps Officer Candidate School undoubtedly saved my father's life and thus made mine possible. The chances of survival for a young Marine Corps Officer in the Pacific Campaign were infinitesimal. They were expected to lead their troops into battle from in front of their men.

Despite his deep disappointment and his physical limitations, my father then enlisted in the U.S. Marine Corps on 14 July 1943 at the age of 22 and agreed to serve for the "Duration" of the war. By contrast, I entered Harvard Law School on about 7 September 1971 at the age of 21. I thought of my father a lot during that first year of law school. At about my age, he was fighting for his life in the jungles of the Pacific. But my father would have wanted it that way for me. According to his Honorable Discharge papers (A108534, Series A, NAVMC70-PD) and war stories, my father invaded Saipan, Tinian and Okinawa. According to my father, after the battle for Okinawa, all but two Marines from his original Company were either killed or seriously wounded. The Marine Corps then ordered my father and his friend to begin training for the invasion of mainland Japan where they were scheduled to be among the first Marines ashore because of their combat experience. My father told me that at the time he believed it was a miracle that he was still alive. He knew that he would never survive the planned invasion of the Japanese mainland, but had proceeded to train for this invasion anyway because he had enlisted for the "Duration" of the war. *Semper Fidelis.* My father was a very aggressive, relentless, fearless, and ferocious warrior. After his Honorable Discharge from the Marine Corps on 16 January 1946 as a Corporal with his "Character of service" rated as "excellent," my father attended Loyola University in Chicago, Illinois and graduated from their Law School in the Class of 1950, shortly after I was born. He went to work as a plaintiff's litigator for a law firm in downtown Chicago where, his hiring partner told me, he was very

aggressive in court and otherwise. Eventually, my father opened his own law firm as a plaintiff's litigator in downtown Chicago in 1959. On the night he transferred his files from the old office to his new firm, my father put me into our 1955 Chevy, the first car he ever bought, and brought me along for the ride and the opening of his new law firm. Soon thereafter, he designated me as the Clerk for his law firm, and promptly put me to work at the age of nine running messages, filing documents in court, taking money to and from the LaSalle National Bank, etc., all over downtown Chicago on school holidays and during summer vacations. At the end of a hard day's work around 5:30 p.m., I would walk over to the corner of State and Madison in order to take the bus home by myself while my father continued to work away at his law practice late into the night. Now if I did that to my nine year old son today, the Illinois Department of Children and Family Services would step in and take him away from me—the "home alone" phenomenon. But that was a different era, and my father was of the old school: spare the rod, and spoil the child. It was not easy being the oldest child and namesake of a World War II U.S. Marine Corps combat veteran of invading Saipan, Tinian, and Okinawa.

I continued to serve as his Clerk until he died of a heart attack on 10 January 1968 at the age of 46. Because I worked for him at his law firm for all those years, I was fortunate to have spent an enormous amount of time with my father. I learned a lot about life from my father. Two of his favorites were: "Son, there is nothing fair about life." And: "Just remember, son, no one owes you anything." Of course he proved right on both counts—and many others as well.

But in particular, since I was his oldest child and namesake, at a very young age he began to tell me these astounding, chilling, hair-raising stories about what hand-to-hand combat in the Pacific was really like that literally left an otherwise talkative boy dumbfounded. My father supplemented these stories by taking me to see almost every war film ever made about combat in the Pacific, where he punctuated these war movies *in medias res* by telling me whether or not the incidents portrayed therein were authentic, and then comparing them with his own war experiences afterwards on the way home. It dawned upon me at a very young age that it was literally a miracle that my father had survived the war.

My father was very proud of his combat service in the Marine Corps and for the rest of his life continued to consider himself to be a Marine. He never bragged about his combat experiences in the war to me or to anyone else that I was aware of. His record in combat spoke for itself. Indeed, when I was a young boy, his fellow

warriors elected him to be the Commander of the local American Legion Post, a distinct honor as he saw it. He brought my mother, my next younger sister, and me along for the installation ceremony and dinner that night.

My father had nothing good and nothing bad to say about the Japanese Imperial Army and its soldiers. But it was obvious from his tone of voice that he considered them to be dangerous warriors who were prepared to fight to the death, as large numbers of them did at his hands. My father and mother never raised any of their eight children to be biased or prejudiced against the Japanese or any other people for that matter.

According to my father, immediately prior to the invasions of Saipan, Tinian, and Okinawa, his Captain issued direct orders to his Company not to take Japanese prisoners of war on the grounds of reciprocity: "The Japs don't take prisoners of our men, so I don't want to see any Nip soldiers cluttering up our rear lines!" Notwithstanding, my father took surrendering Japanese soldiers as prisoners of war, escorted them to the rear of the line, and then returned to battle. When the odds are overwhelming that you will meet your Maker in any instant, you want to do so with a clear conscience. I tell this story to my law students when they object that it is unrealistic to expect soldiers to obey the laws of war during the heat of combat. But that is the difference between a warrior and a war criminal.

At first glance it appeared that my father had survived the war relatively unscathed. He had picked up a fungus on his leg that stayed with him for the rest of his life, which he called his "jungle rot." Also, his hearing had been impaired by the big naval guns bombarding the coasts while he and his comrades waited on ship to board the landing transports in order to storm the beaches, as well as by artillery, grenades, bombs, machine guns, flame throwers, and other ordnance that he endured, advancing under withering enemy fire during the day, repulsing bonzai charges at night, repeatedly volunteering for what looked like suicide missions behind enemy lines, etc. It was Hell on Earth.

Only years later, long after he had died, and as a result of medical research on veterans of the Vietnam War, did I realize that my father came back with a severe case of Post Traumatic Stress Syndrome (PTSS), something that was undiagnosed at the time. Combat veterans of World War II were simply expected to go home and resume their civilian lives without further adieu. As my father's Marine Corps Honorable Discharge papers state: "Requires neither treatment nor hospitalization." In retrospect, my father should have

had medical treatment for Post Traumatic Stress Syndrome if it had been available then.

My father built a very successful law practice as a plaintiff's litigator. Shortly before he died, my father told me that he had almost become economically secure enough from his law practice in order to run for a Judgeship in Cook County, which he intended to do. Given that he was born Irish on the Southside of Chicago and with his Marine Corps combat record, he would have had no problem being nominated, run and elected by the storied Dick Daley Machine —he grew up with them all. But my father's further ascent in the legal profession was cut short by the physical condition of his heart. Nevertheless, my father always demonstrated heartfelt compassion to those less fortunate than he and taught all of his children to do the same. My mother still does the same, today.

While it was likely not my father's intention, his stories told over many years about the terrors and horrors of combat in the Pacific turned me against war and violence as a solution to human problems. I had the same reaction while reading through *Home Front*, Rick Anderson's powerful new book which indicates not only those ills which arrogant and rapacious government officials can perpetrate on those who are expected to sacrifice their very lives, but also the terrible tragedy that is so characteristic of war itself. War is always the ultimate defeat for the human spirit. War is an abomination on the face of God's Creation. There has to be a better way. Law is that better way.

We Americans cannot keep sending our young men and now women off to fight and to die, or to survive with terrible physical and mental injuries, scarred for the rest of their lives by the horrors of warfare as my father was. Every American who has a child contemplating joining the military for any reason should buy him or her a copy of this book to read. I have three sons, and I will be sure to give a copy of this book to each of them.

America's endemic cycle of warfare, bloodshed, and violence, both internationally and domestically, must stop with us. We must teach our children that there is a better way. Given the pervasive American culture of glorifying and worshiping violence, warfare, death, and destruction, this important book will enable American parents to better educate our children about the absolute necessity for peace, justice, human rights, and the Rule of Law, both internationally and domestically. This book provides an extremely moving, compelling and irrefutable account of what happens to the young men and women of America when they go into the military, and also when they come home—if they do.

Home Front should be required reading in every American high school in order to counteract the outright pro-war propaganda, militarization, and military solicitation currently being inflicted upon our children by the Pentagon and the news media. It should also be required reading for beginning college courses in political science, history, and the other social sciences, which have an inherent bias in favor of power, domination, violence, and warfare. Finally, *Home Front* is a very powerful tool for those of us in the American Peace Movement to use in order to stop the Bush Jr. Administration's attempt to create an American hydrocarbon empire abroad in Iraq, the Persian Gulf, Afghanistan, Central Asia, Colombia, West Africa, the Horn, and elsewhere by means of exploiting, manipulating, abusing and deceiving the members of U.S. armed forces to serve as pawns in their geopolitical pursuit of oil, natural gas, and corporate profits, while amassing personal family fortunes in the process. We need as many loyal, patriotic, humanitarian, and principled American citizens as possible to read this book, contemplate its lessons, and then act upon them: Stop these wars!

Professor Francis Anthony Boyle, Jr.

Author's Note

This book grew out of a Gulf War II story I wrote—"Crippled Home Front," April 9, 2003—for *Seattle Weekly.* It drew wide response and is still displayed at numerous websites including that, perhaps most appropriately, of Arlington National Cemetery. It was inspired by a number of veterans, reservists and active-duty service members disgusted by a government that heaped well-earned praise on troops at war while slashing their promised benefits back home. To that, others added complaints of faulty weapons, inadequate gear, having to buy their own equipment, and living at poverty levels in substandard military housing. Veterans talked about medical benefits diminishing in tandem with the public's fading memories of their service. Combat soldiers worried about becoming guinea pigs like so many troops had before them, and about the mysterious deaths that began to occur among troops and civilians—from Army cook Sandra Larson to TV correspondent David Bloom—during the ongoing combat in Afghanistan and Iraq. They thought another Gulf War plague was breaking out as they fought to fully prove the existence of the first one, which resulted in the single largest chemical-weapons exposure to American soldiers ever recorded—aided and abetted by the U.S. corporations who sold biological agents to Iraq.

They weren't asking for much: the right to know what harm was and is being done to them, and the opportunity to cure and prevent it. But they have a formidable doubter to convince: the government that caused and fosters this war within wars through its weapons, medicines and bureaucracies of mass destruction.

Here is their argument.

Introduction

"What did the Army ever do for you besides treat
you like dirt and give you one awful going-over and
get your friend killed?"

Alma, to the AWOL soldier, Prewitt,
in *From Here to Eternity*

Joe Soldier: "No-value-added" casualties on the home front

Draft eligible during Vietnam, I was never summoned and never volunteered. The closest my father came to combat was donning a rusty metal helmet during WWII and power tripping around the block as neighborhood Air Raid Warden. My genealogy-smitten sister tells me we had a distant relative who fought in the Civil War. Unfortunately, he deserted.

But then, what would I have added to the Vietnam War? No value, says Donald Rumsfeld.

"If you think back to when we had the draft, people were brought in; they were paid some fraction of what they could make in the civilian manpower market because they were without choices," the Secretary of Defense said in January 2003, as we prepped for war in Iraq. "Big categories were exempted —people that were in college, people that were teaching, people that were married. It varied from time to time, but there were all kinds of exemptions. And what was left was sucked into the intake, trained for a period of months, and then went out, adding no value, no advantage, really, to the United States armed services over any sustained period of time."[1]

> Under 'occupation,' the medical examiner kept putting 'None. Vietnam Veteran.'

That ungrammatical rant dropped a few jaws among the millions who were called, and served in—and survived—America's wars, especially the 75 percent of Vietnam draftees from lower and middle-class backgrounds, the sucked-in grunts who helped advance the science of live amputation.

Rumsfeld was forced to make a public apology. But I think he meant what he said. The Pentagon is not an equal opportunity employer for the average spear-carrier.

As a writer, though, I did get to know and chronicle some of those no-value-added veterans. There was Chester, who checked into a motel at noon carrying only a brown bag containing a Charter Arms .38 special revolver that he bought three days earlier. He was broke, unemployed, and living with his brother. He never managed to reassemble his life after Vietnam, never stopped thinking about the killing. One job failure followed another. With the VA—the Veterans Administration, now the Department of Veterans Affairs—overwhelmed by cases like Chester's, there was not much others could do. So Chester fixed himself. Sometime during the night, having spent hours in a cheap motel room likely thinking about his life and how to end it, he raised the .38 to an ear and blew his troubles away. He was 26.

Similarly, Carlos had been forced to sue the VA to get help for the epilepsy he brought home from Vietnam. The only medicine that worked for him was Jack Daniels. One night he went to bed with a Winchester 30-30 and his father found him two days later. He was 30.

There was Bobby, 39, using a belt to hang himself; Lee, 31, overdosing on prescription drugs; Les, 30, sitting in a car with an engine running; Gene, 38, squeezing off a round into his chest; and Alan, 34, sticking the shotgun in his mouth. Under "occupation," the medical examiner kept putting "None. Vietnam Veteran."[2]

They died in the midst of what seemed a suicidal epidemic among Vietnam veterans. Rumors persist that as many as half of the 2.7 million veterans who served in Vietnam killed themselves. That's an exaggeration; more reliable estimates range closer to *merely* 200,000—roughly equivalent to losing, in one awful season, every high school student, sophomore to senior, in Alaska, Delaware, Montana, North Dakota, Rhode Island, South Dakota, Vermont and the District of Columbia, combined. But while some data gathering continues there are no conclusive studies or hard counts on these home front casualties, a national tragedy.[3]

And as bad as we thought Vietnam was then, we now know it was even worse. If the slaughter at My Lai was an aberration, what do you call the seven months of carnage by the Tiger unit? The elite 101st Airborne's Tiger Force allegedly killed and mutilated hundreds of Vietnamese civilians during a seven-month period in 1967, according to military records unearthed in 2003 by the *Toledo Blade*. The paper said women and children were intentionally blown up in bunkers, elderly farmers were shot in the fields, and prisoners were tortured and executed, their ears and scalps taken as souvenirs. One soldier, said the *Blade*, kicked out the teeth of executed civilians

for their gold fillings. Two soldiers tried to stop the killings but their pleas were ignored by commanders. The Pentagon's 4½-year investigation concluded that at least 18 soldiers committed war crimes but the results were never revealed publicly and no charges filed. "My Lai was a one-day incident," former medic Rion Causey told the Reuters press service. "People were angry. They had had their friends, their comrades, shot. They made a conscious effort on one day to do this type of atrocity. In Tiger Force, it went on every day. That first operation that I was involved in went on for 37 days; 37 days we averaged right at three people a day. That's a conscious effort every single day that you are going to kill people."[4]

A soldier didn't have to be complicit to an atrocity—as overwhelmingly hundreds of thousands of troops were not—to nonetheless return home bearing the stain and blame of Vietnam and be haunted by the killing fields he patrolled. Those who couldn't handle it faced dwindling opportunities for aid when President Ronald Reagan blithely proposed to fire 20,000 VA medical personnel and scrap part of the VA counseling program. There just wasn't enough money to go around, said the former Hollywood soldier, who was spending record amounts on an arms buildup. This is the kind of logic that government values. In 2003, at the same time it was trying to cut soldiers' pay on the Iraq war front, the Pentagon launched a new Nimitz-class aircraft carrier—our ninth—costing $4.5 billion. It was named after Reagan. In May 2003, while George W. Bush was prematurely calling the battle for Iraq "one victory in a war on terror," the keel was laid for the tenth Nimitz carrier, costing $5 billion. It is named for his father.

I'd like to suggest another name for a ship. The *USS Joe Hooper*. Hooper, too, was a no-value-added vet under the Rumsfeld Classification. He was also the most-decorated American fighter in Vietnam, a war he came to hate as much as did the people who called him a baby killer when he returned.

"At high schools, when I speak," he told me once, "the question kids most often asked me was `Would you do it [risk your life] again?' I would, the reason being I thought my abilities helped save lives. But I would tell my children, if I were to do this over, `Go to Canada...Don't fight a war you can't win.'"

In the 1960s and '70s, Joe Hooper was Joe Soldier. He remembered Richard Nixon squeezing his hand, Lucille Ball welcoming him before the cameras, and Bob Hope slinging an arm around him. But even those fleeting moments of fame grew regrettable, and Hooper drank to forget.

His binges lasted days. Sometimes he was carried out of

bars by military buddies the way he carried the wounded over his shoulders in Vietnam.

"When you retire from guerrilla fighting," he told me matter-of-factly as we shared a drink one night, "it's not something you just walk away from without losing some part of you. In those days, you lived, almost thrived, on fear. Now there's no fear in my life. And I admit I'm a little flat."

He shrugged. I almost felt sorry no one was trying to kill him.

In fact, at age 40, an old enemy had snuck up on him. Hooper suffered a cerebral hemorrhage that doctors related to his own doing—drinking professionally. (More on war and alcoholism later.)

Hooper had killed at least 115 North Vietnamese in his Vietnam tour, sometimes wading through withering machine gun fire, taking bullet after bullet as he pulled the wounded to safety. He dazzled his men with speed and footwork developed as a high school track star in Moses Lake, Washington. Later, before his wounds were healed, he amazed them by breaking out of the hospital and racing back to war. He was John Rambo, on the battlefield at least, four years before writer David Morrell invented that character for his 1972 *First Blood* novel—followed by Sylvester Stallone's successful movie portrayal coincidentally set in Hooper's Pacific Northwest. Rambo was the overblown superhero and victim. Hooper saw himself as neither.

He earned more medals—thirty-seven—than did WWII's Audie Murphy and WWI's Alvin York. But those are names that, unlike Hooper's (or, for that matter, Korea's great hero, Ray Davis), still have a familiar ring today. The media barely noticed Hooper's death in 1979. And despite his most-decorated status, his name did not make it onto the Vietnam Veterans Memorial wall in D.C.: he was neither killed nor missing in action.

But he was a war casualty nonetheless. The VA had decided it couldn't help him or, for that matter, even work with him. Hooper had first been a patient, then a VA counselor. Then, the government fired him.

"He drank hard, there's no denying that," Hooper's friend Larry Frank, also a former VA employee, told me. "But the VA couldn't deal with him drinking and running around, and that's exactly what the VA is there for: people with problems like Joe's."

"If we can't save our heroes," asked another pal, Vietnam vet David Willson, "who can we save?"

A military-industrial complexion

I'll tell you more later about Hooper, who was one of the

friends I made hanging around newspapers most of my life, writing, in part, about the home front and about soldiers dead and alive— including one I killed myself.

As a cub reporter, I didn't quite get the difference between KIA (killed in action) and WIA (wounded in action). So I split the difference, and wrote in effect that the soldier was apparently dead.

The next day an editor made me get on the phone and explain to the soldier's sobbing parents why their son wasn't really deceased and how I came to be such a freakin' screw-up. I remember the father asking, "You don't know the difference between life and death?" I guess not, I said meekly. But I was willing to learn.

There is a major home front of military installations where I live—Seattle, in the Other Washington. The region, unlike D.C., has no encircling beltway through which all thought must be ideologically filtered for maximum power and wealth—unless you count the radiating aura around Bill Gates' mansion. Nor is it an overwhelmingly khaki-colored world like Fayetteville or Twentynine Palms. Actually, Seattle, where anarchists battled the establishment in the 1999 WTO street war, may be better known as a leftist outpost, the home of Sister Jackie Hudson, the 68-year-old anti-war nun who went to prison for 30 months after damaging a Minuteman III nuclear missile silo and painting a cross on it with her blood; of Army National Guard Col. Margarethe Cammermeyer, the highest-ranking service member to be discharged for being lesbian (and who would later win reinstatement), even after she earned a Bronze Star in Vietnam and was named the VA's Nurse of the Year; and of Democratic congressman-for-life Jim McDermott, famous for his cake-walk re-elections and infamous for saying before the Iraq war that George Bush was misleading America but we could take the Iraqi government at face value. (Not to be out-boneheaded, McDermott's fellow Washington congressman, Republican George Nethercutt, announced that the recovery effort in Iraq "is a better and more important story than losing a couple of soldiers every day," to which *New York Times* columnist Maureen Dowd rejoined: "The congressman puts the casual back in casualty." McDermott recanted and Nethercutt said he was misquoted).[5]

It was here in Seattle that former acting U.S. ambassador to Iraq, Joseph Wilson, felt sufficiently comfortable to say he relished the day when Bush advisor Karl Rove would be "frog-marched out of the White House in handcuffs." A onetime Olympic Peninsula carpenter who got his diplomatic service start in Seattle, Wilson spoke at a 2003 forum hosted by Rep. Jay Inslee in suburban Seattle. Wilson's wife Valerie Plame Wilson, a CIA operative, had just been

outted allegedly by a White House source to Republican-friendly columnist Robert Novak, possibly putting Valerie Wilson's life and those of her covert contacts at risk, and leading to an ongoing U.S. probe for Novak's source. (According to writer Murray Waas in a 2004 *American Prospect* report, Rove has admitted to the FBI he was Novak's source).[6] Wilson thought the leak was in retaliation for his discovery that Saddam Hussein had not sought to obtain yellowcake uranium from Niger to develop weapons of mass destruction, contrary to George Bush's claim in justification of his intended war against Iraq. The Rove frog-walk remark got lots of mileage although Wilson later told C-SPAN, "I was carried away in the exuberance of the moment" in Seattle.

Presumably Seattle instills a laid-back liberal exuberance. Yet in contrast there are few other military-industrial complexes to compare with Puget Sound, and many countries envy the state's government paychecks and surrounding firepower. Eight major regional military facilities with more than 55,000 personnel are situated here, including the Army's Fort Lewis, McChord Air Force Base, a U.S. Navy base and shipyard in Bremerton that is home for Nimitz-class carrier *USS Carl Vinson*, the Whidbey Island naval air station, and the nuclear submarine base in Bangor—site of seven world-ending Trident subs (with more nuclear punch than Britain, France, and China combined) and the grande dame of world espionage, the *USS Parche*, a spy sub with high-tech gear so strategic it has been rigged for self-destruction should it be captured. The *Parche* is due for decommissioning in 2004 and will be replaced by the new $2.5 billion ultra-high-tech espionage boat, *USS Jimmy Carter*, adding to the debate over U.S. reliance on high-tech versus human intelligence-gathering.

There's also a Navy base in Everett, north of Seattle, that is home to the carrier *USS Abraham Lincoln*. You may best remember it for its great flight deck on which President Bush took his televised, and hasty, Iraq victory lap in May 2003.

Few other regions seemed more involved in fighting that war, yet more opposed to starting it. An estimated 20,000 of the more than 200,000 original Operation Iraqi Freedom troops were from the Seattle area, while in one day more than 25,000 demonstrators marched Seattle's streets to protest the coming war.

There had been no sizeable marches opposing Bush's plan to attack Al Qaeda and track down Osama bin Laden, something that also had a historical Seattle footnote. The first solider to die at the enemy's hand in Afghanistan—on June 4, 2002—was from the Seattle area: Army Sgt.1st Class Nathan R. Chapman, 31, of

suburban Puyallup. A Special Forces soldier based at Fort Lewis, Chapman and an unidentified CIA officer were searching for Al Qaeda members and were fired upon shortly after leaving a meeting with local Afghan leaders. His widow, Renae, said she wanted people to remember Nathan as a quiet professional "who just wanted to change the world."

Iraq was another story. Despite the largest global pre-war protests in history, the "pre-emptive defense" of America went forward. It began like Grenada, turned into Somalia, and transformed into Vietnam. Marine Gen. Peter Pace, vice-chairman of the Joint Chiefs of Staff, said the military didn't plan ahead for the occupation of Iraq, fearing it could create a self-fulfilling prophecy. "We did not want to have planning for the post-war make the war inevitable," he told Congress. "We did not want to do anything that would prejudge or somehow preordain that there was definitely going to be a war."[7] In other words, we prepared to be unprepared. That explanation was matched for inscrutability by George W. Bush's definition of what our invasion would mean to the average Iraqi: "You're free. And freedom is beautiful. And, you know, it'll take time to restore chaos [pause, thinking] and order—order out of chaos. But we will."[8]

Funeral Muzak

Lost in the chaos of every new war are the veterans of earlier ones. The theme of Memorial Day and Veterans Day—in addition to those half-off mattress sales—is "Never Forget." Why do veterans have to keep reminding us they're there? Or sell paper poppies to get by? Or plead with the public and media to understand? Pick a newsroom and there's a screwed-over-vet story waiting on somebody's desk. Gene Lessard's story, for one, wound up on mine. Lessard was a veteran of WWII, the only war still dubbed a Good War, who distinguished himself in battle. But the government that needed him in war snubbed him in peace, unable even to help his widow plant a goodbye kiss on the old soldier's cheek. In 36 years of marriage, Helen Lessard said, Gene never laid a hand or swear word on her. She wrote an endearing obituary when he died at age 73, and gave it to me to put in the paper.

> Was in the Army 8 years, 2 months, as staff sergeant, WWII and Korea. Earned the American Defense Service Medal, European, African, Middle Eastern Theater campaign ribbons, Korean Service Medal, three Bronze Stars, Purple Heart with Oak

Leaf Cluster. Was born in Kingston, Mass., and came to Seattle after the war and met his wife, Helen and married her Aug. 27, his birthday, in 1955. Drove Yellow Cab for 5 ½ years and worked in the lumber industries, until he retired. Enjoyed bowling and his friends, and was always teasing people he liked.[9]

When she called the government about burial benefits and an honor guard, Helen, who lived on Social Security, was informed the deal Gene made with the military had expired. Budgets had been cut, new legislation passed, and different people put in charge. Then there were and are those new wars to fight. In so many words, the VA and a funeral home told her: no burial, no soldierly salutes, not even a final kiss Helen hoped to plant on Gene. The funeral home would have to prep the body for that, at a cost Helen couldn't afford: $85.

The newspaper was barely on the streets with this story when the VFW called to offer services of an honor guard. A stranger also came forth with a free plot at a local cemetery. And a VA official apologized and offered assistance. Gene Lessard got not only the proper burial his country had reneged on, he got his widow's kiss goodbye, too.

Stories like Helen Lessard's hold the government to its word. I like to think she's one of the reasons new veterans burial fees are in effect today: $2,000 if the death was service-connected, $300 if not. In 2003, about 110,000 veterans, service members, and eligible family members were buried in 120 VA national cemeteries and 54 VA-funded state veterans' cemeteries. Thousands more were buried by choice in civilian cemeteries. Four new military cemeteries will open in 2004. Apparently, in a Superpower, you can never have too many military boneyards.

New York Senator Charles Schumer says that, while almost all families of veterans think the VA will pay for their loved ones' funerals, a large number are given just $600 for the burial. Virtually every honorably discharged veteran is entitled to interment in a VA cemetery. A veteran (or his survivors) who chooses otherwise receives a $300 plot allotment benefit. A veteran who dies in a VA facility or receives a pension or compensation is eligible for an additional $300 (although vets who leave their VA facility to die at home may receive no reimbursement). It's the veteran who dies of a service-related condition that is eligible for the $2,000 benefit, says Schumer. Even at that, he points out, private funerals in his state, for example, average at $6,700. He's pushing for more benefits to allow veterans "to die with dignity, with a funeral that recognizes their distinguished service."[10]

The military also remains cheesy about ceremony. Claiming it is chronically short of bugle players, the Pentagon in 2003 introduced an electronic, push-button bugle that plays "Taps." At funerals, an honor guard member holds the replicated bugle as if playing a real one, giving the country's old vets a digitally recorded sendoff. The newly invented "ceremonial bugle," costing $500 apiece, is button-activated; a five-second delay gives the ersatz musician time to raise the instrument to his lips and fake the final salute from America. Despite all the loose change that falls on the floor at the Pentagon—for 2004, a record $401.3 billion budget, or about 45 percent of the world's total defense spending—there wasn't enough to hire a few good buglers. Fortunately, a group called Bugles Across America has begun filling the gap by training volunteers, including teens, who have played at 31,000 services in 50 states.[11]

Military-issue buglers are used, however, at funerals of service members killed in action. Survivors have been receiving a $6,000 death gratuity to cover costs; the benefit was doubled to $12,000 in 2003 by Congress. The families of some troops killed in war can receive a $250,000 life insurance payment if their loved ones opted for the special group policy; unfortunately, many military counselors are unaware of the coverage.[12]

The government was handing out more of those death bennies than planned for in 2003-04. I wrote about some of them, such as the memorial service for Army Capt. James Shull, deployed to Iraq May 1, the day that the war, in some minds, ended. At the service, brother Brad Shull remembered Jim as the wild baby boy who once bounced his crib across the room, a high-school athlete, a peacemaker, and a married father of three kids. Kim Cooney, a spokesperson for the Kirkland, Washington, Third Ward church, told me about a surprising coincidence between James Shull and a Utah man, Nathan Dailey. Both were Mormons. Both were Eagle Scouts. Both were in the Army. Both were captains. Both were in the 1st Armored Division. Both were hit by non-hostile fire. And both died the same day. "It's amazing," Cooney said. Regrettably, we were achieving the casualty numbers to make the amazing possible.

I also watched Army Specialist Justin Hebert be lowered to his grave. It was a small space in which to squeeze a bursting life. Born July 28, 1983 in Everett, Washington, he died August 1, 2003, in Kirkuk, Iraq, only 20 years and four days old. A paratrooper with the Sky Soldiers of the 173rd Airborne, Hebert was on patrol, enforcing a nighttime curfew, when a rocket-propelled grenade sailed into his Army vehicle. That is all his family knew.

He was the 52nd American casualty since May 1, when a dressed-for-battle commander-in-chief arrived aboard the *Abraham*

Lincoln—home-ported in Hebert's hometown—and declared an end to major fighting in Iraq. Fourteen years earlier in a similar photo op, Bush's father took to the flight deck of the carrier *America*, vowing reform of wasteful Pentagon spending. Like Iraq, that earlier Bush mission also awaits success: at last check, the Pentagon could not account for almost a trillion dollars in assets and taxpayer funds.

A few weeks before George W.'s victory declaration, the overall U.S. combat death toll in Iraq had hit 149, surpassing by one the number of soldiers killed in the 1991 Gulf War. The count of wounded was then officially around 830 although it already could have been more than 4,000. So many battle and non-battle casualties were at the time swamping Walter Reed Army Medical Center in D.C. that they had to use beds reserved for cancer patients or be sent to local hotels.[13] In early November 2003, *Stars and Stripes* reported that as many as 7,000 wounded had been treated at Landstuhl Regional Medical Center in Germany, and UPI subsequently said the number of U.S. troops killed, wounded or evacuated in Iraq due to injury or illness had passed 9,000. By April, 2004, one year into the battle, the death toll topped 600 and casualties reached beyond 10,000.

It was difficult to know what initially was happening in Iraq. Then-Central Command leader Gen. Tommy Franks said, "We don't do body counts" even though there is no clearer indication of victory or defeat than the carnage one side rolls up against another. The military thinks it can do its job better if its troops and the public are not reminded of solider deaths or civilian collateral damage. The notion of a righteous victory is dimmed by a death rate that reveals the war to have been a lop-sided slaughter. Six months into the war, British medical charity Medact was already estimating the Iraqi civilian toll as between 22,000 to 55,000 in a country where Dick Cheney had predicted American soldiers would "be greeted as liberators". On the topic of combat deaths, the higher road is always taken. Gen. Edward Soriano, the three-star commander of Fort Lewis, told me at Herbert's funeral, "All politics aside, this young man paid the ultimate price. He gave his life for his country."

The potential loss of functions, body parts, or life, is part of the job description that most regular warriors are presumed to accept, along with the notion that a psyched-up, righteous belief in the cause is the fighter's survival zone. Loyalty and faith of purpose, as Soriano rightly suggested, are as important as a gun and helmet in war. Still, as we asked of Vietnam, how do you put politics aside in a transparently political war? Vietnam vet and U.S. Senator Chuck Hagel, the Nebraska Republican, said he found it curious that those

who wanted to rush into war in Iraq, thinking it would be sure and swift, were those who knew nothing about battle. "They come at it from an intellectual perspective," he said of the war hawks, "versus having sat in jungles or foxholes and watched their friends get their heads blown off."[14]

As a 2004 military report would subsequently reveal, the rush to war resulted in supply shortages and left troops to advance toward Baghdad without necessary intelligence on how Saddam might defend the city. "The morass of problems that confounded delivering parts and supplies—running the gamut of paper clips to tank engines—stems from the lack of a means to assign responsibility clearly," said the 504-page report. The media wasn't holding the government's feet to the fire for justification of a rushed war effort. TV, in particular, was airing pro-war spokespersons on an average of 25-1 over anti-war proponents in the early going.

Newsday columnist Jimmy Breslin soon became frustrated at the lack of widespread coverage—of mentions, even—of the young men and women who were dying loudly in Iraq and quietly in much of the home front press. He began to write columns that simply listed the names of those KIA. "You can find the names in virtually no other place," he explained. "Obscure people dying in obscurity." As for Bush, Breslin said as the country tuned in for the World Series that week, "It is his duty, and one that he shirks, to get up and read these names to a country distracted by a game for boys."[15]

Bush was busy elsewhere, in part trying to justify the war or mute its results. In October, the *Washington Post* reported the Defense Department had banned—since March—any news coverage and photography of dead soldiers' homecomings at military bases. The directive said in part: "There will be no arrival ceremonies for, or media coverage of, deceased military personnel returning to or departing from Ramstein [Germany] airbase or Dover [Del.] base, to include interim stops." A Pentagon spokeswoman said the policy dated to the last days of the Clinton administration in 2000, but had been unenforced during the war in Afghanistan.[16] What made Iraq different? Had the Pentagon anticipated the high cost of getting Saddam? She didn't say.

A few days later the Pentagon reiterated its no-coverage policy while opening a $30 million expansion of its mortuary, the military's largest, at Dover Air Force base, which handles the bodies of U.S. troops and government officials and their families stationed abroad. The remains of more than 50,000 service members since 1955 have arrived there for identification and funeral preparations. "The mission of a mortuary is to prepare remains with dignity, care

and respect," said defense spokesperson Meg Falk. "If we expose that process to the media, we lose that."[17] The military made it sound as if Dan Rather hoped to do a live remote from inside the embalming room, when the media was asking only to take respectful, far-away shots of America's other, less joyous troop homecomings: caskets on the tarmac. But then, such photographs would give an indication of what really was happening in Iraq—the bloodied bodies and flying limbs, the screams for help and the stinging "smell of combat" that soldiers say they never forget. To the military, those images are counterproductive—another lesson of Vietnam.

The mortuary opened just before the eight-month Iraq body count crept over 400 following a week in which 34 American troops were killed. "The fact is," said Don Rumsfeld, trying to explain something he couldn't, "we just had a bad week. We had a tragic day or two with one helicopter being shot down and a number of people being killed...." Other bad weeks followed. In just over a month later, the body count crossed 500. [18]

Bush has yet to attend a military funeral, His supporters argue that if he attended one, he'd be required to attend all. But then, why not? Didn't he make the decision that cost them their lives? In wartime, a military burial should be at least as fundamentally important as a campaign fundraiser, which Bush always had time to attend. He did place a wreath at Arlington National Cemetery's Tomb of the Unknowns on Veterans Day, as presidents do. That still didn't go over well with some veterans, especially those who remembered Bush's own spotty military career. Bush and his war hawks, said commentator and retired colonel David Hackworth "almost to a man dodged service in the Vietnam War, just like the majority of our members of Congress." Bush ("I am a war president") served in the Texas National Guard from which he reputedly was sometimes AWOL. Vice President Dick Cheney avoided service by obtaining at least three deferments and said he "had other priorities in the 1960s than military service." Among White House policy-makers who avoided the battlefield were Richard Perle, John Ashcroft, Karl Rove, and Paul Wolfowitz. Not one was sucked into the intake.

Bush's "war" record became a major campaign issue in 2004 especially after Vietnam vet (and war protestor) John Kerry emerged as the leading Democratic contender for the White House. Sen. Kerry, who earned the Bronze Star and three Purple Hearts as a Navy lieutenant, was also passionate about his belief that America had betrayed the troops of Vietnam. As a leading war dissident in 1971, he recounted to the Senate Foreign Relations Committee the horrors of that war and what soldiers told him they had done and

witnessed. They "had personally raped, cut off ears, cut off heads, taped wires from portable telephones to human genitals and turned up the power, cut off limbs, blown up bodies, randomly shot at civilians, razed villages in a fashion reminiscent of Genghis Khan, shot cattle and dogs for fun, poisoned food stocks and generally ravaged the countryside of South Vietnam."[19] Meanwhile, the current commander in chief was finally revealing more details of his service background. A release of his military records seemed inconclusive, at best—although copies of a 1973 military dental exam did reveal the Bush scion was getting cavities attended to at taxpayer expense.[20]

Between Iraq and a hard place

Only weeks before the mortuary ban was reiterated, the Department of Defense launched a letter-writing campaign from the war front to the home front, enlisting the enlisted to fill out form-style letters and send them to U.S. newspapers. "Don't be misled," the letters maintained in robotic phrasing, "we are making progress." The campaign was designed in part to counter reports of soldiers going Absent Without Leave (AWOL) or deserting to other countries, such as Canada (AWOL's are reclassified as deserters after 30 days).

The Army Public Affairs Office said specifically that 3,800 soldiers went AWOL or deserted in 2002 during the war in Afghanistan; 3,255 were returned to military control. Among those apparently not planning to return was Jeremy Hinzman, 25, a member of the 82nd Airborne Division who in January 2004, fled to Canada with his wife and their son. He told the *Fayetteville Observer* he could barely stomach chanting "Kill, we will!" during basic training and, as a Quaker, objected to shooting anybody. "I would have felt no different than a private in the German Army during World War II," said Hinzman whose name, like all deserters, has been entered into a federal database that can lead to his arrest and prosecution should he reenter the U.S.

AWOL/Deserter numbers in 2003/2004 are estimated in the thousands, while other soldiers—just griping or not—said they'd changed their minds about re-enlisting. The military spin control was often upset by reporters such as ABC's Jeffrey Kofman, who detailed the dissention and sagging morale along the front lines in Iraq. Members of the Army infantry said they wanted to go home, felt "kicked in the gut" by repeated extensions of tours of duty. Some even suggested it was Bush, Rumsfeld and other American leaders who really belonged on the Pentagon's infamous deck of cards featuring the most-wanted Iraqis. "If Donald Rumsfeld was here, I'd

ask him for his resignation," volunteered Spc. Clinton Deitz. The military's retaliation was swift: "It was the end of the world," one officer told a *San Francisco Chronicle* reporter in Fallujah. "It went all the way up to President Bush and back down again on top of us. At least six of us here will lose our careers." The soldiers learned one of the lessons of war, *Chronicle* reporter Robert Collier noted: Don't talk to the media on the record with your name attached unless you're giving the sort of chin-forward, everything's-great message the Pentagon loves to hear.[21] Later, in what some call a White House-inspired dirty trick, the ABC reporter, Toronto-born Kofman, was outed on the Matt Drudge web site as being not only gay but *Canadian*.[22]

Understandably, soldiers, especially the "civilian army" units called up, were homesick and wondering what they'd gotten themselves into. The 101st Airborne and thousands of reservists were being told their tours would go beyond a year, creating home front dilemmas especially among families who, in some cases, rely on food stamps to stretch the budget. Guard and reserve members suffered special hardships. Maj. General Timothy Lowenberg, commander of the Washington Army National Guard, says mobilization creates a 40 to 60 percent reduction in family income. Despite the Uniformed Services Employment and Reemployment Rights Act, which protects the civilian jobs of those called up, many reservists still lose their positions with impatient employers and may have to fight to get them back. Those who have businesses or are otherwise self-employed have no such protection.

Besides packing their bags and being good to go, non-regulars must also be ready to actually depart. That's the emotional side: coping with sudden family separation, home front concerns, and dealing with the cultural shock of barracks life and possible failure to survive combat. "You need letters as much as air and water," the Army advises soldiers, urging them to keep in touch with home. Each waking moment is a new challenge: the hours, the food, the gear, the gun. From the moment the new solider looks in the mirror at his induction high-and-tight haircut, his other life is also on the cutting-room floor. "It's a weird feeling," a solider friend tells me about his first day. "You feel both invincible and vulnerable. You're an anxious dog on a tight leash." But, he adds, he had his portable DVD and GameBoy to get him through the night.

Just in case soldiers needed another unnerving concern, the Pentagon was quietly proposing to cut the pay of soldiers on the front line in Iraq. A private who makes $18,000 a year (poverty level for a family of four) normally would receive an additional $100 a month in a Family Separation Allowance and $150 a month in Imminent

Danger Pay for combat (troops also get tax breaks for combat). In April 2003, Congress authorized temporary increases in both categories: $250 a month in separation pay, $225 in combat allotment. These increases were set to expire at the end of September 2003. But defense officials, with apparent White House backing, urged Congress not to extend the increases, saying they did not have the funds in their $400 billion budget(!). That would drop the average soldier's pay by $225 a month. The notion of cutting even a penny of front line pay seemed traitorous. In an untraditional editorial assault on Congress, the White House and the Pentagon, the *Army Times* commented: "The bottom line: If the Bush administration felt in April that conditions in Iraq and Afghanistan warranted increases in danger pay and family-separation allowances, it cannot plausibly argue that the highest rates are not still warranted today." The White House wouldn't comment on the cuts, and the Pentagon claimed it was merely shifting funds around. Ultimately, it backed off and paid for the extensions.

It didn't back off, however, on charging combat troops wounded in Iraq and Afghanistan for meals during their hospitalization. The daily rate was $8.10 for hospitalized troops, which the military has long charged all troops, it said. Nonetheless, "I was amazed. I couldn't believe it when I heard it," said Florida Republican Rep. C.W. Bill Young, the House Appropriations Committee chair, who quickly introduced a bill to repeal the practice. "Some things don't meet the common-sense test, and this is one of them."[23]

Here's another. Pay and benefits for some wounded soldiers in the hospital had been cut off altogether, due to chronic snafus in the Pentagon's payroll process. The General Accounting Office said the disarray in the military pay system was having "a profound financial impact" on troops and their families. Up to 94 percent of members of six mobilized Army guard units surveyed had pay problems that included three-month delays and both overpayments and underpayments. Thirty-four soldiers in a Colorado guard unit stationed in Afghanistan, instead of receiving paychecks, were told they *owed* the Army an average of $48,000 each. A U.S. sergeant in Uzbekistan risked his life to set bureaucracy straight. Armed with the correct pay records for the Colorado troops, he flew to Oman, then to a military finance office in Kuwait, back to Oman and finally back to Uzbekistan—where, enroute, he was fired on by the enemy over Afghanistan.[24]

One soldier, after returning home from Iraq, told *Intervention Magazine* that his tour of duty seemed more like basic training to become a private defense contractor. "You know, they [contractors]

actually come up to you and offer you jobs. They say, `Once you get out [of the military], go to this company to apply and you can come back over. We can use people like you.'" He wasn't interested. "I don't think it's worth any amount of money to be in a combat zone. You know, over 100,000 soldiers were offered $10,000 to re-enlist. Hardly anyone took it. I do not want to go back." [25]

Nonetheless, top military officials were indeed worried about an exodus of troops, in particular Special Operations forces, to higher-paying civilian security positions in Iraq and elsewhere. Though security forces were taking casualties (most memorably, in 2004, four Blackwater USA workers would be shot, burned and their bodies hanged from a bridge in Fallujah, Iraq), some jobs were paying up to $200,000 annually, four times what a Green Beret or Navy SEAL can earn in the service. "They're not leaving out of disloyalty," Gen. Wayne Downing, a former SpecOps commander, told Congress. "The money is just so good, if they're going to be away from home that much, they may as well make top dollar." [26]

Still, Bush insisted, conditions in the Gulf were "a lot better than you probably think. Just ask people who've been there." Not the dead, of course, or the thousands maimed. But even the growing death toll of Americans could be a twisted measurement of progress, the president suggested: "The more successful we are on the ground, the more these killers will react." There was in fact a full-blown PR campaign afoot in Iraq to change attitudes about high tolls and military failures. The *Stars and Stripes,* after interviewing soldiers on the ground, reported the military was putting on a dog and pony show for visiting Congress members. "Some troops even go so far as to say they've been ordered not to talk to VIPs because [military] leaders are afraid of what they might say," the paper reported.[27] On the Internet, family members of troops said the unscripted letters they got from their loved ones in Iraq pleaded with relatives to send them basic necessities, especially bottled water because entire units were coming down with dysentery. Said one mother: "Military protocol states that the troops are to be provided with 2 bottles of water daily, equaling 3 liters, and unlimited access to potable water in water buffaloes [large water tanks filled up and towed to the troops on the front]. Perhaps in theory this protocol may appear sufficient…but in reality, our sons and daughters are suffering tremendously! Dehydration is rampant, as are dysentery, vomiting, and diarrhea from ingesting the 'purified' water in the buffaloes." She had recently sent her son a case of bottled water, she added—"and the shipping cost for that was $75.00!!!!."[28]

Other families were sending goods to their sons and daughters, including top-of-the-line bulletproof vests. Most regulars

were well outfitted but guard and reserve units were saddled with older, less effective vests. Eight months after war commenced, more than 70,000 members of the Army National Guard and Reserve, Naval Reserve, Air National Guard, Air Force Reserve, Marine Corps Reserve, and Coast Guard Reserve on active duty in Iraq were still thought to be under-equipped and, in many cases, under-prepared, given that most train on average only 39 days a year. At one point, reservists, who make up more than a quarter of the U.S. troops in Iraq, accounted for a 40 percent share of non-battle injuries and illnesses.[29] The effect this might have on a volunteer army sparked talk of reintroducing the draft, and in November the Pentagon actually placed a small notice on its website asking for "men and women in the community who might be willing to serve as members of a local draft board," explaining that "if a military draft becomes necessary," the Pentagon would need to staff up to 2,000 draft boards in the U.S. After fielding press inquiries, Defense officials pulled the notice from the site. In early 2004, the Selective Service System did concede it was mapping out a possible targeted drafting of specialists in linguistics and computers, of which the military is woefully short. New York Rep. Charles Rangel and South Carolina Sen. Ernest Hollings were also floating draft-restoration legislation, though for reasons different from the Pentagon's. "In Iraq, minorities represent a disproportionate 32 percent of the deaths among combat-related specialties and 40 percent of those among the non-combat ranks," said Rangel. "I do deplore the fact that Americans and Americans-to-be of their socioeconomic positions make up the overwhelming majority of our nation's armed forces, and that, by and large, those of wealth and position are absent from the ranks of ground troops."[30]

For sure, said some members of Congress, it was not wealthy families they were hearing from who had to fork over $1,500 each for new ceramic armored vests to send to their soldiering offspring in Iraq. Supplies for such top-line gear were also inadequate and the military couldn't explain why. "I can't answer for the record why we started this war with protective vests that were in short supply," Army Gen. John Abizaid, chief of the U.S. Central Command, told Congress. Members wanted to know what part of "war planning" the Pentagon didn't understand. Was the military budget, perhaps, too focused on big-ticket ships and high-tech vehicles or the experimental toys of war like electromagnetic bombs, and not enough on minimum gear for grunts? Despite Abizaid's apology, the vest shortages nonetheless continued into 2004. Similarly, the military was shy of armored Humvees and asked Congress late in the war to fund 900 more vehicles. Like the improved vests, the maxi-armored Humvees

save lives. Numerous stories surfaced of soldiers' deaths prevented when bullets were stopped and deflected by the body and vehicle armor, such as the incident related by Lt. Gen. James Conway, commander of the 1st Marine Expeditionary Force, who told of a Marine taking four rounds from an Iraqi's AK-47 and suffering little more than bruised ribs. A Seattle-area mom, Susan Locke, said her son, an airborne Ranger, had repeatedly been shot up and saved by his vest and a little luck: "Bullets went up his pants, around his chest, pelting off his helmet. He said 'I really shouldn't be here [alive]."[31] Once that donated equipment was ready for delivery, the next challenge was getting it overseas. In one instance, the Defense Department dallied for more than five months on a citizen effort to deliver 500 air-conditioning units donated for the relief of heat-seared soldiers in Iraq, despite the attempted high-level intervention by the U.S. Senate.[32]

The preemptive war on Iraq was such a hurried effort it resulted in troop pullouts in Afghanistan where, some military officials believed, they were then closing in on the world's most-wanted man, Osama bin Laden. That opportunity was lost with the troop shifts. The pursuit of Saddam Hussein, meanwhile, turned into an unexpected shooting gallery—the battle to make Americans safer was actually making them easier to kill. Or, for those who survived the war, making life harder to live. As American casualties mounted, *The New York Times* Magazine recounted the stories of GI Robert Shrode, 29, and his buddy Brent Bricklin, 22, a fellow Army specialist in the 101st Airborne Division. Both were wounded by a rocket-propelled grenade that struck their Humvee on a June night near Fallujah. Shrode lost most of an arm, and his face is pocked from shrapnel. Bricklin has scars from thigh to neck. Both have hearing losses. Between them, they've had nine operations. Wrote the *Times*' Sara Corbett:

> Both men say they feel more vulnerable since coming back from war. When someone recently dropped a tray in the hospital cafeteria, Shrode dove, horror-struck, beneath the table. A crackling summer thunderstorm sent Bricklin into a panic, convinced he was caught in the back blast of a grenade again. Both say they have frequent nightmares. And then there's something less tangible, a visceral undercurrent of anger that makes them walk around feeling ready to explode. "I can go from being happy-go-lucky and joking to having someone's throat in my hand, like that," Bricklin says, snapping his fingers. Shrode nods. "My fuse is short," he says.

"It's real short."…for whatever societal void the dead disappear into, it is the wounded who must live with the confounding mix of anonymity and exposure wrought by surviving a war.[33]

Ultimately, Iraq had people saying something you don't hear too often: that the French, who implored the U.S. to wait, *were right!* As Winston Churchill noted, "The United States can always be counted on to do the right thing—after it has exhausted all other options."

While we counted down those options, deaths such as Justin Hebert's counted up. So many were fresh-faced kids who had looked to the service for training and a future. Hebert, legally underage when he joined while in high school, had his parents sign enlistment papers. Like him, most Gulf II dead were in their 20s, if not teens. "That's why they call it the infantry," says retired Army colonel and *Medal of Honor* author Jack Jacobs. "These guys are just kids."

After I wrote the Hebert story—noting the nondiscovery of weapons of mass destruction, the lack of other justifying evidence, and asking what Hebert died for—a U.S. soldier in Iraq sent me his theory.

"Spc. Justin Hebert did not lose his life for nothing, but for a cause," e-mailed Spc. Jorge Vance Gonzalez. "The cause is hard to see unless you are here in Iraq. We're old news to the people that have nobody in Iraq, but instead of complaining, help us in the ways that we can no longer help ourselves. The support of people that we don't know is a huge morale builder, because you do lose your focus here on a daily basis."

The thing is, the ultimate sacrifice of young men and women demands a noble reason. When there isn't one, such as a demonstrable threat to a country's safety, the government's strategy is to designate soldiers themselves as the noble reason.

Still, there were weapons of mass destruction in Iraq—the depleted uranium shells we brought. Others, mostly biological, we furnished to the Iraqis, supplied in the years leading up to Gulf I by corporate America, according to government reports and a lawsuit filed by a group of veterans in 2003. "The question that should be on the table," former flight nurse and veterans' advocate Joyce Riley told me, "is how complicit was the U.S. government and its corporations with Iraq? And what is anyone going to do about it?"

I wish the best to Spc Gonzalez. Whatever the ultimate truth of Gulf War II is, he has my sincere support. I hope he and all his buddies on the battlefields in Iraq and Afghanistan return home in good health.

They'll need it to survive life on the home front.

Chapter One

The Cocktail Effect: America's New Agent Orange

The Vietnam connection

Toney Edwards met his daughter around midnight in the hallway at Fort Sam Houston's Brooke Army Medical Center in Texas. Prepare for a shock, she told Toney and his wife, as they entered the hospital room that night in 1998. The father edged to the bedside and peered down at the distorted face of his Army son, Kevin. Toney flinched. The boy's face reminded him of something he'd seen in Vietnam: a battered, swollen GI, the victim of friendly fire.

One of America's 26.4 million war veterans, father Toney had joined the Army 30 years earlier, going from the back woods of Virginia to become an airborne solider in the Vietnam jungles, where he was exposed to the herbicide Agent Orange. "The Army gave me a life," he liked to say, then add that the life included post traumatic stress disorder and maybe prostate cancer, linked, he thinks, to the chemical defoliants he was told were harmless to humans.[1]

'Imagine,' says a father, 'being in a position in which you cannot even cry.'

It had been tough to live with his military memories. Now he had to face living with his son's as well.

Hovering over Kevin, Toney was confused. How could the boy suffer such injury? The father had witnessed members of his own unit in 'Nam after they were hit with napalm fired by U.S. aircraft. Their faces looked seared, inflated, cockeyed.

Did Kevin's Army truck turn over? Was there a fire? An explosion?

Say what? An *inoculation*?

Moments after being given, under orders, a shot of anthrax vaccine while on duty in Korea, Army Spc. Kevin Edwards lapsed into a partial coma and stopped breathing. While being airlifted by

helicopter to a hospital, he was given a tracheotomy.

The stab of vaccine was supposed to protect him. Instead, it put him near death, and cost him part of his eyesight.

Kevin Edwards survived, though he will never fully recover. The Army sent him to the Boston Foundation for Sight—a year after he began complaining about his fading vision—where he was fitted with special lubricated lenses.

His father says he's convinced by what he's read in medical journals and heard from doctors and other veterans that his son's condition was caused by an adverse reaction to the anthrax vaccine.

Injections of the vaccine, which was considered experimental and was not fully approved for the way the military uses it, were often given without the informed consent and other precautions required in civilian medical practice. The drug has never undergone controlled testing in humans for long-term effects. But under the military oath, recruits solemnly swear or affirm they will support and defend the constitution and obey the orders of their president and commanders, an oath that concludes, appropriately, "So help me God."

Refusing the vaccination is out of the question, unless soldiers are willing to face being drummed out of the corps. Congress approved the law enabling the president to order inoculations. Some soldiers say their commanders have threatened to tie them down and forcibly inject them if they decline to follow orders.

The Pentagon insists its vaccine is safe, effective, and has the studies—its own—to prove it. But this much Toney Edwards knows: One day his son was marched into an Army vaccination tent and wound up a casualty of war. He even had to undergo an operation to remove his tear ducts.

"Imagine," Toney says, "being in a position in which you cannot even cry."

There are other Kevin and Toney Edwards. They're the soldiers and veterans who have increasingly been injected, gassed, medicated, experimented on and exposed to chemicals by their own government in recent decades. Some may have died from chemicals we sold to our enemies. Anthrax, for one, was provided to Saddam Hussein by American firms in the years just before Gulf War I.

They have also faced the threat of faulty weapons and equipment. They face ever-vanishing health services and the broken promises of veterans' benefits from the country they risked everything to defend.

They endure the hazards of foreign battlefields, then return home to face another wave of oncoming forces: the Pentagon, the VA, the Congress, and the White House. Talk about incoming.

Government is not out to injure its soldiers. The military is no democracy. But the Pentagon has a vested interest in defending its hazardous medicines, vaccine and the munitions it thinks are needed to fight wars, and will mislead, misinform and lie to its troops if, in the mind of war makers, that's what it takes to win. The policy is to experiment now and worry later.

This is later.

A chemical and biological hangover

The American combat death toll from Desert Storm, the "100-Hour" Gulf War of 1991, was 148. Another 145 were killed in non-battle incidents and, officially anyway, 467 wounded in combat. That's how we tend to see wars—in terms of battlefield casualties.

But the major battle toll today, more than ever, is the one that relatively quickly follows a war.

11,000 veterans have died since the 1991 Gulf War. Don't make too much of that, says the government.

In the decade since the first Gulf War, more than 320,000 veterans of the 696,000 deployed have sought medical treatment from the VA—the country's largest hospital system, run by the Department of Veterans Affairs, the second biggest government agency next to the Pentagon.

About 214,000 of those veterans have filed disability claims for war-related injuries, diseases, and conditions, and so far 161,000 are receiving war-related disability payments.[2]

That's right, 214,000. And counting. The public perception is we suffered minimal losses in a war that flittered across TV screens for hardly a week. Yet almost a third of America's soldiers came home as casualties.

Here's another figure to think about—especially if you're serving or have served in Iraq and Afghanistan: since the first Gulf War ended in 1991, at least 11,000 veterans, whose average age during the war was 36, have *died*.

Eleven thousand. That's based on both government figures and veterans' estimates.[3]

The VA says not to make too much of these raw numbers. "The use of these data to draw conclusions regarding mortality rates will result in inaccurate conclusions," a VA disclaimer warns. The government doesn't explain how it knows in advance that your

conclusions will be inaccurate. But then, it's the government.

One post-combat study found that veterans of the Persian Gulf War—Gulf War I—had a significantly higher mortality rate than veterans who had been deployed elsewhere during the war. But the study linked most of the increase to routine accidents—cars crashes, for one—rather than war-related diseases.[4] That was a finding consistent with patterns of postwar mortality among veterans of previous wars, the VA claimed.

To date, there's no agreement on what, exactly, *are* the war-related diseases of the Gulf. Despite more than 150 federally funded studies at an estimated cost of $150 million, there's no meaningful breakdown of those mortality figures.

But anecdotal evidence and the widespread illnesses of Gulf veterans suggest they're a select group of humans facing an early demise.

Many of them suspect it has something to do with serving in the most toxic war in military history. So far.

The head cases

Gulf War illness was earlier called Gulf War syndrome, which addressed the existence of patterns but withheld the admission of illness, and drew the line at establishing any clear source. The term carried the implication that such ailments were the imaginary manifestations of whiners and opportunists seeking to get on the government dole. While there are surely deceivers in the VA system as there are, say, in Congress, too many thousands of Gulf veterans took ill or died for the government to continue insisting there is no distinct correlation to their encounters with the battlefield-related combination of chemical releases, radioactive munitions, oil-fire fumes, and unapproved investigative drugs and vaccines along with anti-botulism and anti-malarial medicines, and pesticides. Gulf veterans refer to this volatile concoction as the cocktail effect. Their ailments can include neurological, skin, cardiac, GI, and urinary tract ailments, commonly manifested as chronic fatigue, muscle and joint pain, as well as difficulties with concentration and memory. They are, at best, life-limiting complications. At worst, they are fatal.

"I don't know why the government, if it cares so much about its troops, isn't saying 'My God, 200,000 disabled in that war, 11,000 dead! What did we do?'" Joyce Riley of the American Gulf War Veterans Association tells me. "Instead, if you make the mistake—as some veterans have—of going in and saying you have Gulf War illness, that just gets you a trip to the psych department. You're an

instant head case. That way they don't have to treat you medically. They'll give you Prozac or Zoloft and send you on your way." She and others say mental health and drug addiction treatment are two of the greater challenges facing the VA. Some doctors report fourfold increases in addiction patients and overwhelming mental health caseloads.

The *Washington Post* told the story of fully disabled Gulf War vet Dr. James Stutts, a retired lieutenant colonel who commanded military-base medical staffs and helicoptered into combat zones to treat the wounded. Though 54 and disabled by dementia, he keeps his Army uniform pressed and ready as if he might be called back to duty. He, too, at first doubted reports of Gulf War illness, then began to suffer spasms and seizures that caused him to fall down stairs. He has medical records that include an image of his brain, which he describes as looking like Swiss cheese. The Pentagon informed him he might have been exposed to sarin, one of the world's most dangerous chemical warfare agents, when the nerve agent was unintentionally released on U.S. troops by U.S. troops while destroying Iraq's chemical storage depots in 1991. "I would have preferred to have stepped on a land mine than to be exposed to what I was exposed to over there," Stutts said. He's a patient at a VA clinic in Virginia where 100 other Gulf War veterans, 20 years younger, are being treated for the onset of Alzheimer's, and where Dr. Wes Ashford, a psychiatrist and Alzheimer's specialist who runs the hospital's memory disorders clinic, told a reporter: "The striking thing is, you don't see these problems in the Vietnam veterans, the Korean War veterans, the World War II veterans."[5]

According to a Central Intelligence Agency report, the possible weapons of mass destruction that could have been released on Gulf War I coalition forces due to accidental exposures through our mishandled destruction of Iraq's chemical-weapons storage sites included the blister agent sulfur mustard, the mixed nerve agents sarin and cyclosarin, and the riot control agent CS.[6] The United Nations Special Commission on Iraq found indications that some warheads had contained VX gas. A General Accounting Office review says that containers of 19.9 metric tons of sarin and cyclosarin and 15 metric tons of the chemical agent mustard were damaged, and some of their contents released, by allied air strikes on the storage sites.[7]

In one incident, more than 134,000 American troops were exposed to chemical warfare agents at Iraq's Khamisiyah chemical-storage depot in 1991, which was destroyed by U.S. forces. After denials and false starts for more than a decade, the Pentagon has

now confirmed Khamisiyah as a friendly fire incident, which I'll detail later. Not only was it the single largest chemical-weapons exposure of American soldiers ever recorded, the Army had been aware of the depot's hazards all along. The Pentagon covered up the miscommunication, as it was called, until Gulf War veterans and others turned up military documents and forced disclosure.

Official government lies about the health of its soldiers are—surprise—not rare. As Agent Orange was to Vietnam veterans, Gulf War illness has become the military's intestinal disorder of the day: You don't have a disease until we say you do. If we're wrong, well, we have those new burial benefits.

The government seems in no great hurry to solve all this. Steve Robinson, executive director of the National Gulf War Resource Center—a hell-raiser for veterans' rights—formerly worked for the Pentagon's Office of the Special Assistant for Gulf War illness. A Gulf vet, he took the desk job with no preconceived notions about the government's role to keep veterans informed about their post-war health complications. What he saw made him the activist he is today.

"From the day I walked in there I saw a concerted effort to lean against the veteran, to minimize the truth, to summarize events favorable to the government, to come to assumptions and conclusions that could not be proven, and to make great leaps of faith," he told me. "There was a callousness to everything they did."

After the war, a Senate Committee on Veterans Affairs survey of 146 Gulf veterans demonstrated how dismissive the military was of soldiers who complained of illness. Vets complained about quality of care and lack of compassion by VA physicians and nurses. One recounted a doctor's comment that the Gulf War "wasn't a real war" and another said a doctor told her she was fine—after using a stethoscope he forgot to plug into his ears.[8]

The veterans' comments and investigators' observations as recorded in the survey suggest a pattern of neglect if not contagious stupidity:

On Medical Records:

"Asked for my medical record and was told all had been disposed of."
"Medical record is lost forever."
"20 years of medical records are now mysteriously gone."
"All our medical records were destroyed."
"Doctors refused to put vaccinations in my medical record."

"Was told my leave would be held up if I wanted copies of my medical record."

"My medical record says my illness is not related to Agent Orange. This VA doctor has the wrong war!"

On Vaccinations:

"Passed out after anthrax shot."

"We were told not to tell we got anthrax shots because there wasn't enough for British and French troops."

"Several reported flu symptoms at time of vaccinations."

"I argued that I was pregnant, so finally they let me not take the shot. It was a big argument."

"They made me sign something, but the form was folded so I couldn't read what I signed."

"We were ordered to sign the consent form."

"I could refuse the shot—if I wanted court martial."

"I tried to refuse anthrax; was threatened with Leavenworth."

On the VA Hospital System and Doctors:

"VA doctors don't want to know what is making you sick."

"VA is minimizing our illnesses."

"Navy doctors told my wife to terminate her pregnancy."

On Effects of illness:

"Sometimes I forget to feed my son."

"I got lost while going to get my children from school."

"I don't have a spleen and wonder if I should have taken those drugs and vaccines."

"Lots of men in the unit have swollen testicles."

Says veterans' leader Robinson: "The first thing the government said when you returned was, ok, you're sick? Prove it. One by one. That's tough to do when you have no expertise at this. Which they are counting on."

Military-related illness: A history of misdiagnoses

It's not a new attitude or phenomena. Mysterious battle illnesses can be traced back to the "irritable heart" of the Civil War—subsequently called the "soldier's heart" and eventually found to be

a psychological disturbance not unlike shell shock in WWI, battle fatigue in WWII and Korea, and post traumatic stress disorder (PTSD) in Vietnam. With newer ways to fight wars came newer ways to die from them, including from the very drugs intended to protect against such deaths. Then came the new denials.

Strategically and politically dependent on those weapons and medicines to fight wars, the government grew ever more reluctant to curtail their use. It similarly grew more defensive about their friendly fire-like consequences.

In Gulf War I, the military's M8 chemical detection alarms went off an estimated 14,000 times—likely *all* of them false alarms, said the Pentagon. But who really knew? A later Army audit determined the alarms weren't regularly inspected to see if they were operational. There was a similar disregard for the condition of protective masks, and no system existed to report the alarms or the masks as broken or hazardous. "Accordingly," declared the audit, "up to 90 percent of the monitors and 62 percent of the masks were either completely broken or less than fully operational."[9] The military ultimately concluded that diesel smoke and gas fumes regularly caused the alarms to false trip. Apparently higher-ups were pleased. They figured no one was harmed because, well, no one had died on the spot.

The military's overriding policy was to be contradictory and tentative. Give shots, hand out gear, set alarms, and shrug it off when it all turns to shit. Ret. Marine Col. Carl Bernard, a WWII, Korea, and Vietnam combat vet, told Soldiers For The Truth—a veterans' watchdog group—that his greatest fear was how a minor chemical attack could cause panic among even the best-trained troops. "The first soldiers caught under a chemical attack—their *reactions* are going to be contagious," he said.

Were there in fact such chemical attacks? The official answer is no. But Debbie Judd, an Air Force Reserve aeromedical nurse who served six months at a Saudi Arabian field hospital—and who herself suffers from Gulf War illness—says she saw a lot of chemical burns. "The alarms were going off every couple of hours to indicate chemical exposure. We didn't know what it was and, afterwards, we were told by the higher-ups that it wasn't enough to hurt us," says Judd, now an activist with the National Gulf War Veterans Resource Center. "Unfortunately, we believed them."

Judd, who has nursing degrees and a master in health administration, is almost too sick to talk at length anymore. To her list of illnesses, she recently added colon cancer. In 2003 she told *Revolution* magazine, a journal for RNs and patients, that soldiers were unhealthy even before they went to battle. Like her, troops "didn't go [to war]

with a healthy immune system, because they gave us 10 inoculations in one day, including the anthrax vaccine. It was especially disturbing to see this happen as a nurse." Among the risks was the ill-advised mixing of one vaccine with another, she said, a standard military practice.[10] There were doctors who agreed with Judd, although some paid heavily for their dissent. Dr. Yolanda Huet-Vaughn, a reservist, refused to vaccinate military personnel with experimental drugs, claiming it was her duty under the Nuremberg Code of Justice. She refused to report to her unit during Gulf War I and was tried for insubordination at an isolated military site, Fort Leonard Wood, in the Ozark Mountains. Not allowed to make her Nuremberg argument, Huet-Vaughn was sentenced to 2 1/2 years hard labor, pay forfeiture, and dismissal. Thanks to pressure from activists who found her imprisonment unjust, she was released after eight months.[11]

Of course, delayed reaction to treatments and environmental hazards is one of the many lessons of earlier wars. It took years before the nation realized many Korean War vets were suffering from a cancer they developed from the frostbite of Korea's bitter cold (Gen. Douglas MacArthur told Americans their boys would be home by summer, and to go along with that charade, the military didn't issue its troops winter gear). In WWII, thousands of service members came down with hepatitis, puzzling doctors. A lengthy review finally determined the troops had been injected with an infected yellow fever vaccine. But before the source was found, 50,000 Hepatitis C cases were recorded. For Vietnam veterans, it took much longer, nearly 30 years of complaining about toxic defoliants ruining personal and family health and shortening life spans before the VA accepted many of the disorders as a treatable group of Agent Orange diseases. One more time: Nobody died in the field from those ailments. What's the hurry?

In fact, the hazards of Vietnam's dioxin sprays are still being discovered, most recently in links to diabetes (2000) and a form of leukemia (2002). Hundreds of thousands of Vietnam veterans still suffer the effects of Agent Orange and post-traumatic stress disorder. Many of those PTSD victims are among the quarter-million to half-million veterans that make up one-third of all homeless adults in the U.S. (Of the 26 million U.S. vets, most—8.5 million—are Vietnam era, followed by 5.7 million WWII vets). A 1999 Australian study showed that suicide rates in the children of Vietnam veterans in Australia were three times that of the general population. It was something researchers still can't explain.[12]

Returning home, Vietnam veterans had to blaze new trails through the bureaucracy to pry loose the secrets of their sicknesses.

It's an endless quest. The Vietnam Veterans of America organization is still fighting to determine all the facts of how veterans were exposed to biological and chemical experiments in the 1960s, and how they are three times more likely to die of respiratory and neurological diseases than the general population.[13]

Now it's the 1990-1991 veterans of Desert Shield, the defensive Gulf War buildup in Saudi Arabia, and Desert Storm, the offensive war in Kuwait and Iraq, who are being asked to retroactively prove and explain their illnesses. As in Vietnam, it remains the burden of the Gulf vet to demonstrate a cause and effect, while it seems the government's only burden is to try to deny it.

The VA has conceded that Gulf I veterans are twice to three times as likely to develop ALS—Lou Gehrig's disease. But officials are not persuaded that anthrax vaccine, depleted uranium used in munitions, oil-well fires and sarin gas are necessarily the Gulf killers. The Defense Department only recently—2002—agreed to sponsor a landmark study on brain stem injury in Gulf War veterans, and will examine 400 veterans over a five-year period at the San Francisco Veterans Medical Center to gauge the cocktail effect.

Spouses and other family members can also be affected, if not infected. Some studies contend the illnesses of the Gulf, like those of Vietnam, can be passed through sexual and other contact; other studies claim the illness is contagious.[14]

Gulf War II illness

Tomorrow it will be the 2003-04 veterans of Iraq and their families seeking redress. In addition to exposure to hazards similar to those of 1991, more soldiers were injured in the close-up combat that marked the initial Gulf II battles, followed by house-to-house fighting and ultimately by ambush and guerilla warfare. By 2004, the number of U.S. casualties—dead, wounded, injured physically and mentally—in Iraq rose inexorably past 10,000.

Not to be forgotten are the veterans of Operation Enduring Freedom in Afghanistan where more than 100 U.S. troops died from 2001 into 2004, and where thousands more were wounded. Just 16 were killed in the lightning-fast war that drove the Taliban from power in 2001, and the public perception was that the war was over. However, more than six times that number have died in Afghanistan since, and it, too, seems a war without an exit.

For that matter, lest we forget, many survivors of Beirut, Grenada, Panama, Somalia, Bosnia and random acts of terrorism have war illnesses that include PTSD and vaccine reactions.

Our newest Gulf veterans could face altogether new health complications, beginning with brain injuries. A Walter Reed Army Hospital review in December, 2003 showed more U.S. troops in Iraq are suffering brain damage casualties than their predecessors in earlier wars—the cause being the high explosives being used by the fedayeen resistance fighters, with many of the bombs set at roadsides to pick off passing U.S. soldiers. (As of early 2004, more than 100 of the 370-plus U.S. troops in Iraq killed by hostile fire died from such improvised explosive devices; in February 2004, 10 soldiers were killed by the bombs, which can be triggered by such simple devices as remote garage-door openers or egg timers).[15] The Reed review showed that 67 percent of 105 wounded soldiers they studied had suffered effects ranging from mild concussion to coma to death. "Even Kevlar helmets are not designed to absorb concussive blast wave impact," said Dr. Louis French.[16] Then there is the soldier's comparatively longer exposure to environmental hazards—like sand. A field report by the Marines says Iraq's desert dust not only made operations difficult but "living conditions for Marines become intolerable. A bigger concern is that commanders in the field are faced with a Catch-22 situation of spraying oil on the ground." They had to choose between the hazardous environment produced by oily chemicals or the one produced by sandy grit.[17]

The report also said that due to faulty equipment, some troops had trouble with their gas masks and occasionally lost the automatic injectors they carried into battle, used to stab-inject themselves in the thigh to protect against possible chemical attacks. If they sense the arrival of a nerve agent, for example, troops are told to immediately hold their breaths, don their masks, and inject themselves with the meds, atropine and pralidoxime chloride. That's supposed to prevent the sudden narrowing of the airway, unconsciousness, convulsions, and paralysis produced by such an attack, allowing a victim time to get medical help. The meds come with their own side effects, though they are minor compared to the potential harm of a nerve agent.

By early 2004, in a limited survey of troops already discharged from service after Afghanistan and Iraq, the VA reported that more than 11 percent of 83,753 Iraqi veterans and 10 percent of 17,541 Afghan vets had health problems—the most common being diseases and injuries to muscles, bones, skeleton and connective tissue. However, it was an early and incomplete snapshot of Gulf II effects involving mostly Air Force and Navy veterans, and didn't reflect the likely higher toll on combat soldiers or hundreds of thousands of active duty troops. Even at that, about 1,600 of the early vets were

being treated for mental disorders including psychoses, post-traumatic stress disorder and substance abuse. Though many of those surveyed had what the VA called "ill-defined conditions," the government insisted it had not yet encountered any mystery diseases.[18]

Reports from the front, however, begged to differ. As far back as March 2003, the first month of the war, pneumonia-like illnesses began sweeping U.S. troops in Iraq. More than 100 were initially affected. Fifteen service members suffered serious respiratory problems and were evacuated. Two soldiers died. One of them, National Guard Spc. Joshua Neusche, 20, of Montreal, Mo., had been serving with the 203rd Engineer Battalion in Baghdad. He died July 12 of major organ failure. His father, Mark Neusche, said the Army told him that Joshua had complained of a sore throat and breathing difficulties and collapsed at the foot of a medic. The father suspected it was the result of a "chemical weapon or something. For Josh to fall into a coma in just a few hours, it has to be something like that. He was a strong boy and he knew how to look after himself. This could not have been a natural thing: we have been told that his lungs and kidneys collapsed and he had toxins eating at his muscle structure."[19] Yet no chemical attack had taken place.

In September, the true dimensions of Gulf War II's casualties began to filter out publicly. On average almost 10 American troops a day were being declared wounded in action. The spin on the high count was pure Pentagonese. Officials said the reason for so many wounded was due to the advances in medicine: in another war, many of those wounded might have been listed as KIA, but modern medicine was turning them into merely WIA. But then, that also meant more casualties for the government to treat back home. More than 6,000 service members had already been flown to the U.S. for treatment to tend medical wounds and injuries, as well as for psychological and psychiatric treatment, including stress.[20] Within two months, the casualty toll passed 9,000, then climbed to 11,000 in 2004. Estimates were that just over half were physically wounded while many others suffered from mental or environmentally related ailments.

What were the ailments that so many troops were suffering from? The military would not specifically break down the numbers.

Vet groups asked the Centers for Disease Control to step in and undertake an independent study. It's not only GIs in the field at risk, they say, having learned the lessons of Vietnam and Gulf I, but those who may come down with related mystery ailments in the future. Data gathered in the immediate battlefield can go a long way

towards proving cause and effect. The military has begun doing some of that. Since 1998 it has been developing its Defense Occupational and Environmental Health Readiness System, or DOEHRS, a software program to record chemical and biological exposures; the data can help commanders determine the risks in battle and help medical professionals determine future health risks. But full use of the system is years away.[21]

Arthur Caplan, director of the Center for Bioethics at the University of Pennsylvania, wonders if Gulf War II illness is not inevitable. "We have improved the way we monitor our soldiers before and after deployment," he says. "But we still don't test treatments against biological or chemical agents in human subjects, relying instead on interpreting results from animals for humans." There are obviously ethical conflicts to testing dangerous agents on human subjects, but that in effect is what the military is doing with its soldiers. If we're not doing it in a controlled setting with volunteers, using great new medical technology, Caplan asks, how can we justify battlefield experiments? "In a world threatened by weapons of mass destruction, using hundreds of thousands of troops and civilians as guinea pigs makes little sense," he says.[22]

The smallpox vaccine: opening Pandora's Box?

Certainly to her family, the death of Army reservist Rachael Lacy made little sense. A combat medic headed for Gulf duty, Lacy, 22, of Illinois, was vaccinated for smallpox and anthrax, and apparently given an anti-malarial drug and possibly other injections, all in one day. She died shortly thereafter in 2003.[23] As a medic, Lacy might have been more aware than other soldiers about the possible side effects of the medicines. But they can prove to be elusive and unpredictable, especially when used in combinations the body has never experienced.

In particular, the smallpox vaccine, known as vaccinia, is the most toxic vaccination in existence. It is used to combat a disease that no longer exists outside of tightly controlled stocks. A live poxvirus that is similar to smallpox itself, the vaccine helps create antibodies to stave off an attack of a "dead disease" that has been eradicated for more than two decades. The vaccine had not been widely given to combat troops until Afghanistan and Iraq, when fears were raised that Saddam and the Afghanis had developed stored supplies of smallpox for use as a bioweapon—a suspicion that remains unproved but nonetheless hair-raising in light of our present knowledge of the extent to which American companies provided Iraq with

chemical and biological weapons in the 1980s.

President Bush wants all troops to eventually be vaccinated with what are old stocks of the vaccine, called Dryvax, that are licensed by the Food and Drug Administration. That vaccination program continues, even though U.S. researchers in Iraq, called Team Pox, reported in late 2003 they had found no indications of smallpox in Saddam's suspected WMD arsenal—and in fact had found evidence to the contrary: potential disease-spreading equipment had long ago been rendered harmless by U.N. inspectors. Dr. Meryl Nass, a Maine internist who is critical of the government's vaccine policies, considers Dryvax an expired drug, and says "Never mind that expired drugs and vaccines are considered adulterated, and cannot be licensed. Last October [2002], FDA went ahead and licensed old Dryvax anyway." Significantly, it wasn't licensed for civilian use.[24]

So far, hundreds of thousands of GIs have been vaccinated with Dryvax, although as many as one in three were being allowed to opt out due to potential complications. (Unlike anthrax vaccinations, smallpox vaccinations are not mandatory. But soldiers are pressured to get them.) A drug information advisory given to troops says the "Vaccine used for Service Members passes all tests required by Food and Drug Administration" and that "Smallpox vaccine was the very first vaccine (1796) and has been used successfully for over 200 years... Smallpox would disrupt military missions, because it is contagious and deadly."[25]

After receiving her shots, Lacy developed pneumonia. A month later, the young solider died. Her family says her death certificate lists lung damage as the direct cause. Under contributing factors, the certificate mentions "lupus-like autoimmune disease" and "recent smallpox and anthrax vaccination." Some doctors think a severe reaction to vaccines can look like lupus, a systemic inflammatory disease that can affect various body parts, especially the skin, joints, blood, and kidneys.[26] Two military panels that reviewed the death later said it indeed seemed clear that Lacy's vaccinations triggered her death, although in three other similar soldiers' deaths, the panels found no such link. The military was emphatic that Lacy's fatal reaction was a rare one, and it downplayed the fact she'd received multiple shots in one setting—perhaps as many as ten injections. "Infants can get five in one day," said Dr. John Grabenstein of the Army surgeon general's office. "It's considered safe practice." But it wasn't safe for Rachael Lacy, counters her family. "Unless somebody breaks this story wide open," said her father, Moses, "we are going to have a lot more deaths."

For that matter, Lacy's vaccination put her father and other

family members at risk. Injection of smallpox vaccine can lead to disfiguring skin disorders, neurological impairments, blindness and death. Smallpox "shots" are given not with hypodermic needles but with a two-prong needle head that merely pricks the skin. The vaccine does not become airborne in any fashion but a pustule left by a successful inoculation *is* a threat—the live virus can be spread by touch. Thus someone in a soldier's family could be contaminated—a child cradled in her father's arm, one spouse hugging the other goodbye. Doctors at Madigan Army Medical Center, for example, say a soldier spread the vaccinia virus to his infant daughter via his lactating wife. It was the first documented case of vaccinia transmission from a mother to her infant through contact while breastfeeding. Lt. Col. Mary Fairchok, chief of Pediatric Infectious Disease at Madigan, who wrote about the case for the *Journal of the American Medical Association* along with two other doctors, noted that such cases are "extremely rare" but said troops should be aware of precautions. Of the 578,000 people the Defense Department vaccinated for smallpox from December 2002 through January 2004, there were just 29 suspected and 18 confirmed cases of such person-to-person virus transmission, Fairchok said. Yet, she advised, "I think it is sensible and reasonable to ask [a vaccinated soldier] to do his own laundry" until the vaccine rash and all side effects subside, as they reportedly did in the cited cases.[27]

Shots are often given just prior to deployment, when troops still have contact with their families. Wives, children and others who have not given their informed consent yet could be unknowingly contaminated, may be at high risk for side effects. Those most vulnerable, according to the Centers for Disease Control, include (take a breath):

> People who have had, even once, skin conditions (especially eczema or atopic dermatitis) and people with weakened immune systems, such as those who have received a transplant, are HIV positive, are receiving treatment for cancer, or are currently taking medications (like steroids) that suppress the immune system. In addition, pregnant women should not get the vaccine because of the risk it poses to the fetus. Women who are breastfeeding should not get the vaccine. Children younger than 12 months of age should not get the vaccine. Also, the Advisory Committee on Immunization Practices (ACIP) advises against non-emergency use of

smallpox vaccine in children younger than 18 years of age. In addition, those allergic to the vaccine or any of its components should not receive the vaccine. Also, people who have been diagnosed by a doctor as having a heart condition with or without symptoms, including conditions such as previous myocardial infarction (heart attack), angina (chest pain caused by lack of blood flow to the heart), congestive heart failure, and cardiomyopathy (heart muscle becomes inflamed and doesn't work as well as it should), stroke or transient ischemic attack (a "mini-stroke" that produces stroke-like symptoms but not lasting damage), chest pain or shortness of breath with activity (such as walking up stairs), or other heart conditions being treated by a doctor should not get the vaccine at this time. (Heart disease may be a temporary exclusion and may change as more information is gathered.) Also, individuals who have 3 or more of the following risk factors should not get the vaccine at this time: high blood pressure diagnosed by a doctor; high blood cholesterol diagnosed by a doctor; diabetes or high blood sugar diagnosed by a doctor; and a first degree relative (for example, mother, father, brother or sister) with a heart condition before the age of 50.

Oh, and add one more group, says the CDC: People who are currently cigarette smokers. There may be a few of those in the military. In March 2004, the Department of Defense said about one third of service members smoke. Its latest military health survey also showed the first increase in smoking among DOD personnel in 20 years.[28]

It is the hope of President Bush that all Americans can receive such inoculations. It is the hope of Barbara Loe Fisher, president of the National Vaccine Information Center, that they don't. Mass inoculations come with another side effect, she says: The creation of widespread fear and distrust of government-promoted vaccination programs in general, including beneficial ones.

No mystery deaths?

Also under study were the deaths of a National Guardsman who had a heart attack after getting shots, and battlefield casualty David Bloom, the popular NBC television correspondent who died of

a blood clot several weeks after receiving smallpox and anthrax vaccinations. Rival CBS News reported that a government program set up to detect vaccine trends found 11 cases of unusual heart inflammation among military troops who got the smallpox vaccine; Bloom's death, however, which clearly should have been reported as a vaccine-related death, wasn't included in the government case count, raising issues of the count's credibility.[29] Two female health care workers who were vaccinated against smallpox also died around the same time as Bloom and Lacy. The two workers were over 55 and had a history of heart problems, making it uncertain the vaccine was to blame. Many doctors believe the vaccine causes potentially fatal cardiac reactions, although the Centers for Disease Control released a new study in late 2003 that suggested otherwise. The issue remains unsettled.

Across America, other families have been puzzled at the non-combat deaths of their loved ones. Among them, Army Spec. Levi Kinchen, 21, of Albany, La., died in his sleep August 9th in Iraq. Lt. Col. Anthony L. Sherman, 43, of Pottstown, Pa., died August 27th of unknown causes in Kuwait. The word "unexplained" has regularly been used to describe non-combat deaths.

Female soldiers face separate and unique threats from military medicines. Smallpox vaccinations are clearly not to be given to pregnant soldiers, while use of anthrax vaccine on expectant moms is, militarily anyway, up for debate. The Army and Navy, for example, are at odds over the risks. A 2002 Navy study "identified a possible relationship between maternal anthrax vaccination in the first trimester and higher odds of birth defects," according to a summary of the findings.[30] The Army's 2002 study concluded that the vaccine appears to have no ill effects on pregnancy rates and birthrates.[31] The CDC claims there "is no convincing risk from vaccinating pregnant women" with the anthrax vaccine, but says further study is warranted and plans to issue more complete data in late 2004.

Nonetheless, keep in mind that massive human injection programs are not controlled studies that determine the true efficacy of a medicine. Anthrax vaccine is neither recommended nor licensed for use during pregnancy. Female soldiers, pregnant or not, should always be advised of possible fetal hazards, and many say they were not so informed.

At least one mother, Chandra Carroll of Clarksville, Tenn., a former solider who underwent the anthrax vaccination, says her newborn daughter, Nyla, died in 2001 as a result of the inoculations the mother received a year earlier. She is part of an ongoing federal lawsuit brought by 75 current and former service members against

the vaccine's maker, detailed in a later chapter.

A 1996-97 presidential commission on Gulf War illness said that then-current scientific evidence did not support a causal link between symptoms and illnesses reported by Gulf War veterans and their assorted wartime vaccinations and exposures. Though the commission said more study was needed, it laid much blame on stress. It was "likely to be an important contributing factor to the broad range of physical and psychological illnesses currently being reported by Gulf War veterans." Dr. Murray Raskind of the VA Puget Sound Health Care System in Seattle says the more common PTSD symptoms are great difficulty sleeping, nightly thrashing, and terrifying nightmares. "Typically, the nightmare will be that they're facing an enemy force and their rifle jams and the enemy is coming closer and closer. And they try desperately to get their weapon to operate and it doesn't and they start running and fear that they'll be killed at any moment."[32]

Experts estimate 30 percent of Vietnam veterans still suffer from PTSD today while a similar number of Gulf veterans have symptoms. They're arguable percentages and veterans are suspicious of them. Such estimates can be used to demonstrate that war illnesses are psychogenic—in the head rather than the body—with the problem ostensibly stemming from some inadequacy of the individual soldier. Of course an impairment that is "only" psychological does not diminish the very real suffering endured by thousands upon thousands of service people, leading to a calamitous range of further side effects including job loss, divorce, broken family relationships and substance abuse. But by favoring a constricted medical definition, the military can limit its service-related obligations to the veteran.

Obviously, there's stress in and after war. There's also the stress of not being treated for what truly ails you. Or stress from the belief that your leaders don't have a clue about what has gone wrong and how to prevent a reoccurrence.

Just prior to launching the 2003 war in Iraq, the Pentagon mulled over a plan for bulldozers to mass-bury soldiers killed in a biological attack, should their $200 chemical-protection suits fail. Despite the decade it had to prepare for another war with Iraq, this was the government's only answer to a bio-warfare attack in the field: Ditch the infected bodies.[33]

Saddam's WMD: Made in the USA

Don Rumsfeld said America had good cause to worry about

biological and other weapons of mass destruction in Iraq. In fact, he knew where they were: "They're in the area around Tikrit and Baghdad and east, west, south and north somewhat." Everywhere. And nowhere.[34]

Actually, it was our late-night commando, Jay Leno, who put the debate over WMD in perspective. "Of course we know Saddam has weapons of mass destruction," Leno said in the weeks leading up to the 2003 war launch. "We have the receipts."

That's what a lot of veterans believe. And they have government documents to back them: a report from the United States Congress and the records of Saddam's government indicating we supplied WMD to Iraq prior to Gulf War I.

In 2003, a vet's group sued two American and several European companies for exporting chemicals that they said Saddam Hussein had once used to attack both soldiers and civilians—an American connection Secretary of State Colin Powell didn't mention in his pre-Gulf II war speech to the United Nations, saying only that Iraq uses "an extensive clandestine network" to support its deadly biological and chemical weapons program. Filed by Houston attorney Gary Pitts, a retired Army National Guard captain, the lawsuit cites Iraqi documents revealing a list of banks that provided letters of credit for Iraq and identifying more than 50 chemical suppliers who may have contributed to Iraq's manufacturing of mustard gas, sarin and VX. (The United Nations has refused to completely reveal the Iraqi documents detailing the corporate connections.) One of the plaintiffs, former Marine Capt. Dan Hammond of Chicago, was among the first wave of troops into Kuwait in 1991, and is now one of the veterans receiving VA benefits for Gulf War illness, which he says is linked to the WMD furnished by his own country. Pitts filed the suit in a New York federal court that has directed settlements in Agent Orange cases.[35]

The banks targeted in the veterans' lawsuit include Lloyds Bank of the UK, Deutsche Bank AG of Germany, Credit Lyonnais of France, Banca Roma of Italy, Bank of Tokyo, National Bank of Pakistan, Arab Bank of Jordan, and Kuwait Commercial bank. Among the suppliers that allegedly aided Iraq's efforts in establishing a biological or chemical program are ABB Lummus Global Inc., an engineering and contracting firm based in New Jersey. It is a subsidiary of ABB Limited, a global engineering firm headquartered in Zurich with $18 billion in annual revenues. According to the company, its forte is engineering and building power and industrial plants. Most recently, ABB Lummus was picked as prime contractor to upgrade equipment for the National Aeronautics and Space Administration's Scramjet Test Facility used to develop high performance aircraft. ABB and others named in the vets' lawsuit

"made large profits by helping Saddam Hussein make the nerve gas and mustard gas," the veterans claim. ABB Lummus and the others deny the accusations.

There have been similar lawsuits by veterans, and all failed, although a companion suit to the New York action, also filed by Pitts, is still active in a Texas state court. Joyce Riley of the American Gulf War Veterans Association thinks all such suits are unfortunately doomed. "I don't think there was ever the intent for them to be successful," Riley tells me, "because they [the veterans] were naive. These connections [between Iraq and corporate America] lead to the White House, and you won't get past the gate."

Congress hasn't scaled that barrier either, although Arizona Republican Sen. John McCain has launched periodic probes into the sales and former Sen. Don Riegle, a Michigan Democrat, labored to throw some daylight on the weapons transfers. In the 1990s, he and others penned an extensive report that claimed the government approved the shipment of biological agents to Iraq in the 1980s that could be one of the causes of today's Gulf War illness According to the 1994 Riegle Report, American Type Culture Collection, a Rockville, Maryland, company that curates and distributes biological specimens worldwide mainly to public health agencies, provided the germs that Iraq developed into weapons. Included in shipments from 1985 through 1989 were anthrax bacilli and germs that cause botulism, meningitis, influenza, tetanus, and lung failure.[36] (The Riegle report also offers one of the most extensive reviews of Gulf War chemical and biological effects and is posted on the Gulf War Veterans Resource Pages at http://www.gulfweb.org.)[37]

The shipments were approved by Ronald Reagan's Commerce Department. Though the virus strains were supposedly weakened to allow their sale, the report said, in fact "These exported biological materials were not attenuated or weakened and were capable of reproduction" into weapons of mass destruction. Among the chemical agents were anthrax and botulinum bacteria—against which American Gulf fighters have ever since had to be vaccinated, contributing to if not directly causing Gulf War illness. Reagan allowed the transfers with the apparent intention that biological weaponry could be trained on our enemy du jour, Iran, which Iraq had attacked. The president could almost be assured that mass-murderer Saddam would use such weapons. He certainly hadn't been shy about using mustard gas on the Iranians. He also gassed thousands of Iraq's Kurdish citizens in the late 1980s.

But, as evidence of the biological transfers began to leak out in the 1990s, neither the Bush I nor Clinton justice departments

were interested in pursuing a claim that American products had been used to harm American soldiers in the Gulf—even while we were pushing vaccines and debilitating medicines to prevent such harm (more in Chapter 3).

Historically, the government's attitude has been that it's all right for the U.S. to have and use biological and chemical weapons but it's not all right for others to do so. The Bush White House reaffirmed that policy in 2001 when the U.S. refused to sign an international agreement that would enforce a ban on biological weapons. More than 50 other countries had accepted the proposal, which in part called for signatories to allow inspections of sites that could be used for bioweapon development. The U.S. said some countries—surely not the U.S!—could still cheat and would try to steal industrial secrets. Meanwhile, American firms, with the government's approval, continue to sell chemical arms to foreign countries—even supposedly pacifist nations such as Japan. According to a 2003 State Department report, defense contractors sold the Japanese $6.7 million worth of chemical agents and herbicide in 2002 alone, along with $666,000 in chemical dispensing equipment. South Korea bought $7 million in chems and herbicides from U.S. defense companies and our alleged friends, the Saudis, imported $1.7 million worth. Lets hope they remain our allies.[38]

Toxic black rain

Another WMD in Gulf I was fire—those that Saddam's retreating troops set to the oil wells of Kuwait. More than 600 wells were ignited, turning day to night and air to toxin. In some cases, an oil rain fell on service members who were closest to the burning wells.

Though veterans think all 696,000 troops deployed in Gulf War I were exposed at some level to the fallout, the Pentagon has so far concluded there were not widespread health effects. The military's studies are typified by the 1999 findings of the Harvard School of Public Health, which claimed the oil well fallout was no more toxic than the air in some American cities.

The American Lung Association and bleary-eyed Los Angelinos can tell you that's scary enough. But obviously none of the post-fire tests were able to recreate the hazards of 600 burning wells. There *is* general agreement that the exposures were risky at some level—possibly creating medical complications that have yet to develop. Vets say it's important that the well-fires' effects be seen as another jigger in the Gulf War cocktail.

New Yorkers, by the way, have a few things to say about

war fallout and government veracity. The Environmental Protection Agency assured the people of New York City their air was safe after the World Trade Center and nearly 3,000 humans came crashing down from the September 11th terror attacks. In August 2003, the EPA inspector general revealed that, under pressure from the Bush White House, the EPA issued misleading assurances that there was no health risk from air pollution after the attack. In fact, a study had found the air was dangerously polluted by fine metals, sulfuric acid, glass particles and carcinogenic organic matter. "They lied," wrote one New York columnist. "They lied the first week and they lied the week after that and they have lied every day of the past two years to the people of this city."[39] Veterans say it has been even longer for them.

Portable WMD

Other WMD we brought with us both in 1991 and 2003. They're called depleted uranium weapons: bombs and shells that deposit a radioactive residue on the land, in the air, and throughout the human body.

Douglas Rokke, an ex-Pentagon health expert, says depleted uranium (DU) is nothing less than a toxic nightmare for soldiers on either side of the trench. U.S. forces used more than 300 tons of DU weapons during Desert Storm. Troops in 2003's Operation Iraqi Freedom fired off hundreds of tons more. The figure is still classified, but reports indicate use of DU was concentrated in urban areas; at hot spots in downtown Baghdad, reporters measured radiation levels that are 1,000 to 1,900 times higher than normal background radiation levels.[40] American soldiers in 2003 were already traveling through what some scientists called a DU zone of death left over from 1991 battles (not to mention—and indeed, it rarely is—the civilian population in Iraq, which remained mired in the residue from our warfare for more than a decade, and is likely to remain so for untold generations.) Like U.S. defoliants in Vietnam, the depleted uranium munitions fired at Saddam's tanks, weapons and soldiers left a contamination that cannot yet be gauged. (More on this in Chapter 3.)

Just how much damage did America's government do to America's troops?

The inherent problem in diagnosing Gulf War illness, as it was with Agent Orange, is incubation periods. The true effects of drugs, chemicals and biohazards may show up almost immediately in some soldiers but not for 10 to 20 years in others. In the meantime,

the government can continue to administer vaccines—even those considered dangerous or not emphatically approved for such use—and fire its radioactive rounds by declaring there's no scientific proof they're harming their own soldiers. Also among the undetermined effects of war is the mixing of new medicines and chemicals with each other and with older medicines.

Scientists continue to uncover startling evidence of unintentional and intentional harm done decades back in other wars, injuring soldiers who were under orders to submit to the medical cocktails of their day. Convinced by years of preliminary investigations, for example, the Institute of Medicine in 2003 opened a study to determine the possible long-term effects of biological and chemical agents secretly sprayed during the Cold War on 5,842 servicemen aboard U.S. ships.

Known as SHAD (the Shipboard Hazard and Defense program), the tests included the release of VX nerve gases and sarin, 500 times more toxic than cyanide. The 50 separate experiments from 1962 through 1973 were top secret, thus, the Pentagon said, the unsuspecting service members—many of them now Vietnam veterans, if still surviving—couldn't be told of the dangers. In one case, a ship was sprayed with a bacterium that simulates biological warfare agents, then was sprayed with a chemical called betapropiolactone to "decontaminate" the ship. But the decontaminant was itself toxic. Service members who were aboard one Navy ship, the *USS Power*, in 1965 say many of them became old men in their 40s as a result. A retired Navy commander, Jack Alderson, told a congressional committee he was unable to find his medical records for that period. "The part of 1964 through 1967," he said, "is expunged." (A fire at the National Personnel Records Center in St. Louis on July 12, 1973, destroyed about 80 percent of the Army's personnel records, but only of those discharged between November 1, 1912, and January 1, 1960. About 75 percent of the records for Air Force personnel with surnames from Hubbard through Z discharged between September 25, 1947, and January 1, 1964, were also destroyed). Alderson said the government gave him and his men the run-around for years before finally admitting to the harmful tests. "Some of the guys tried to go to the Pentagon or the American Legion and said, `I did biological warfare testing.' They basically threw them out, told them they were crazy. They told them, `We didn't do things like that.'"[41] The Pentagon was still stalling in 2004, refusing to give up documents related to the experiments, claiming they contained military secrets. A former military scientist had revealed the existence of the documents and films recording the tests. One of the films reportedly showed a soldier

loading a chemical into a plane that would spray shipboard soldiers and sailors. Without protective gear, the solider is shown caked with the orange-colored substance.[42]

A vaccine called botulinum toxoid (BT)—used to prevent botulism which can be turned into an aerosol—was given to 8,000 Gulf War I troops. A drug, pyridostigmine bromide, (PB), a tablet intended to protect soldiers principally against soman, a muscle-corrupting chemical warfare nerve agent, was used by more than 250,000 Gulf soldiers. It has also been made available to troops in Iraq in 2003. BT is approved only informally by the FDA for such use and PB is itself a nerve agent that has not yet been proved safe or effective for repeated use even by healthy persons under any circumstances. Both drugs were approved for military use through what is called the FDA's interim rule, issued in December 1990, under the theory that obtaining informed consent from military personnel was "not feasible" under combat conditions—despite the drugs' lethal nature. The FDA reports that "Based on trials in animals, however, the two investigational medications at the time appeared to offer the best available protection against the toxic chemical and biological agents anticipated to be in the Iraqi military arsenal."[43] But with drugs such as these, troops were and are virtual guinea pigs, tested sometimes without being fully informed of the effects and possibly lethal complications.

Parts of the Gulf cocktail were also made from military pesticides used on the assorted bug life of distant lands. Their harm, too, was originally downplayed by the military. In 2003, the Department of Defense released a belated review lauding its own anti-pest efforts (only 40 human cases of pest-borne diseases were documented). But the report said it was also likely that at least 41,000 service members were overexposed to the Gulf pest strips, sprays, and fly baits. Approximately 30,500 members of the general military population may have been at elevated risk for short-term health effects because of exposures, said the DOD. The overexposures, especially to such pesticides as organophosphates and carbamates, "may have contributed to the unexplained illnesses reported by some Gulf War veterans," the DOD found. Organo-phosphorous pesticides replaced more dangerous organo-chlorine pesticides such as DDT, but their use goes back to 1930s Germany when Nazis used them to produce a nerve gas. The vigilantly skeptical veterans groups thought the findings understated the problems. It was the first such epidemiological study of military pesticide applicators and, as the Pentagon conceded, further research is called for.[44]

The lasting effects of mefloquine, which causes psychotic reactions in some users, are still unclear. Nonetheless, troops are

doled out mefloquine pills along with such other military staples as hepatitis B vaccine and tetanus-diphtheria vaccine depending on where they're deployed. An anti-malarial drug with the product name of Lariam, mefloquine was given to several Fort Bragg, North Carolina, soldiers who killed their wives in a six-week period in 2002, after returning from Afghanistan. The Army concedes the drug causes bizarre brain reactions including suicidal hallucinations, but insists its chemicals did not make its soldiers kill their own.

Nor themselves. After killing their wives, three of four soldiers committed suicide. Which I'll detail shortly.

In 2003, a contingent of Marines from North Carolina, sent to Liberia in support of a peacekeeping mission, was hit by a malarial outbreak. More than a dozen troops from the 26th Marine Expeditionary United from Camp Lejeune contracted malaria. A Pentagon spokesman said he didn't know if the Marines were supplied with the Lariam pills, or if they had just not taken them. Maybe they read the newspaper.

By 2004, however, even the Pentagon was having second thoughts about Lariam. Assistant Secretary of Defense William Winkenwerder Jr. announced the military would finally open a study into the drug's side effects, including its potential mental-health complications. The research could take months if not years. But in the meantime the military would discontinue use of Lariam in Iraq, he said, because of the unwarranted risk of malaria there—even though Iraq is ranked 12th in the world for its malarial rate by the World Health Organization.[45] Perhaps at last the military believed the drug's critics.

Fear of the unproved

The 1996-97 presidential commission on Gulf illnesses, while reluctant to conclude there was a more compelling cause than stress, did admit the Pentagon was simply incapable of handling unapproved drugs, and had a lousy record of alerting soldiers to medical complications.

Commissioners urged the FDA to step in and review the military's practice of waiving informed consent when rushing off to war with unproven drugs. The commission also said the military needed to do a better job of record-keeping and long-term follow-ups of the unofficial guinea pigs who receive investigational products. A few laws were produced, including one commanding the military to medically examine troops before and after deployment. But to the extent that's done, it's not preventing illnesses or deaths, say veterans. The commission's instigations may help produce data

from this experimentation, but it doesn't seek to prevent the ongoing and future use of thousands of service personnel as involuntary guinea pigs.

It's not that soldiers aren't aware of some of the medical, biological and environmental threats of war that are downplayed by the military. Gulf War veterans who served overseas were three times as likely to get sick as troops who stayed home.

Trouble is, what was it over there that caused it? Between their patriotic service and their personal futures there lingers a nagging fear of the unknown—or, in the Pentagon's view, the unproved. The doubts dog them as they stand in line for their shots or march though a microscopic particle cloud across the desert floor. What did they just step in? Breathe in? Touch? Why did they develop that rash? That fear is one of the reasons that some servicemen rushed off to freeze their sperm before heading to Iraq in 2003. They feared the weapons of Saddam Hussein *and* George Bush.

"We're simply asking the VA to do for Gulf vets what it did for Vietnam vets," says veterans' leader Robinson, "to presume these multiple exposures could have a causal effect. That doesn't mean everyone is entitled to a big bag of money for their illnesses. But if you had an exposure, you breathed in oil smoke, you ingested depleted uranium, that ought to be enough to prove you have Gulf War illness and you should be covered by the VA. As it is, you almost need to be an epidemiologist, a lawyer, a scientist and a doctor to prove your claim."

Commander Bush, Jr. was well aware of the Gulf I veterans' concerns, especially if the new war in Iraq could cause a repeat of them, causing political repercussions as well. He showed his support by bravely baring his arm in December 2002 and taking an owie like his troops were being asked to do.

Or at least he said he did.

We didn't get to see the inoculation on TV, or even in still photos, nor did we know for sure it was in fact the smallpox vaccine. The White House issued a brief press statement saying the president was inoculated at Walter Reed Army Medical Center and "feels fine."[46]

Bush said he elected to take a dose of vaccinia, as it's called, to demonstrate to soldiers and the American public the importance of preparation to defend against terrorist attacks. Even in the first days of his Pentagon inoculation program, dozens of soldiers had suffered from swollen hearts and other complications when they were shot up with the vaccine in preparation for Afghanistan and Iraq. But the president continued to make inoculations part of his war and homeland security strategies.

Unlike his troops and average Americans, however, the president (once he was presumably shot up) was observed by some of the best doctors in the world. His vaccination was said to have been administered by a senior immunization technician from Walter Reed, watched over by the White House doctor and the White House medical staff. They stood by to begin immediate rescue efforts if complications developed, and continued to monitor his condition afterwards.

Whereas new recruits may not be aware of potential side effects of the vaccinations they're ordered to take, the president was fully informed. Such circumstances likely made it easier for him to believe in a homeland security program he launched, calling for the smallpox inoculation of 500,000 health care workers and 10 million medical and emergency response personnel.

However, only 40,000 health care workers have chosen to be vaccinated—which ought to tell you something: The people most likely to know the side effects are those most likely not to take the vaccine.

Even the president's advisory panel urged the massive program be downsized after encountering "unanticipated" safety concerns (including, as some guinea pig soldiers could already attest, swollen hearts and heart attacks). Bush, at last check, was determined to see it through. He is in part relying on the military to advise him.

The president wasn't, however, putting on a show of taking other medicines the military was doling out to its troops, great doctors or not.

Among those he chose not to take was something called Anthrax Vaccine Absorbed (AVA). It's the anthrax vaccine that more than 2 million troops have been ordered to take since 1997 (and which was first administered to just a portion—about 150,000—of Gulf War I troops). Some 800,000 have received it since 1997.

So widely suspected are AVA's debilitating and potentially fatal side effects that hundreds of soldiers refused orders to take the shots, resulting in disciplinary actions and military discharges—and even threats they would be forcibly injected.

Those such as Sandra Larson, who followed orders like the good solider she was, would likely advise Bush he made a good choice to not take AVA. But she's not around to explain why.

Death by Friendly Fire: The Anthrax Vaccine

Shooting Sandra

Army cook Sandra Larson was 32 when she died for her country. She was shot six times, but there were no medals, no homecoming parades, no purple heart. The killer, says her family and investigators, was anthrax vaccine, known as AVA. It was, in the most profound and painful sense, death by friendly fire.

Like most other soldiers at the time, Sandra Larson was not informed that the AVA being given to combat inhalation anthrax was not fully licensed and that neither its safety nor efficacy could be assured. Almost immediately after her first injection, the young mother had an adverse reaction to the shot. She felt exhausted, developed skin rashes and experienced numbness and pain in her hands. When the symptoms persisted for days, she was granted a two-week leave to recover. She did not then comprehend the storm building around AVA.

She and 425,975 other service members facing duty in Korea and possibly Iraq would receive 1,620,793 doses of AVA by the year 2000, according to government figures. The House Subcommittee on National Security was so worried about the drug's unproven claims that it recommended termination of the inoculation program. The program did shut down briefly but only because of production shortages, forcing some soldiers to suspend their vaccinations in mid-process, and restart later.

How the U.S. military uses an anthrax 'cure' which may have killed more soldiers than anthrax itself.

A company called BioPort, a private corporation whose investors include former Joint Chiefs of Staff chairman Admiral William Crowe, was (and is today) the only authorized manufacturer of AVA in the United States. In 2000, it was seeking formal FDA licensing of its product as an airborne anthrax preventative when a BioPort employee, Richard Dunn, died suddenly.

Dunn, 61, had been employed by BioPort and its state-owned predecessor, MBPI, since 1992. His job was to monitor and care for lab animals, which required him to take vaccine shots. Over eight years he received 11 shots, the last one three months prior to his death. In September, 2000, the *Lansing Journal*, the newspaper in BioPort's hometown, reported that a local pathologist and medical examiner had linked Dunn's death to the anthrax vaccine.[1]

The ME was quoted saying "Even though they didn't find any anthrax in the man's system ... his body's reaction contributed to his death." However, the pathologist later disputed he had ever concluded that AVA was the cause of Dunn's death. He attributed it directly to a heart attack and said it was unclear whether the vaccine was a contributing factor. "You can't definitively link it," he said.

BioPort denied the vaccine was linked in any way and said workers have safely taken the vaccine as a precaution for three decades, suffering nothing much worse than bad headaches.

Barbara Dunn of Ionia, Michigan, widow of Richard Dunn, contradicts BioPort's defense. Her husband had more than a headache after his vaccine was given to him in two parts in April that year, she says. Soon afterward, his left arm began to swell along with his wrist and hand.

"Dick also had some nausea, joint pain, and his arm was hot to the touch," she says. "These symptoms never went away, and they were no different than the other reactions he had every year, except this time they were much worse. I understand that these are the same chronic symptoms our military people have suffered." On May 11, 2000, she says, the swelling and his joint pain worsened, and he became increasingly fatigued.

"My husband seemed much worse than the month before. He went to work on May 13 and called me to say he needed to see a doctor. Dick was put off from work that day. When he would see the BioPort worker's compensation doctor in Lansing, he always stopped to see his friends at BioPort. His company knew of his ongoing symptoms, because they always helped us with paper work and because of the many calls they made to see how Dick was doing. I am very grateful for that. He did think of them as his family."

But when Dunn returned to work, his widow says, "he was still swollen and very tired and still suffered joint pain. Nevertheless, he was given a release to return to work with limitations. Dick died on July 7, 2000, and that has changed my life and the lives of my children forever. This is fact, not fiction. Dick believed in this program, but also wanted it to be a safe program."

In congressional testimony she gave after her husband's death, Barbara Dunn said she had been aware of the company's

legal and regulatory troubles and heard that BioPort had to recall three products including the anthrax vaccine because of an incorrect expiration date.

"I don't know what lot or batch of vaccine the company gave Dick, but I do know that a lot of other Americans have been made sick by the vaccine, and that is why I am here today," she said. "Nothing can be done to bring my husband back, but I ask this committee to please rethink this program and make it a safe one. I hope someday that, if any of you need to take this vaccine, you will have an option of whether or not to take it, and that if your option is to say 'no,' there will not be any repercussions."[2]

Defense officials still insisted, however, that AVA has a relatively low incidence of side effects and adverse reactions among troops. It "has been approved for 30 years by the FDA," Pentagon spokesman Ken Bacon said in 2000, not mentioning it was an informal approval and lacked controlled human testing. "Authorities are not aware of any deaths associated with the use of the vaccine over those 30 years," he added. Other officials said that was true as well in 20 years of monitoring more than 1,000 vaccinated lab workers at Fort Detrick, the Army's infectious-disease research center and former home to secret bioweapons research.

The services were then administering an average of 17,500 doses of AVA monthly. Marine Maj. Gen. Randall West, the Pentagon's senior adviser for chemical and biological protection, said side effects and maybe even death from the vaccine's use might be expected. "That doesn't mean every case in which someone gets sick or dies is caused by the vaccine," he claimed at a hearing where military veterans suffering from what they called anthrax reactions were also in the audience.

"Of the people here today, only one has had a medical diagnosis linked to the vaccine, and only for a portion of his medical problems.... Unfortunately, sometimes that happens. We wish it didn't. We don't want to make anyone sick or deathly ill. But I don't want to sit here someday in the future and have to explain why we had hundreds of thousands of dead when we had protection to keep them from dying."[3]

Instead, he has had to sit there and explain why the *vaccine* may have caused some to die.

130 percent disabled

From 1998 through 2000, Sandra Larson was progressing through her shot routine. Each shot came from batches with identifying lot numbers. The number on Larson's first AVA shot, according to

the attorneys for her estate, was 17. That was the lot number for her next three injections as well, given on September 30 and October 13 1998, and April 6, 1999. On September 10, 1999, she received her fifth AVA injection from another lot, 44. She endured these shots successfully.

Larson got new orders and moved to Fort Riley, Kansas in October 1999. On March 12, 2000, she received her sixth and final injection from lot 31.

Her sister, Nancy Rugo of Spokane, was in constant touch during that time. Sandra and Nancy were military brats—Sandra was born while their father was in Vietnam, one of his stops in 19 years of Army duty. Sandra also married a military man, Martin Larson, at age 16. A decade later, she, too, joined up.

"She was contemplating going back to school or work," Nancy recalls. "In reviewing advertisements about how great it would be to join the military and the prospect of receiving a college education, she decided this was for her."

Sandra called Nancy in April after the sixth AVA shot, saying she was not feeling well. "This time she mentioned she had additional numerous rashes on her arms and legs that we later found out were because blood capillaries were bursting. She was extremely tired and was going to go to the military clinic because she started vaginal bleeding that was 'pouring' out of her."[4]

Once admitted into the clinic, Sandra was given a simple blood test. "Upon reviewing this one test," Nancy says, "they panicked because they found few, if barely any, blood cells to detect. She had no blood platelets which is what is needed to control bleeding."

She was immediately taken by military ambulance to the nearest capable emergency room, a two and a half hour drive to Kansas City. When Sandra next called, "she was in ICU at Kansas City Medical Center," says Nancy. "The doctors had been doing many extreme tests on her to try and figure out what was happening and concluded she had aplastic anemia. I was immediately concerned about her and her daughter, who was at the babysitters, and flew to Kansas to do what I could to support her. When I arrived at the hospital, I seriously thought maybe this was all a fluke and she would be fine as we have no family history of this."

This was not a typically gradual case of aplastic anemia— Sandra went from a healthy woman to a seriously sick one in four weeks. Nancy says she stayed close to the hospital for two weeks, waiting for the day when Sandra's pain would end and she could go home. But her condition remained unchanged. The military finally granted Sandra what is called compassionate leave to be transferred

to Fort Lewis in Nancy's home state, Washington.

"I planned on leaving Kansas for Spokane the same time as her transfer but she developed an allergic reaction to one of the most relied upon therapies next to a bone marrow transplant," Nancy recalls. "She would have to stay another week. I stayed long enough for the hospital to at least type me for a possible bone marrow donor. Unfortunately, my sister did not have any bone marrow left in her own body to be typed herself. It was hopeful that a horse serum treatment would cause her body to produce enough bone marrow for them to type." But that failed.

Sandra was medically prepared to fly to Lewis where she would stay at nearby Madigan Army Medical Center. "The flight did not go well," Nancy says, and that was about the worse thing that could happen in Sandra's circumstance. "The military medevac plane's cockpit had caught on fire when en route. They had to do an emergency landing at Travis Air Force Base in California. I do not understand how this base became the closest landing [site] as you would assume the route would have had a direction towards Seattle, not California."

Travis was not equipped to handle Sandra's case and that prolonged her wait for a blood transfusion. She also developed a lung infection. That, said Nancy, was the worst-case scenario for her sister.

The military was finally able to lift Sandra to Madigan where, Nancy says, she was provided adequate medical care. Suddenly, on May 20, 2000, Nancy received a call from an Army ICU physician. His voice was urgent. "I was told I needed to come visit her right away as they did not think she would live through the weekend," says Nancy. "I called my parents in Montana and we all drove to Tacoma to be with her. We were told on our arrival that she would not make it through this. They would do all they could to keep fighting, but there was not a chance. The hospital had even started to transplant white donated blood cells directly into her lungs which is an extreme, but hopeful, therapy."

When she arrived, Nancy was stunned to see Sandra.

"She was on a ventilator and her whole body looked as if they had inflated her. She was so scared yet in total denial about `leaving,' which made it difficult for me to talk to her about her last wishes. She was very angry at everyone, kept saying she was going to get better and had planned on living in Spokane so she could be near me with her daughter." On June 2, "The VA came to visit with the family while we were at the hospital and said they were in the process to medically retire her as quickly as possible for the benefit

of her two girls. They were successful and a great deal of help for me at that time. She was granted 130 percent medically retired benefit."

Ten days later, "Sandra went into a coma and I had to return again as I had to make a decision about pulling her off of life support. I was terrified. On June 13, 2000 I arrived at the hospital alone, as I did not want to see anyone but her. She was so far gone already, I felt awful for having her live like this. I sat down with a team of eight doctors to discuss pulling her off and told them I would like to pull her off but I would first like to have her oldest daughter Megan to fly from Michigan as she wanted to say goodbye to her mother while she was still living. This was so stressful, it seemed like everything with flying Megan here quickly went wrong—there were flight delays and weather problems—it was almost as if Sandra was trying to avoid having Megan see her like that."

By the time Megan's plane arrived in Tacoma, it was after 2:00 a.m. on the 14th of June. Her mother had died around midnight. The daughter was two hours too late.

"I waited until we got outside the airport to tell Megan that her mother had already left us, her heart had given up," says Nancy.

The daughter went to the hospital anyway, and said her goodbyes at her dead mother's bedside.

Larson had dutifully obeyed when ordered to take injections. She trusted Army commanders who promised AVA would protect, not harm her. She relied on the diagnosis of doctors who said she should maintain the injection routine, six shots over 18 months, even when she complained of disabling medical reactions. Now she was dead.

Sandra Larson's demise did not reverberate. And AVA production continued as usual. In fact, it increased. In 2002, the FDA gave exclusive AVA manufacturer BioPort a license to supply some of its product from a new filling and packaging facility, operated by Hollister-Stier Laboratories LLC. The new filling plant, it turned out, was Hollister-Stier's lab in Spokane—not far from Nancy Rugo's house.

"Our goal has always been to assure that the anthrax vaccine meets high standards for safety and efficacy," said Bernard Schwetz, an FDA deputy commissioner, in pronouncing the new facility fit.

An FDA press release noted that, currently, the government did not recommend vaccinations against anthrax "for the general public."[5] That didn't mean a lot of people weren't getting them. And with such dangerous variables as incubation, cocktail effect and individualized reactions, there was anything but consensus on the safety of AVA.

Get shot, that's an order

In 1990, Army doctors described the anthrax vaccine as an

"unlicensed experimental vaccine" with "limited use". Nonetheless, tens of thousands of U.S. troops and personnel began receiving at least one dose of AVA during Operations Desert Shield and Desert Storm.

Altogether, about 150,000 Gulf War service members were inoculated with AVA before and during 1991, when "Vac A" shots, as they were known, weren't mandatory but, veterans say, routinely given. "They told you," recalls Gulf vet Steve Robinson, "'Line up for your shots.' And you did. Period."

In 2002, the *Augusta Chronicle* reported how National Guard Sgt. Teresa Andrews tried to avoid getting her shots back in 1991 after doctors and two medics arrived unannounced at the 1148th Transportation Company's camp in the Saudi Arabian desert. One wore a cowboy hat and boots. They told the company commander to line everybody up for shots. Andrews bolted from the tent. She didn't get far before officers corralled her, dragging her kicking and screaming back to where the rest of her Augusta-based Army National Guard unit had lined up. "They told me if I didn't take the shot, they'd give me an Article 15," said Andrews, referring to the disciplinary action that could mean a rank and pay reduction. She took the shot.[6]

Despite the ever-growing evidence of the vaccine's harmful effects through mass military inoculations, troops who refused to undergo the AVA drill from 1997 into 2004, under Presidents Bill Clinton and George W. Bush, were sometimes court-martialed and discharged with Less Than Honorable separations.

Pfc. Mathew R. Baker, a 20-year-old soldier, said an Army commander at Fort Stewart, Ga., "told me to my face that if I refused the anthrax vaccine, he would strap me down or have me strapped down to a gurney, and inject me with the anthrax vaccine." Baker took his shot but went AWOL and was later discharged. The Army believed it was proper for the service to shoot up its soldiers by force. "Yes," Army spokesman Lt. Col. Guy Shields told the *Army Times*, "we could have used restrained force to administer the shot."[7]

Rep. Christopher Shays, R-Conn., held a series of congressional hearings that, among other things, discovered the vaccine actually used in the military's inoculation program was different from that used in the Pentagon's own studies—which conveniently supported the vaccine's efficacy and showed no link to Gulf War illness. In a subsequently revealed e-mail, Brig. Gen. Eddie Cain, onetime director of the Joint Program Office for Biological Defense, worried such findings were misleading, and thought Pentagon officials were "digging ourselves a hole that will be too difficult to crawl out."[8] Testimony also showed that the military did not keep a complete

record of personnel who received the risky vaccine. Shays later helped draft a law that allows a president to waive the consent requirement for military personnel if obtaining consent is infeasible during an emergency, is contrary to the best interests of the individual, or not in the interests of national security. But recipients must be told that they have the right to refuse—fully informed consent includes the right to refuse—albeit they can be discharged for doing so.

In 2001, Air Force Capt. John Buck, a doctor, underwent a career-ending court martial for refusing the vaccine prior to deployment to Bahrain. Buck's basic argument was about fairness. The vaccine, he said, "should be considered investigational. Our servicemen deserve to be told the risks and potential benefits, yet ultimately be given the choice." He was right. But he's now ex-Air Force Capt. John Buck.[9]

Many reservists, meanwhile, left the service on their own, while some top officers retired rather than take AVA. Among them is Air Force Reserve Col. Redmond Handy, who now campaigns against forced inoculations. He points out the FDA removed five million doses of older, poorly manufactured anthrax vaccine from the market just a few years ago due to questions of their purity. He questions why the Pentagon keeps changing its story about the safety and efficacy of the vaccine issued under a system the colonel considers "forced experimentation." Though anthrax vaccine has been around for years, it has never been used in such a widespread, sometimes haphazard way as in recent years, he notes. In 2002, a committee of the Institute of Medicine said the vaccine "appears sufficiently effective and safe for use [but] it is far from optimal," and should be urgently replaced by a new and better substitute.[10]

BioPort in a storm

The original anthrax vaccine in the United States was developed by George Wright and other scientists in the 1950s and was first produced on a large scale by the pharmaceutical manufacturer Merck Sharp & Dohme, according to a brief history provided by the General Accounting Office.[11] A clinical study in 1962 evaluated the safety and effectiveness of the Merck vaccine in mill workers, forming the basis for subsequent licensure of a modified vaccine in 1970. The Division of Biologics of the National Institutes of Health issued the original license for anthrax vaccine to the Michigan Department of Public Health. In 1995, the facility became the Michigan Biologic Products Institute (MBPI) and was sold in 1998 to BioPort.

The lab has had frequent quality control problems and has

in the past failed to produce enough AVA to fulfill its military contract. In November 1999, a year after it took over the state lab, BioPort was cited by government inspectors for 30 deficiencies in safety, sterility and consistency, and told by the FDA "The manufacturing process for the production of Anthrax Vaccine Absorbed is not validated."[12]

Four months later, the Pentagon's Office of Inspector General said that over $2 million in taxpayer funds had not been spent as planned to improve vaccine production for soldiers but instead had been blown on office remodeling, furniture for the CEO, parking lot re-paving, unwarranted travel expenses, unsubstantiated consulting costs, and an unrelated medical program. Additionally, senior managers planned on awarding themselves $1.2 million in bonuses from the funds. BioPort was not exactly instilling confidence in the military's vaccine program.[13]

Among the investors of BioPort is former Admiral William J. Crowe Jr. He served the country for a half-century in the military and later as Clinton's ambassador to the United Kingdom (he publicly supported Clinton's presidential bid). Today he is, among other things, a businessman and syndicated columnist and can be seen now and then on a re-run of TV's "Cheers," in which he plays himself.

Crowe's partnership in a business that is the sole provider of the vaccine to the Pentagon raises ethical questions. After all, it was Crowe's friends and successors, the Joint Chiefs, who in 1997 recommended that Defense Secretary William Cohen make the anthrax vaccinations mandatory.

When BioPort took over the vaccine production the following year, it won a military contract worth as much as $45 million when the Pentagon agreed to pay at least triple the amount per dose it was previously paying. The government also helped Crowe's company to the tune of $24.1 million in what it called "extraordinary contractual relief," meant to get the vaccine plant rolling towards full production. The Pentagon will be investing hundreds of millions more in AVA and in developing alternative vaccines.[14]

Crowe, who says he has undergone anthrax vaccination and believes it is a safe and reliable prevention, admits he was asked by the investors to join in the venture with little or no investment on his own. In effect, he became BioPort's corporate recruiting poster and got a piece of the action worth potentially millions in return.

BioPort is controlled by Fuad El-Hibri, 43, a German-born entrepreneur and former director of British vaccine-maker Porton Products, which made a fortune selling vaccines during Gulf War I. *Salon*, the online magazine, reported in 2001 that El-Hibri became a principal silent investor in Porton and son Fuad was installed as

director of a subsidiary, Porton Products. They used their Middle East connections to help sell tens of millions of dollars worth of anthrax vaccine to Saudi Arabia and other countries. The el-Hibris and Crowe, whom they had known for years, came up with the concept of BioPort, which they thought could do in America what Porton did in Britain: generate big profits by privatizing a public research lab.[15] In a book on Bioport and AVA, former F-16 fighter commander Tom Heemstra, who says he was forced by the Air Force to retire over his opposition to the vaccination program, claims Fuad made a small fortune selling anthrax vaccine to the U.K., where, like their American counterparts, British soldiers are suing the British Ministry of Defense over the vaccine. He cites reports that investment firms such as the Carlyle Group, tied to former President George H.W. Bush, have invested in BioPort. Reports also connect BioPort to former president Clinton through its investors' contributions to Clinton's last campaign, says Heemstra.[16]

At a 1999 congressional hearing, Fuad el-Hibri testified that "When BioPort was originally conceived, we believed that Admiral Crowe's background would be important in ensuring that we did everything correctly in establishing a company that would best serve DOD's needs." Crowe himself told congressional members: "It has on occasion been rumored that the decision to inoculate all service personnel was made to benefit BioPort Corporation and indirectly me, presumably because of my past associations with the military and the administration. If this charge were not so ridiculous, it would be offensive. It outrageously exaggerates my influence. Let me be completely clear. I never, repeat never, solicited any official of this administration to install or promote a mandatory inoculation program."[17]

Besides, BioPort's goal was humanitarian, Crowe maintained. It was in effect a defense contractor supplying the military with a defensive weapon. And we'd need it if we went to war again in Southwest Asia—where Saddam was suspected of having anthrax—that was, of course, in the past supplied partly by U.S. companies.

What went around was coming back around, once again to profit American corporations.

Unlicensed, experimental, and good to go

It was too late to reconsider the advantages of having provided deadly bio-toxins to Saddam Hussein back in the day when, as one U.S. diplomat put it, he was "our S.O.B." On a limited basis in 1990, and then in an all-out mandatory effort beginning in 1997, the U.S. faced a military preparedness issue that it had helped to cause—vaccinating troops against the threat of anthrax.

The problem, however, is that victims of anthrax can be infected several ways:

• By contact or touch (cutaneous anthrax), for which penicillin is most extensively used as a treatment.

• By ingestion (pharyngeal and gastrointestinal anthrax, caused by the consumption of contaminated meat) which is rare and for which penicillin is also used.

• By breathing in the floating microscopic spores (inhalation anthrax) which is what the Pentagon fears most. Ciprofloxacin or doxycycline are recommended as treatment.[18]

Cipro, which is still doled out to GIs today, was handed out in massive doses—the Army had a supply of 30 million tablets made by Bayer—for use during Gulf War I. In his Gulf War diary, *The Neutral Zone Surf Club*, Gregory M. Smith remembers: "We received our anti-anthrax pills yesterday, some powerful antibiotic called Cipro. We feel like walking pharmacies."[19] Similarly, Dr. Larry Goss, a Lawton, Oklahoma physician who has worked in VA hospitals, cared for Gulf War vets, and thinks he may have contracted a form of Gulf War disease as a result, says veterans told him that "medics in their units pulled up in the back of their Humvees and started shoveling out cases of Cipro, and said `Fill your pockets and start taking it twice a day.'"[20] In 1998, Ciprofloxacin became the Army's drug of choice, as cited in its *Medical Management of Biological Casualties Handbook*. It gained wider support and in 2000 Cipro was added by the FDA to its list of approved antibiotics to combat anthrax inhalation.

But Cipro comes with health problems of its own, including warnings for frequent or unnecessary use. C. J. Peters, ex-deputy commander of Infectious Disease Research at Fort Detrick, says Cipro is no more effective than penicillin or tetracyclines and has lost its curative edge.[21] Three drugs, chemical cousins of Cipro, were linked with severe side effects and death, and have already been pulled off the market. As one of several types of fluoroquinolones, Cipro can lead to bizarre side effects that include central nervous system disorders and seizures.

The Centers for Disease Control and Prevention points out that using strong antibiotics such as Cipro can promote the development of antibiotic-resistant bacteria. Medications for serious bacterial infections thus may be ineffective. NBC news anchor Tom Brokaw, a target of one of the 2001 anthrax mail attacks, under-standably praised the drug—"In Cipro we trust," he said—and people

rushed to their doctors for prescriptions to self-medicate with a fluoroquinolone. But experts are now predicting that such treatment with antibiotics—by civilians and the military as well—will make populations increasingly susceptible to illnesses, leading perhaps to the day that some superbug kills us all. In the end, the use of Cipro may threaten the health of far more people than any anthrax attack. Such widespread use by Gulf I soldiers also raises a question about diminished immune systems that could have contributed to Gulf War illness.[22]

Yet Ciprofloxacin is only a secondary response to inhalation anthrax. Such an antibiotic remedy may not be effective if there is a massive attack on troops, says the Pentagon. It needs a prophylactic, of which there is only one, AVA. The vaccine is given to troops before any battle deployment, assuming there is such lag time.

The catch is, AVA had all along been fully approved by the Food and Drug Administration to combat anthrax only when it is absorbed through the skin, *cutaneously,* and not when inhaled. That's why it's called Anthrax Vaccine Absorbed.

In essence, there has been no fully approved preventative for anthrax inhalation or ingestion. So AVA was used for want of something better.

Despite never having been clinically tested by humans for use in humans, AVA in December, 2003, got approval from the FDA for use to counter the airborne spores—the fine powdered version like that inhaled by postal workers during the 2001 anthrax attacks. (After the attacks, more than 10,000 congressional staffers and mailroom workers were offered the vaccine; fewer than 100 accepted. Pentagon please note: none of the abstainers were fired.)

It takes but a single whiff of the odorless, colorless, and tasteless aerosolized anthrax to cause a life-threatening illness that even intensive medical treatment might not stave off. Anthrax is tricky to detect as well, with its indeterminate incubation period. Symptoms can show up within two days or as late as two months; one case on record developed 46 days after exposure.

The Pentagon calls the vaccine safe and effective against an airborne assault on its troops. Of course, that remains in the zone of theory. To date, no troops have been bombarded with anthrax, thus none have actually faced dying from it.

Death from the vaccine itself is another issue.

Originally, AVA was used to protect veterinarians, farmers and wool workers against contact with infected animals. Inhalation anthrax, also called woolsorters' disease, is often found in agricultural regions where sheep, goats, and cattle are unvaccinated. To

Americans, anthrax seems a relatively new, post-September 11th public risk, heightened by those East Coast attacks that killed six people, sickened others, and caused thousands to undergo risky antibiotic treatment.

But neither anthrax nor use of its vaccine is new. Government figures show that from 1974 through 1989, for example, 68,000 doses of anthrax vaccine were given principally to medical and industrial workers in the U.S, though not administered under any widespread controlled test conditions that could document possible complications. Nonetheless, due to risks and limited supply, the vaccine was not then, and is not now, available for general civilian use.[23]

To be safe—from lawsuits, anyway—Army Secretary Michael P. W. Stone agreed at the time to indemnify BioPort's predecessor, MBPI, against all liability arising from "the unusually hazardous risks associated with potentially severe adverse reactions and the potential lack of efficacy of the AVA."[24] The Army later gave MBPI the Commander's Award for Public Service for supplying AVA during Gulf War I.

Able to provide only limited AVA at the time, MBPI continued to have production troubles afterward. In 1993 it failed an FDA inspection of its facilities and in 1995 was warned by the FDA to correct still more violations. Yet the FDA, pressured by the Pentagon, allowed the Army to do much of its own drug-manufacturing inspections at the Michigan plant so it could remain in business.

Believing more and more in a battlefield anthrax threat, in 1997 then-Secretary of Defense Cohen announced the Anthrax Vaccination Immunization Program (AVIP) for all U.S. military personnel. Though lacking solid evidence that anthrax could truly be weaponized and delivered, the potential to do so was proof enough for the U.S. Certainly there were scary scenarios. In his book *Biohazard*, defector and former Soviet scientist Ken Alibek discusses the possibility of putting anthrax on a warhead and delivering it to the other side of the world. "A hundred kilograms of anthrax spores would, in optimal atmospheric conditions, kill up to three million people in any of the densely populated metropolitan areas of the United States," he says. But he warned also of the threat of vaccinations. He personally required many of them himself, some similar to those given U.S. soldiers, to protect against the chemicals he was experimenting with. The injections destroyed his sense of smell, gave him allergies, prevented him from eating certain foods, and, Alibek writes, "weakened my resistance to disease and probably shortened my life."[25]

The U.S. AVA program required that between 1997 and 2003, all military personnel—2.4 million including all new recruits—would

begin receiving the six-shot series of the anthrax vaccination (some troops report they received a powerful single shot of AVA in Gulf War I) in the following inoculation program: Phase 1) Forces assigned to or rotating to high threat areas in Southwest Asia and Korea; Phase 2) Forces being deployed early into high threat areas; Phase 3) Remaining forces and new recruits; and Phase 4) Annual booster shots.

In February, 1998, the FDA issued a report that listed 11 pages of quality-control failures for anthrax vaccine production at the Michigan lab, including reuse of expired vaccine, grossly inadequate testing, and use of "lots" of vaccine that failed testing. Despite this report, the immunizations got the go-ahead—after, once again, the Army legally indemnified the lab against all liability. The indemnification concerns were a result of the limited use of the vaccine on too small a scale to permit accurate assessments of adverse reactions and, insufficient experience in mass immunization programs to evaluate the vaccine's efficacy.[26]

AVA innocent until proved guilty

That same year, 1998, Pfc Sandra Larson got her first shot. She shortly became one of six people who died after getting one or more anthrax vaccinations, according to the FDA. Three had cardiovascular problems, another had cancer, and one committed suicide. The FDA does not include at least two other deaths that, in lawsuits, were allegedly linked to the vaccine. Others are also suspected.

The relatively "low" death rate is among the reasons the FDA and the Pentagon say proves the vaccine's reliability, since millions of doses have been given to hundreds of thousands of soldiers, sailors, fliers and marines, as well as civilians.

There have been at least 18 studies of the vaccine's risks and efficacy, though many contradict each other or lack the rigorous test of peer review. The National Academy of Sciences and its Institute of Medicine performed a detailed review of the studies themselves and in 2003 reported no long-term "patterns" of side effects.

What makes Sandra Larson's family think she was killed by the negligence of the government that ordered her to take the vaccine? Clinical evidence, they contend. Besides being an unlicensed experimental vaccine, AVA is selectively administered without informed consent, they argue. They also cite a February 20, 1998 FDA inspection report which says lot 44—a supply from which Sandra's fifth shot was drawn—had an "invalid" potency test

in December, 1997. And lot 31, the source of her final shot, was contaminated with microorganisms, according to their findings. The FDA says some lots contain as many as 700,000 doses, while others as few as 20,000 doses. Even were the vaccine itself to be determined to be "safe," it's clear that a contaminated lot still poses a risk to huge numbers of people.

Prior to its administration to soldiers by the military, there was already a widely held civilian belief that the vaccine is faulty. The Association of American Physicians and Surgeons, for one, is opposed to its use. Association director Jane Orient calls AVA "a miserable vaccine" and says it's "kind of a national disgrace that we've poured all our money into this one unsatisfactory manufacturer."[27]

Dr. Meryl Nass, the Maine doctor opposed to AVA use, says, "there is no good evidence" that the vaccine is safe, effective or even necessary. The Pentagon's insistence on using the unapproved vaccine on service members, she adds, may have been illegal. The U.S. has not yet demonstrated that Secretary Cohen's 1997 order to vaccinate is a lawful order. "The Pentagon obfuscated the causal role of vaccines by classifying immunization records and controlling the deliberations of expert panels, which allowed subsequent injectees to suffer the same complications," she says. "One wonders whether the Department of Defense has the right to order a vaccine of questionable efficacy and dubious safety to be administered, willy-nilly, to 2.4 million service members."

Mark Zaid, director of the James Madison Project, and General Counsel for the non-profit organization Veterans for Integrity in Government, obtained thousands of pages of previously unseen documents pertaining to the anthrax vaccine and the Pentagon's vaccination program. He also served as the lead civilian defense counsel for Airman Jeffrey Bettencourt, who was the first serviceman to face court-martial for refusing to take the vaccine under orders of a superior commissioned officer.

Zaid's research shows many servicemen have been and continue to be threatened with forcible inoculation despite military policy that force should never be used in such cases. Bettencourt, stationed at Travis Air Force Base, refused the vaccine in December 1998. He was offered an Article 15 and was found guilty. He received a grade reduction and 45 extra days of duty, despite his otherwise good record. After a second refusal, he was court-martialed.

Zaid challenged the key element underlying that charge: whether the order that Bettencourt disobeyed was lawful. As part of his pre-trial discovery, Zaid requested samples of the vaccine to make independent tests. He wanted to know whether or not the Defense

Department had modified or altered the vaccine in any way. The request was refused. But before the issue was litigated, the Air Force agreed to accept Bettencourt's Chapter 4 request for a discharge and he was processed out of the service with an Other Than Honorable Discharge.[28]

"It is a sad fact that we regulate industries, such as machinery and automobiles, far better than we do those industries that affect what may be placed within our own bodies" says Zaid. To be sure, "anthrax is an intensely dangerous biological weapon. It is imperative that we seek out ways to adequately detect the spores before contact and protect ourselves after. But the Defense Department's anthrax program represents nothing more than an easy out from the hard task of devoting time and money to develop adequate detection equipment and, if possible, efficient vaccines that are truly safe and effective."

Sandra Larson's sister, Nancy Rugo, is campaigning to inform others, including Congress, of the risks raised by AVA. In particular, Rugo recalls a motivating conversation with Sandra prior to her death.

"She made it clear to me to do whatever I can on her behalf if, as she said, something were to happen. She had frantically begun researching the causes of her condition and started to suspect vaccine connection. As her condition worsened, she communicated some of her discoveries and she told me emphatically, "Nancy, I mean it. Don't let this go."

Rugo also filed a federal lawsuit on behalf of Larson's daughters, ages 15 and 4.[29] That and another suit were later combined into one, representing 115 plaintiffs including 75 current and former military personnel, all of whom, the suit says, suffered severe and disabling injuries. Three plaintiffs—Sandra Larson, Nyla Carroll and Daniel Close—died.

More frightening yet, Nyla Carroll, lawyers say, died as a result of a secondary exposure, coming into contact with another person who was vaccinated—her mother. According to the suit, Chandra Carroll, an Army chaplain assistant and logistics specialist from Tennessee, got her first three shots in September and October 1988. Until then, she'd been active and healthy. Her fourth and final injection came on May 25, 2000. Like a number of other plaintiffs who belatedly learned of the risks involved, she did not complete the six-shot routine. (It can take up to a year before the system is fully rid of the potential risks posed by the vaccine.)

A year later, on May 29, 2001, Chandra Carroll gave birth to a daughter, Nyla, who was born with severe birth defects and died on June 19, 2001. The suit claims that Chandra's condition and Nyla's

death was caused by the mother's involuntary inoculation with AVA.

Daniel Close, who joined the Marines in February 1996, told others he was suffering from headaches, nausea, diarrhea and fatigue after receiving his first injection. After his final shot, a knot developed on his upper right arm at the injection site. He reported fatigue, loss of appetite, abdominal and joint paint. In 1999, a lesion formed on his heart, and he died in December 1999.

New Jersey attorney Derek Braslow, representing Larson and the others, says the amended complaint filed in 2003 links all the plaintiffs to certain lot numbers of what the suit contends were bad batches of vaccines.

Braslow says his first battle is to convince a judge that BioPort and the State of Michigan, as well, can even be sued. In the lawsuit, Braslow says the case "is not about whether the Department of Defense lawfully chose to inject America's soldiers with the anthrax vaccine [or] whether this court has the power to stop such a program, or impose liability against the DOD. Instead, this case is about whether a private corporation and its predecessors can be held liable for selling the DOD an experimental and defective vaccine knowing it would be used on soldiers without their informed consent. It is about whether these defendants, engaged in a for-profit private enterprise, are entitled to immunity if they have produced and manufactured a vaccine in violation of numerous federal regulations and standards. And, it is about whether American soldiers are entitled to compensation from these defendants for the injuries they have suffered as a direct result of adverse reactions to this defective and unreasonably dangerous vaccine."

The company and the state deny the claims; a spokesperson says they have never knowingly produced any bad vaccines. BioPort and Michigan also say they are protected in any case by their standing as military contractors. As mentioned earlier, the Army repeatedly indemnified BioPort because of just the sort of damage that Rugo and the others hope to prove in court.

If Braslow can't convince the court that BioPort and Michigan should be held for damages, that would leave only the Pentagon to sue. And there he runs into the Feres Doctrine, a body of law that holds that a serviceman cannot sue the government for putting him or her in harm's way. The doctrine helped the government avoid damages most notably for injuries to service members caused by its freaky LSD experiments in the 1960s. The heart of the 1950 U.S. Supreme Court decision states: "The United States is not liable under the Federal Tort Claims Act for injuries to members of the armed forces sustained while on active duty and not on furlough and resulting from the

negligence of others in the armed forces" although military dependents and retired military personnel can submit damage claims.

"If Feres prevails," Braslow tells me, "we have nowhere to go. Then no one is responsible."

No shortage of AVA horror stories

It turns out there is no shortage of AVA horror stories, despite the stay-calm message from the government. The Vaccine Adverse Events Reporting System (VAERS) that the CDC and FDA created to gather and review the complaints of side effects has received over 123,000 reports since 1990, although the agencies say most describe mild side effects such as fever. However, the majority of those reports are sent in by the vaccine makers, the military and civilian health care providers. "Very rarely," say the FDA and CDC in a notice to report filers, "people experience serious adverse events following immunization. By monitoring such events, VAERS helps to identify any important new safety concerns and thereby assists in ensuring that the benefits of vaccines continue to be far greater than the risks."

Service members have long complained that the military does not report all its side effect cases, and in fact discourages reporting almost as much as it discourages dissent. Meryl Nass, the Maine doctor, told an Institute of Medicine panel in 1999 that "VAERS depends upon the likelihood that adverse events are suspected as being associated with vaccination, and that they will be reported. In the case of adverse events that occur following anthrax vaccination, military health providers have been told that only classic allergic reactions may be due to the vaccine, and that other reactions that have been reported by service members, such as rashes and joint pains, must be due to something else. In addition, military health providers have been specifically told not to report to VAERS any reaction, unless it leads to at least 24 hours of lost duty time, hospitalization, or if contamination of the entire vaccine lot is suspected. This has, in my opinion, made the VAERS system incapable of serving its assigned role: to identify possible vaccine-related illness in excess of the expected numbers."

Which brings us to former USAF Airman Thomas J. Colosimo.

Deployed to the Middle East eight times, Colosimo recalls getting sick after his first shot in 1998. He was puzzled since he was unaware of potential adverse effects. "There were no handouts, product inserts, literature, or health questionnaires to read or fill out. I just had to report to immunization, turn in my shot records, and receive

the shot." When he voiced concerns about the vaccine, he was told failure to comply was punishable under the Uniformed Code of Military Justice. "I was uncomfortable with accepting the vaccination," he recalls, "but I complied and put my faith in the system." Among other reactions, he developed cysts on his skin including nine on his scalp, another near his eye.

He received another injection in September 1999. "This time the pain at the injection site was unbearable. While leaving the hospital, I kept my arm at my side because it hurt to move it." After he was deployed to Al Jaber, Kuwait, his condition worsened, he says. He lost almost 50 pounds and suffered from ear ringing, tremors, and fatigue. A doctor ran several tests and said he was fine.

Back home, he saw other doctors and got similar dismissals, despite a constant sickness and weight loss. He refused to take his fifth shot, and, when ordered to do so, contacted his congressman and got a delay while he sought more medical reviews. He also suffered from blackouts. His wife had to call 911 and perform resuscitation when he stopped breathing.

Thanks to some media exposure and the further intervention of his congressman, Rep. John Peterson of Pennsylvania, Colosimo was checked at Walter Reed Army Hospital. While there on one occasion, he says, his home was illegally entered and searched by security police. They asked neighbors if he had a mental problem or beat his wife. At a hearing in D.C. he told a congressional panel: "I have an illness even I do not understand. I took the anthrax shots healthy and am now ill. No one is sorrier for this than me."

He is still sorry. "My condition is the same," Tom Colosimo, 31, of Pennsylvania, told me in 2003. "I think I am only getting worse and feel I don't have any future." He apologized for being negative, but he was having more bad days than good. "Just when I think I am getting used to my situation," he said, "something else happens or goes wrong."

Beth Warkentin told her AVA story in 2002 to the Military Vaccine Education Center, one of the watchdog groups that double as clearing houses for anthrax-reaction stories. Warkentin spent four years in the Navy and seven in the reserve and National Guard. At Navy boot camp in 1985 in Orlando, she received one dose of anthrax vaccine and was told she didn't need more shots. She subsequently came down with lupus, often linked to the vaccine, developing rashes, fevers, flu-like symptoms, swollen glands, memory loss, major fatigue and frequent infections. She is one of a large number of Gulf War vets who have an uncommonly high percentage of children born with difficulties. Says Warkentin: "Some days, I

don't understand why I'm so sick all the time, and I feel as though people think I only complain and that I'm well ... it's hard, but you know that. Yesterday, I woke to find that my hands, joints up to my elbows, were so swollen, that I couldn't see my wedding ring. That was a little scary. I was diagnosed a month ago with hypertension as well as everything else, and have a claim in now with [Social Security] disability. I miss work so much ..."[30]

The Military Vaccine Education Center says the single shot Warkentin received may be the so-called single super shot reportedly given to some military via an improperly souped-up dosage. The MVAC cites the similar case of Ingrid Franco, who entered the Army in October, 1990 and was sent to Dharhan, Saudi Arabia where in 1991 she received a single shot "that was often given out to troops in the Gulf without explanation that year—only with the statement that those troops who received it wouldn't have to take more anthrax vaccine shots. This was—somewhat coincidentally—just after the vaccine's manufacturer, BioPort, changed its filtering and fermenting equipment, *resulting in a 100-fold increase in the potency* of the vaccine. The FDA was never notified; the vaccine was used anyway." Skeptics figure that if even one dose of AVA can be harmful, a super shot was flat out dangerous. Franco also took the experimental PB pills—pyridostigmine bromide—to protect against nerve gas. Shortly after the shot, Franco was hospitalized with numerous ailments including infections, flu-style symptoms and a severely swollen arm. She thinks she never completely recovered. Her hair began falling out, she had bumps on her hands and, later, while assigned to the Pentagon, she was temporarily paralyzed on the left side of her body for a day. Doctors thought it was a stroke and sent her to Walter Reed Army Hospital. She was told she had Mennier's disease, an inner-ear problem. Later on, a doctor overturned that diagnosis in shock that it was given in the first place. Franco says these days she's too exhausted and weak to work fulltime. Her short-term memory loss is severe. She stutters. She was diagnosed with fibromyalgia and irritable bowel syndrome. A large cyst on her right ovary was taken out. She has attacks of vertigo and is having blackouts. Her blood pressure spikes and falls. She has severe upper airway obstruction. Her white blood count fell low and she became prone to many infections. The MVAC says these are, unfortunately, some of the symptoms that many other vaccinated veterans report.[31]

Army Major Jon Irelan of Oregon suffered assorted reactions and recalls that after his fourth shot in October 1999, while stationed in Saudi Arabia, he woke up sick and started to develop the following symptoms: loss of facial hair, testicles shrunken to peanut size,

rapid weight gain, mood swings, severe groin pain, a substantial loss of muscular strength and complete loss of libido. In May 2000, he says, "while I was in Riyadh to out-process, the flight surgeon was reviewing my records to ensure that they were complete for my return to the States and reentry into the Army Medical system. It was during this meeting that the connection to the anthrax vaccine was raised by the flight surgeon when he reviewed my shot records. The flight surgeon specifically said that I should never take another anthrax shot." He directed Irelan to report to an Air Force medical company to file a Vaccine Adverse Events report. He wondered though just how seriously the military took such reports.

"When I arrived at the medical company, an Air Force sergeant got very excited, told me to stay put, and he ran from the room. Moments later, an Air Force doctor came in, grabbed my records, read the referring flight surgeon's note and then promptly bent-back the top sheet in my medical records and wrote that he did not believe that there was any connection between my unexplained or 'idiopathic' hypogonadism and the anthrax vaccine, recommended that I first see an urologist and sent me on my way. He never even spoke to me nor did he examine me. Had he bothered to read my file, he would have seen that I had been under medical care for this problem for nearly six months." Irelan says his patriotism and military beliefs are unflagging. But he had grave doubts about the trust that is supposed to exist between the Department of Defense and its soldiers. "No one needs to tell me that military service is a dangerous occupation and that there are risks associated with that service," he said. "But what I wish someone would explain, is why certain civilian and uniformed members of the Department of Defense have been permitted to inflict this unproven investigational drug on my fellow soldiers and why they have been permitted to perpetrate the deceptions and half-truths that surround this program."[32]

Tragic AVA-related stories aren't limited to the U.S. In 2004, the London *Sunday Mirror* reported on a series of deaths and other complications that British soldiers felt were related to anthrax vaccinations they received in Iraq. The *Mirror* cited the case of 33 Field Hospital, an army unit of 105 men and women who served in the Gulf in 2003, claiming every pregnancy involving members of the unit has been troublesome. One couple's baby died five weeks after birth; another was stillborn. There also were two miscarriages, a forced termination and two premature births. In every case one of the parents was given anthrax shots. The paper said that while Gulf War I women soldiers were warned not to conceive within 12 months of their vaccinations, members of 33 Field Hospital and other Brit troops who served in Gulf II were not so warned.[33]

Rep. Dan Burton, a conservative Republican from Indiana, is a non-partisan critic of the Pentagon's vaccine policies. "We have received numerous reports of adverse effects from the anthrax vaccine. Oftentimes, we hear that the illnesses are not taken seriously. One individual was diagnosed with the flu—for over eighteen months. Individuals suffering with Gulf War syndrome, suffering physical symptoms that mirror what we are seeing with anthrax injuries, are being given psychological evaluations and sent home. The Veterans Administration has been directed to provide our Gulf War veterans with adequate medical care. I am disturbed to learn that these men and women, over one seventh of those that served in the Gulf, are being shuffled into psychological evaluations and not being adequately diagnosed and treated."

The General Accounting Office added another criticism. In an October, 2000 report, "Depleted Forces," it revealed that adverse reactions to AVA were being grossly understated—that they were in fact almost three times the number BioPort was claiming in its product insert given to advise patients of the risks they face.[34]

The insert said only 30 percent of users would experience some adverse reaction—in itself an exceptionally high reactive rate for a vaccine. In reality, the GAO found, 85 percent of the 1,253 troops it surveyed reported experiencing some type of reaction. Twenty-four percent

General Accounting Office: AVA adverse reactions grossly understated.

of those reactions were serious enough that the shot series had to be discontinued. Each shot triggered an average of four or more reactions in those who suffered reactions, said the GAO, some lasting more than a week, with reactions more common in women.

If the GAO sampling is accurate, an unscientific extrapolation of the numbers means more than 400,000 service members endured some side effects from AVA. That's a mind-boggling reaction rate. If the vaccine were being offered to the population at large, the FDA would have sent in a strike force to sweep it off pharmacy shelves.

If the world didn't know all that, the troops obviously sensed it. The GAO determined that about one in five of the Air Force Reserve and Air National Guard members it surveyed had transferred to other units or left the military between 1998 and 2000 because of the forced vaccinations.

Though the AVA product insert had been revised to include more detailed warnings, the GAO survey found that 60 percent of the

aircrew personnel were unsatisfied with information provided by the Pentagon. About 77 percent of those surveyed said they would have refused the drug if given a choice. Also, a good number of troops who had negative reactions did not report them, the GAO found, in part because they were unaware of the military's voluntary Vaccine Adverse Events Reporting System, or simply thought no one cared to know.

Anthrax vaccination for every American?

In 2002, a group of veterans and activists wrote to Donald Rumsfeld seeking suspension of the military AVA program, stating: "Please pardon the frankness, but hasn't this shot done more than enough damage already? It defies all logic that such a program could possibly be up for renewal." The group, the National Organization of Americans Battling Unnecessary Servicemember Endangerment (NO-ABUSE), said AVA "has been a desecration of the sacrifices made by thousands of Americans in WWII to establish the Nuremberg Code" which protects against illegal medical experimentation such as occurred in Nazi Germany. The organization noted that BioPort's production conflicts with the legal norms of sound vaccine policy, "especially the FDA's approval of BioPort's filter changes ten years after they were first made without notification to the FDA, but with BioPort and Pentagon knowledge that those changes were associated with greater reaction rates and a 100-fold increase in potency. It is incomprehensible that the FDA would make such approval without conducting a study of the health effects of these changes on our military." The letter concluded: "The only conceivable basis for continuing this program would be on a totally voluntary basis with each member being fully informed about the vaccine's risks—and that means reading aloud to vaccine recipients all the product insert describing the 60 or so reported types of reactions along with each of the six associated fatalities and their conditions at death."

None of those efforts were successful and the Pentagon stands by its vaccine, despite its questionable variations by lot, potency and quality. Its official view is stated in a Defense Department doctrine on AVA:

> The anthrax vaccine has an excellent safety record and is effective. No vaccine, indeed no medication, can offer assurances that it is both 100% effective and 100% free of adverse effects. As in countless other health-care decisions, whether with a single patient or a whole population, the decision comes

down to a comparison of the risks of medical inter-
vention versus the risks of disease from not
vaccinating. The risks of receiving the FDA-licensed
anthrax vaccine are consistent with other commonly
used vaccines, including temporary local reactions
at the injection site or common systemic symptoms
like headache or muscle ache. Most of these events
last less than 72 hours. A smaller number will have
somewhat larger injection-site reactions. A very small
number will have serious reactions, characterized
by hospitalization or lost work time of more than 24
hours. There are no known or suspected long-term
(delayed) adverse effects of anthrax vaccine, just
as there are none with other inactivated vaccines.
The risk from not immunizing Service Members
against anthrax is not acceptable. The deaths of
large numbers of U.S. soldiers, sailors, airmen, or
marines is likely, if unvaccinated troops are exposed
to this potent and lethal threat. Today's military force,
including both active and reserve components, is
highly mobile and deployable to high-threat areas
on short notice. The risk-versus-risk balance clearly
requires Total Force immunization.

BioPort, meanwhile, sometimes uses the threat of another
disease, smallpox, as a selling point for its vaccine, though AVA
does nothing to combat smallpox. At a 2003 congressional hearing,
a BioPort official described an "inequity between our readiness for
smallpox and our readiness for anthrax," and Prof. Lawrence Wein
of Stanford maintained that indeed "A better case can be made that
there is a much bigger risk for an anthrax attack" on the U.S. One
government study asserted that an airborne release of 100 kilograms
of anthrax spores over Washington D.C. could cause up to three
million deaths. Even though no known mass anthrax weapon-delivery
system exists, and the 2001 East Coast anthrax attacks were thought
to have come from single domestic sources, BioPort claims that a
dozen countries have or are developing anthrax weapon systems
that could be used on the U.S. or its troops. And the Soviet Union
manufactured, in Wein's words, "tons of anthrax. There's a lot of this
stuff around."

The government has awarded contracts to research firms
seeking to find an alternative, safer vaccine. Avant Immuno-
therapeutics, Inc., for example, has established a new pilot

manufacturing facility to support clinical development of bacterial vaccines, including vaccines for biodefense. In 2003, it announced the award of subcontracts in partnership with DynPort Vaccine to develop anthrax and plague vaccines for the Pentagon. DynPort is a prime systems contractor for the Pentagon's Joint Vaccine Acquisition Program and, according to the watchdog Military Vaccine Education Center, DynPort is owned by some of the same private parties who have ownership in BioPort.[35] Biotech firm Human Genome Sciences Inc. also is developing a new drug called Abthrax, and VaxGen Inc. has an experimental, genetically-engineered anthrax vaccine that it plans to test on 100 human volunteers, with FDA approval. (Shares of VaxGen surged in 2003 after the company announced it was negotiating to sell rights to its experimental anthrax vaccine in the United Kingdom; the company's fortune rose again in 2004 when the U.S. announced it was speeding up the approval process and may buy as many as 75 million doses of VaxGen's experimental vaccine to inoculate up to 25 million civilians in case of an anthrax attack). The 100 volunteers won't be exposed to anthrax itself, although animals will be exposed to the disease in separate tests. Harvard scientists have also shot mice up with a new vaccine intended to attack the anthrax toxin, like AVA does, and also the bacteria that produces it.

In December 2003, a federal judge stunned soldiers and veterans when he ruled the military would have to halt its anthrax inoculations because they were experimental and being used for unapproved purposes. But vaccine opponents' elation lasted just two weeks. In 2004, U.S. District Judge Emmit Sullivan rescinded the order after the Pentagon and the FDA reassured the court the vaccine was safe. The FDA suddenly issued a bulletin saying it had finally concluded its 32-year study and decided "the licensed anthrax vaccine, Anthrax Vaccine Absorbed, is safe and effective for the prevention of anthrax disease—regardless of the route of exposure."[36] "This alleged Final Rule is nothing more than after-the-fact gamesmanship to overrule the court's findings," said attorney Mark Zaid, who had challenged the injections through a civil lawsuit. Added his co-counsel, John Michels Jr: "The FDA pronouncement is not retroactive and, at best, means that the FDA has issued a ruling that makes the vaccine properly licensed from this point forward." Pending further hearings, Sullivan did ban forced vaccination for six unnamed defendants. But the Pentagon, which had temporarily administered shots voluntarily during appeal of the ruling, resumed its forced march of vaccinations.

In January 2004, BioPort triumphantly announced a new three-year, $245 million contract to continue supplying the vaccine, which it now calls BioThrax, to the Pentagon. "This contract

demonstrates the Pentagon's faith in our company," said BioPort President Bob Kramer, "and underscores the importance of the vaccine as the centerpiece of protection against a bioterrorist attack."[37]

Actually, BioThrax may be coming to a hospital or clinic near you. Eventually, BioPort says, it hopes to inoculate every U.S. citizen with its vaccine.

Depleted Uranium/ Depleted Forces

Making Geiger counters sing

VA budget cutters in Congress argue that, with veterans of WWII and Korea dying off, the VA's hospital rolls will eventually drop. Since 1996, enrollment in the VA's health system has soared from 2.9 million to 6.8 million. But older veterans have been dying at the rate of 1,000 a day and newer veterans are signing up for benefits at a much slower rate, in part because many are being refused services due to budget and service cuts at the VA. Private corporations, meanwhile, are assuming bigger military roles, reducing the size of America's forces by as much as 30 percent in the last decade.

Within twenty years, the VA predicts, the vet total will fall by a third, from the current 26 million down to 17 million.

That's assuming there's no Third or Fourth World War, or that no unknown disease or war-related ailment belatedly emerges, sending tens of thousands of additional veterans from Afghanistan, Iraq or future battles seeking VA hospitalization.

An ailment like, say, depleted uranium poisoning.

"What we saw can be described in only three words—*Oh my God!*"

Uranium 238, known as depleted uranium, or DU, isn't depleted in the sense that it's weak or ineffective. It's a powerful opponent of a long, happy life. DU, the leftover waste from nuclear weapons development, has been linked to cancer, birth defects and is a primary suspected cause of Gulf War illness. A by-product from the process of converting natural uranium for use as nuclear fuel or weapons, DU is just 40 percent less radioactive than natural uranium. Its heavy metal properties are a bigger threat than its radioactivity through their toxic effects on bones, kidney and liver. It can be inhaled, ingested, or enter the body through wounds and metal fragments.

DU has supplanted tungsten carbide as the preferred material for making armor-piercing projectiles. It is used in the rounds fired by Abraham tanks, Bradley fighting vehicles, A-10 attack jets and some missiles, and even as small caliber ammo by Army Special Forces troops. The rounds are made almost solely of uranium and in combat burst into a small holocaust of flames upon impact, burning through heavy metal and gutting its target. It is a dense and self-sharpening material whose invisible particles are dispersed in the air, forever contaminating the surrounding environment of soil and water and, along the chain, humans. Though Iraqi health authorities report a quadrupling of cancer cases since the 1990 Gulf War, especially in the south where DU bombs and shells were extensively used to destroy many of the 4,000 military vehicles obliterated in the overwhelmingly lop-sided battle, U.S. soldiers have not been routinely tested for their own exposure.

A July 1990 study commissioned by the Pentagon indicates military officials were aware of DU's harm and links to cancer before sending troops to the Gulf. "DU exposures to soldiers on the battlefield could be significant, with potential radiological and toxicological effects," the study said. Particularly worrisome were the bomb fragments that some soldiers carry inside them, in cases when doctors think removing the fragments could be more harmful.

Despite warnings, the White House and Pentagon have unleashed tons of DU bombs in the Gulf region. More than 631,000 pounds of DU were released between January and March 1991 in Kuwait, Iraq and Saudi Arabia, according to a DU study by Swords to Plowshares, National Gulf Resource Center and the Military Toxics Project.[1] An additional 7,000 pounds were released during a July 1991 munitions fire at the U.S. Army base in Doha, Kuwait. The study noted that the DU used during Gulf I released enough radioactive and toxic waste to poison every American man, woman and child 100 times if, somehow, those wastes were spread across America. Of course, *we* spread such wastes across parts of Kuwait, Iraq and Saudi Arabia—a much more concentrated area—and their effects are presumed to last forever. DU's persistence was symbolized in a 2003 *Christian Science Monitor* report from Iraq noting that super-microscopic DU particles "make Geiger counters sing, and they stick to the tanks, contaminating the soil and blowing in the desert wind as they will for the 4.5 billion years it will take DU to lose just half its radioactivity." A *Monitor* reporter who visited an orthopedic surgeon in Basra in 1998 was shown the doctor's collection of x-rays, contained in one box, showing patients with grotesque abnormalities. When the reporter returned in 2003, more x-rays filled more boxes.

A gynecologist at a Basra hospital also had three photo albums filled with children bearing unimaginable birth defects, six times more prevalent today than before Gulf I, he said. Women feared pregnancy almost as much as they feared war.[2]

The United Nations Population Fund reported in 2003 that the number of women who die of pregnancy and childbirth in Iraq has nearly tripled since 1990. Bleeding, ectopic pregnancies and prolonged labor were among the causes of 310 deaths per 100,000 live births in 2002. That was nearly three times higher than the average of 117 deaths per 100,000 in 1989. "Miscarriages," the report added, "have also risen, partly due to stress and exposure to chemical contaminants."[3]

The military's rationale for DU is the same used to explain the deployment of other hazardous chemicals or medicines: It's the best we've got, and it saves— American—lives. That thinking hasn't changed much since 1973 when a Defense Department study concluded, according to a synopsis of the study, "that in combat situations, the widespread use of DU munitions could create a potential for inhalation, ingestion or implantation (via fragments) problems. However, these problems were viewed as insignificant when compared to the other dangers of combat."

Dr. Douglas Rokke, a passionate, crusading former U.S. Army nuclear health physicist and once the Pentagon's go-to guy for advice on the health effects of depleted uranium, says the use of DU weapons is a crime against humanity. Just as soldiers may be better off in the long run without the military's experimental drugs, they would assuredly have benefited from the military's use of the non-uranium munitions of earlier wars that, it seems, could have done the job just as well against the under-gunned hapless conscript armies of Saddam Hussein.

During Desert Storm, Dr Rokke led a team assigned to clean up uranium contamination caused by friendly fire. "What we saw can be described in only three words—*Oh my God!* The wounds were horrible, the contamination was extensive," he says. "Although myself and my team members wore respiratory and skin protection, that protection we know today does not provide any adequate protection against the inhalation, the ingestion, the absorption of uranium compounds." He himself now suffers an assortment of medical ailments including respiratory and kidney problems and cataracts, having been recalled to active duty in Desert Storm twenty years after serving in Vietnam.

Besides cleaning up DU-contaminated equipment and terrains, Rokke's team also provided medical assessments for

exposed personnel. "We had over 100 friendly fire U.S. casualties and several hundred others with verified exposures because of their U.S. Department of Defense assigned duties," he says of his Gulf experience. "We also observed what is known as `Tours Are Us'. This epithet refers to the numerous instances of individuals visiting and climbing all over contaminated and destroyed equipment and terrain without wearing any protection."[4] He subsequently recommended medical care for all exposed individuals, and guidelines were written for screening and care in June 1991. As later verified by a GAO investigation, he says, the recommendations were ignored then and still are today. In 1993, the Pentagon ordered then-Secretary of the Army Togo West to undertake the testing of personnel for exposures. Brigadier General Eric Shinseki signed the order on behalf of the Army. "This order," says Rokke, "in most cases, is still disobeyed without any accountability."

According to Frida Berrigan, a senior research associate with the World Policy Institute's Arms Trade Resource Center, the Pentagon is relying more and more on DU weapons and armor. "The 1991 Gulf War was the first major conflict in which DU weaponry and armor was used," she reports. "Almost 320 tons—an amount equal to the weight of five Abrams battle tanks—were fired in the Iraqi desert. About 10 tons of DU munitions were used in Kosovo and the former Yugoslavia in the '90s. DU weaponry was reportedly used in Afghanistan in 2001 as well, but reliable estimates are not yet available." Depleted uranium was used extensively in Iraq in 2003, but the Pentagon has not released official figures. Gulf-era vet Dan Fahey of Veterans for Common Sense, who has helped in the search to uncover U.S. government documents about depleted uranium, says the Department of Defense, under Bush, has tightened controls over DU documents. "There is less information and more secrecy," says Fahey, who estimates that, during the first few months of the Iraq war, "approximately 100 to 200 metric tons [of DU] was shot at tanks, trucks, buildings and people in largely densely populated areas." Berrigan says the Pentagon claims it needed DU to win a quick war in Iraq, but notes that it was used widely in urban areas and against civilian targets, hardly the war machinery it claimed to be targeting.

DU, by the way, is provided to weapons manufacturers nearly free of charge by the Pentagon, a kind of government surplus program that Berrigan calls "an ingenious method of radioactive waste disposal." The government is less friendly about alerting its soldiers and the public to the hazards of DU, and closely guards details of its harmful effects as issues of national security. "Veterans with Gulf War

syndrome," says Berrigan, "can be seen as the latest in a long line of Pentagon guinea pigs that includes the troops ordered to witness the atomic blasts in the early days of the Cold War, soldiers exposed to Agent Orange in Vietnam, and the black men in Tuskegee, Alabama, who were subjected to federal government-sponsored syphilis experiments."[5]

A rash of censorship

Berrigan has written extensively about DU, as have others, but it's a story that seems to have no public impact in the U.S. Concern seems higher in Europe where British soldiers and other foreign armies are campaigning for more research into what they call the Balkans syndrome. British, French, Italian, Dutch, Belgian, Spanish, Czech, and Portuguese soldiers were under NATO and U.S. command in the mid-1990s when U.S. aircraft fired 31,000 uranium-tipped rounds in Kosovo, and 11,000 rounds in Bosnia. Project Censored at Sonoma State University in California recently picked DU for its annual yearbook on important stories that were underplayed by the mainstream media. "Censored 2004" cited two stories—one in *Hustler* magazine, the other a public radio documentary—detailing DU's hazards. The stories said DU particles can be inhaled even through gas masks and noted that ex-army nurse Carol Picou compiled extensive documentation on the birth defects found among the Iraqi people and the children of our own Gulf War veterans. Her life was threatened by anonymous phone calls on the eve of her testimony to Congress. Her car, which contained sensitive DU documents, was mysteriously destroyed. *Hustler* features editor and the story's author, Dan Kapelovitz, says that "Rather than being ashamed that a porn magazine was more willing than they were to publish the truth, major media outlets kidded themselves into believing that the story didn't need to be covered, claiming it was old news. While it's true that there has been some limited coverage of DU ever since the first Gulf War, the average American has not heard of depleted uranium. Those who have [heard], most likely saw reports focusing on DU's awesome armor-piercing abilities, not its harmful long-term effects on people and the environment."

DU's hazards are less of a secret, however, to soldiers. Kapelovitz says some U.S. troops even placed signs in Arabic to warn Iraqi children not to play with radioactive shells, or around contaminated tanks. Reese Erlich, author of a radio documentary, says that "In Basra, before the U.S. invasion of 2003, doctors showed

me a photo album of horribly deformed children, some born without noses or eyes. They compiled a cancer registry of children suffering from leukemia and other cancers. Children exposed to DU in southern Iraq saw a four-fold increase in cancer and birth defects since 1990." DU stories have surfaced in the mainstream media over the years, but strong denials from the military and the complexity of the topic have muted many of the stories, Erlich says. "I've had editors at prestigious publications tell me they won't touch the DU story because it's too controversial. In my opinion, few reporters or editors are willing to risk the career danger inherent in criticizing the Pentagon, or taking on a popular president during wartime."[6]

In 2003, *Rolling Stone* chronicled DU in an impassioned piece, "Is The Pentagon Giving Our Soldiers Cancer?" Hillary Johnson's story included this passage on a friendly fire incident, when U.S. soldiers were hit by one of their own DU shells:

> The percussion of the first shell pulverized a glass rosary inside the vehicle and knocked the crew unconscious. Jerry Wheat remembers popping the hatch, climbing out and pulling off his burning Kevlar vest. "My whole body was pretty much smoking." That's when the second round struck. "I could feel myself getting hit with shrapnel in the back of the head and back."
>
> Wheat, a divorced father of two who works for the post office in Las Lunas, New Mexico, was twenty-three when he found himself halfway around the world in the Iraqi desert at the center of a fierce tank battle in 1991. A sandstorm was raging. He was driving a four-man Bradley fighting vehicle, on which one of his crew-mates had painted Garfield the cat saying, "Fuck Iraq." In photos of the vehicle, two jagged holes are visible at the top. That's where the Bradley was struck by "friendly fire" from an Abrams tank as Wheat steered toward the center of the battle and rescued members of another American tank crew.
>
> A day later, Army medics removed pieces of shrapnel from Wheat's body as he lay on the back of a truck. Curiously, the wounds hardly bled, though second- and third-degree burns marked the entry points. "They were worried about a chest wound, but the shrapnel was so hot when it went

in, it sort of cauterized, and I wasn't bleeding that bad." His sergeant major stopped by to tell him he had been hit by an Iraqi tank. "When we asked if we were hit by friendly fire, they said no, so I ate, slept, and lived off my vehicle for the next four days."

Wheat continued to drive the Bradley, though he noted a "dusty residue" coated it inside and out. "It was pretty nasty. Imagine a huge fireball going off inside your car—that's pretty much what the inside of my vehicle was like." He and his buddies also smoked eight cartons of cigarettes that had been stashed in the Bradley when it was hit. "You had these little pieces of metal falling out, and you would hold your fingers over the holes as you smoked them. They were all coated with DU. No one had ever even mentioned DU except to say that we were firing it. We were told not to worry. They said, 'It won't hurt you. It's depleted.' It was on your hands, your food. We didn't even think about it. We were just happy to be alive."[7]

DU on the home front

DU is not just a wartime or veterans' story. In addition to its risks to civilians in Iraq and elsewhere overseas, its use in stateside bombing practice and its production at U.S. plants is a hazard to American civilians as well. In the Northwest, the Navy has been firing DU rounds in exercises off the Washington state coast, near the Olympic Coast National Marine Sanctuary, since 1977. "The Navy is willing to put us all at risk, including its own sailors, to improve its war-fighting capabilities," says Glen Milner of the venerable Ground Zero Center for Nonviolent Action, whose group has filed a federal lawsuit against the Navy for violations of the Endangered Species Act related to the Trident nuclear missile upgrade at Bangor, the nuke submarine base. The DU exercises had been unknown publicly until Milner obtained an internal Navy memo dated June 25, 2001, giving Everett-based destroyer *USS Fife* permission to conduct gunnery operations. A Navy spokeswoman said not to worry. Sailors aboard ship were not at risk.[8]

DU also strikes fear in the taxpayers' pocketbooks. In Massachusetts, one of the Army's major DU suppliers, Starmet Corp., polluted soil and water supplies by dumping 400,000 pounds of uranium and heavy metals into an unlined holding pond, and has since filed for

bankruptcy, sticking taxpayers with the $50 million cleanup.

A similar cleanup of DU shells manufactured by Alliant and stored at the government's Twin Cities Army Ammunitions Plant near Minneapolis is projected to cost $235 million.[9]

The Nuclear Regulatory Commission, which oversees production safety at U.S. plants that produce DU bombs, shells and armor, reminds employees to always wear protective masks and film badges to check exposure levels. Production workers at private plants increasingly realize the dangers of the DU they produce. A worker at the Bechtel Corp.'s DU manufacturing plant at the Idaho National Engineering and Environmental Laboratory (INEEL) near Idaho Falls, took the company to court after blowing the whistle on what he said were unsafe conditions causing Gulf War-type illnesses among the plant's workers.

Bechtel is under contract with the U.S. Agency for International Development for the repair, rehabilitation or reconstruction of Iraq's infrastructure. That $680 million—and counting—contract raised suspicions because of Bechtel's corporate connections to the Republican Party and the White House, and because the pact was awarded without a competitive bid. Jack Sheehan, a member of the Defense Policy Board that advises Secretary of Defense Rumsfeld, is also a senior Bechtel executive.

Clint Jensen, an INEEL/Bechtel employee for 20 years, was a manufacturing operator on the classified Idaho program that fabricates DU to be used in the lining of Abrams battle tanks. His job included incinerating uranium chips, and cutting and boring sheets of uranium metal. He also mopped and swept around the plant's homemade metal-burning oven and removed black film left from oven leakage. Jensen was worried about his health and that of others, and raised questions about the deaths of two workers he contended died prematurely. He recalled how his exposure level soared after he realized one day he was standing in water contaminated by DU. For his concerns, Jensen got the back of INEEL's hand. He was referred to a psychiatrist, his security clearance was changed, and some of his leave time taken away, according to the Government Accountability Project, a whistleblower-watchdog organization that helped Jensen fight back. In late 2002, after Jensen brought a retaliation lawsuit,

All of which has to make you wonder: how are our boys doing inside those DU-lined Abrams tanks?

the company settled, restoring his leave and paying all his costs and expenses in the suit. He was not fired. But he continues to have the pains and ailments that mimic Gulf illness.[10]

A 2002 study by the VA's former chief of nuclear medicine, Asaf Durakovic, reported that DU was found in 14 of the 27 ailing Gulf War veterans he tested nine years after the war. Studies like that have persuaded the British, at least, to recognize DU's debilitating effect on soldiers. In February 2004, Kenny Duncan, a Scotsman, became the first British Gulf War vet to win his case for DU poisoning. The Pensions Appeal Tribunal Service agreed that his exposure to DU—one of his war duties was the removal of Iraqi tanks destroyed by DU shells—had been scientifically proved to be medically related to his disability. The British, unlike the Americans, have also agreed to clean up DU contamination in Iraq. As a spokeswoman for the UK Ministry of Defense said in 2003, "Legally, we have no obligation to clean up the remains of the DU we used. It's the responsibility of the new regime in Baghdad. But morally we do recognize an obligation, as we have in the past. We helped in the removal of DU from Kosovo."[11]

Gulf War illness has killed more than 600 soldiers in the UK, according to veterans there, with 6,000 more having applied for illness benefits. But, as in the U.S., Brit veterans think those numbers are just the poisonous tip of the iceberg.

The graveyard factor

Do Americans care about the possible widespread effects of DU, not only on soldiers but on civilians? I think we do. But does the government? Then-Secretary of State Madeline Albright was asked during a 1996 "60 Minutes" interview, "Half a million Iraqi children have died—more children than died in Hiroshima. Is the price worth it?" She answered: "Yes, we think the price is worth it." Some in the government still think some form of genocide is a good policy. GOP Sen. Trent Lott, who avoided the draft during Vietnam, suggested slaughter as an Iraq war strategy: "If we have to, we just mow the whole place down, see what happens."[12]

Some think DU has the potential to do just that.

Dr. Beatrice Golomb, the VA's scientific director on Gulf War illnesses and author of several books, argues there is as yet no substantial epidemiology to support great concern about DU's effects. But, she allows, "with a lot of kinds of things like low-level radioactivity, there may be a time lag of years before certain types of problems like carcinogenic problems, cancer causation, would be evident." Steve Robinson, the veterans' advocate, points out that studies do

in fact show that depleted uranium in laboratory animals causes cancer. The World Health Organization is also studying DU's effects in Iraq, Kosovo, and in the Balkans, worried that governments have poisoned their soldiers and sentenced them to a slow, painful death.

"I do know that the military is considering moving away from depleted uranium and going [back] to tungsten," Robinson says. "There are significant concerns. The scientific studies have not actually come through yet that will either confirm or deny that depleted uranium is or is not a problem…Over the last 12 years, the Department of Defense, being the sole repository of information about what did or did not happen or what samples were taken or where they were sent, hasn't really shared a lot of the information that we'd like for them to share, blood sampling being one of those things. So I would hope that if there are samples and things that would be brought back, that they would be open to independent scientists."

United Nations experts have been doing some new testing in Iraq's region between the Tigris and Euphrates rivers, scene of most combat, and home to the majority of Iraq's 24 million population. Pentagon deployment-health specialist, Dr. Michael Kilpatrick, maintains there will be no health impact from the DU in Iraq. In the midst of the war, Steve Robinson, the UN's Dr. Golomb and Dr. Kilpatrick hashed out some of the truths and consequences about DU in a give-and-take exchange on NPR's "Talk of the Nation" program.[13]

> *Kilpatrick:* The Army Center for Health Promotion and Preventive Medicine has people far forward with very sophisticated equipment to look at soil, water, air for toxic industrial chemicals, other toxic materials that may be there, as well as looking for any of the other nerve agents, biological agents that may be present in an area. We certainly are very focused on getting that data, getting it archived, being able to have it in a format that we can share it with the VA when it comes to what do we need to look at as far as people who may be deployed and come back with any kind of symptoms. The Air Force and the Navy also have forward-deployed people sampling water and food, making sure that what our people are eating and drinking is safe for consumption. And we have people doing vector analysis, making sure that we are using the right level of pesticides to protect our people against

vector-borne diseases…

Host Ira Flatlow: Will the data be available to the public?

Kilpatrick: There will be a process on how we do that, and I think when you gather samples, you have a very limited amount of material, so you want to make sure that the veterans come first, and that needs to be the premise of this. And so the Department of Defense and Department of Veterans Affairs will work together to make sure that the appropriate research is done and whether that research is done within DOD-VA or external, as over 60 percent of the current research going on Gulf War veterans' illnesses is external to DOD and VA….

Golomb: I'd like to offer the additional comment that there was a lag time between the Gulf War and the onset of health problems in many Gulf War veterans and the time that it really became recognized that there was true illness with physical etiology and symptoms that weren't just psychological or caused by stress. And not all of the physicians at all of the VAs have necessarily caught up with that. In fact, there was a mandatory training program for understanding Gulf War veterans' illnesses several years ago that certainly could have led physicians at veterans' health centers to the supposition that there wasn't any concrete cause for these illnesses and that there wasn't any, in some sense, reality to these illnesses. And there hasn't necessarily been any comprehensive training programs to update physicians on the more recent evidence….

Robinson: We get the calls from the veterans, too, that report all around the country that their doctors, some of them that they report to, don't even know what are the myriad of illnesses that Gulf War veterans suffer from. And I think it's important to recognize that the Department of Veterans Affairs, specifically Dr. Leo MacKay, recently announced that Gulf War illnesses are real and that they deserve the attention and the proper care that the veteran

deserves. And the Department of Veterans Affairs recently funded $20 million to look at further Gulf War illness issues. However...what we need to stress is that the message gets down to the VA and it gets down to the individual clinician because part of the reason why veterans often hear that 'Your illnesses aren't real' is because the doctors at that level aren't aware of the current body of research ..."

That is a constant refrain in the evolving body of study on Gulf illness. Bill Clinton's 12-member commission, appointed in 1995 and completing its work in 1997, seemed overwhelmed by its task that spread out over two years and 18 public meetings. The bottom line to its weighty study was that, well, more study is needed. Said the commission: "It is essential, now, to move swiftly toward resolving Gulf War veterans' principal remaining concerns: How many U.S. troops were exposed to chemical warfare agents, and to what degree?"

In 2004, Rep. Jim McDermott, a Washington state Democrat, was still trying to get an answer to that. He filed a bill, supported by 23 other Democrats, that if passed would require the government to conduct studies on DU's effects as well as clean up DU contamination in the U.S. "The need for these studies is imperative and immediate," said McDermott, a child psychologist. "We cannot knowingly put the men and women of our armed forces in harm's way."

At last report, his bill was stuck in a committee somewhere. These things take time. Many graveyards must first be filled to prove the point.

The Rat Brigade:
Medical Testing on Soldiers

'What did they give me?'

Mickey DiMauro was a humble Navy yeoman in the 50s, working in the personnel office at El Centro, in the ass-biting California desert heat where he did seven years on the home front. Years later, crying, he came to me one day at my newspaper in Seattle and set a little red and white box on my desk. Inside were the few medals he had earned. "You can have them," he said.

He didn't want to be in the military any more. He tried killing himself a few times He underwent electroshock therapy. A gaggle of doctors and nurses strapped him in, put a bite block in his mouth, attached electrodes to his brain, and zaaapp! He was supposed to forget he was crazy.

Maybe he still was, I thought. DiMauro had the harebrained notion that someone had put LSD on his steak as he stood in the Navy chow line at El Centro.

Later I sat down in his living room one afternoon and listened first to his apology. A slightly bald, compact man of forty-nine then, he was sorry because he said our conversation probably would be interrupted by more of his crying. He also warned me there could be uncontrolled bursts of screaming and swearing, and that he might suddenly withdraw quietly into the darkness of paranoia.

Conspiracy Theory was not just a movie

He sat at a table holding one of his cats in his lap, saying he already had endured long months of horrendous mind expansion—times when his senses became so magnified that the soft hum of a refrigerator motor could become a wild roar in his head and outdoors, the gentle wind became an explosion to his ears. His suicide attempts included one by self-strangulation when he wound and then tightened material around his neck and slept, hoping not to awaken. Another

time he ran across a room and smashed his head into a wall, and, one further time, he jumped off a table onto his head. These tragicomic acts spanned two decades of confusion.

"I used to think," he told me, "'What is happening? I'm going off my rocker. What did they give me? Did they give me something?'"

"They" would be the Navy, which is where DiMauro thought it all began, even though a service doctor had told him it was something else. Something like "It's your childhood. You were a bad boy."

Mickey had struggled to a point of reason by that afternoon, questioning his past in search of his destiny. Disabled, unable to work, and still on constant medication, he thought the government might have done this to him. "Based on the reactions I've had," he said, "I feel I was given a hallucinatory drug." That may have been in 1951 at El Centro, California, a Navy facility where the Army had what he described as an all-purpose test center. "They tested equipment, clothing, food, medicine and drugs," Mickey said. He was a yeoman PO 3.C assigned to the personnel office. "In brief, the security chief there and I didn't get along. I thwarted him, I was the bottleneck in his harassment of personnel and what I felt were improper disciplinary actions. I was, briefly, introduced one day to a sergeant from the testing contingent. Shortly after that, it began. I suspect I was an involuntary guinea pig, singled out because of the security chief's dislike for me.

"I have no idea how it could have happened. It could have been fed to me, in my coffee, or my food. I remember only once, a day that a mess-hall cook extended a special and unusual invitation for me to have a steak. It was sprinkled with a light powder. I assumed it was seasoning. An hour later in my quarters I was in a heavy sweat, crying, in a state of fear. I would stuff rags under the door and around the windows to stop the noise. The noise was deafening, explosions! My God! I said. My God, what is happening?"

He was later hospitalized in a San Diego Navy facility. "I really believed I was losing my mind, going insane, going to die, that maybe I'd be murdered. I was changing. My face was changing. In the mirror one morning I was a contorted, disturbing image, my pupils were dilated. At the hospital a doctor told me: It goes back to your childhood. It is from your past. The Navy bears no responsibility for that. He said I was going to have a nervous breakdown." DiMauro was discharged in 1952, his pipe dream of a 20-year tour ended by a COG (Convenience of the Government) discharge. DiMauro did in fact suffer the breakdown. He underwent electroshock treatment in California. He had been an outpatient at the Seattle VA hospital since 1967. The VA and the VFW kept him alive, he said.

What did DiMauro think was the substance sprinkled on his steak that day? Lysergic acid diethylamide. LSD. DiMauro was guessing, he said. But he'd read about LSD trips. That's what he thought he took. I wrote his story and said I'd do whatever I could, which amounted to nothing. I didn't necessarily believe his story. But it was one worth retelling. Eventually, he and his story faded away like yesterday's news.

CIA Project OFTEN

Two years later, 1979, I came across a batch of newly released declassified CIA documents that were being distributed by activist groups and obtained under the Freedom of Information Act. The documents outlined the agency's attempts to explore mind control. The plan, according to the CIA's record, was "to develop ways for predictably influencing human behavior through the use of drugs." The tests would be done jointly with the Chemical Research and Development Laboratory, Edgewood Arsenal Research Laboratories, and the U.S. Army. Dr. Van Sim, who led some of the experiments, said he himself took a test drug that affected his nerve endings and made him woozy. "It left me zonked for three days," he said. "I kept falling down and the people at the lab assigned someone to follow me around with a mattress." Altogether, Edgewood drug experiments were conducted on 6,983 military and civilians from 1956 through part of 1975. Don Bowen of Maryland, one of the volunteers, said years later that his wife had gone through nine pregnancies but six of their children were stillborn. "We were tested on a drug that they [doctors] didn't know what it would do exactly or where it was going to lead."[1]

The testing was part of the CIA's Project OFTEN, last in a series of secret drug and mind-control experiments. They began in 1949 and ultimately involved a range of testing sites stretching from San Francisco whorehouses to prestigious United States universities. The experiments were at times unorthodox. In some instances, records showed, one CIA operative would test another without his colleague's knowledge by, for example, dropping a drug into the fellow agent's coffee when he wasn't looking (something like Spy Vs. Spy, the *Mad* magazine subversives). Drugs were tried in a casual manner on the unsuspecting. Anything was possible. Even, back in 1951, someone's steak being laced with a powder at a California Army Base.

What kind of drug was the CIA using at its Army base tests?

LSD.

I have been unable to contact Mickey DiMauro about the tests. I wrote about it and said I hoped he saw the story. But he no

longer lived where I had visited, had no phone listing and left no forwarding address. I left it at that, opting not to check county death records. I wanted to think he was alive and well and perhaps, finally, at peace.

MKULTRA mind control experiments

MKULTRA was the brainchild of Sidney Gottlieb, who also directed the CIA mind-control project. It was his concept that allowed LSD and other drugs to be secretly given to several hundreds of Americans during the Cold War. The project was the subject of 1970s congressional hearings and the plot featured in the Mel Gibson/Julia Roberts movie, *Conspiracy Theory*. The CIA along with federal agents in the 1950s and 1960s handed out mind-altering drugs first to prison volunteers, then experimented on citizens and government workers without their knowledge. The intention was to perfect techniques and drugs to control human reactions, America's attempt to conquer brainwashing techniques used in earlier wars by our enemies. A 1999 documentary on the Arts & Entertainment network featured an operative bragging "We tested these drugs in bars, in restaurants, in so-called massage parlors, any place where there was a drink and people were eating and drinking." There were fatalities, including Army chemist Frank Olson, who in 1953 jumped to his death from a hotel window. An investigation disclosed that LSD had been slipped into his drink (his widow belatedly received a $750,000 settlement from Congress).[2] After lengthy pursuit, the U.S. also paid a settlement to Canadian psychiatric patients who were the unwitting subjects of Gottlieb's experiments in the 1950s.

In 1987, the United States Supreme Court considered the case of Army Sgt. James B. Stanley, who'd been surreptitiously dosed with LSD as part of the mind control experiments. Stanley knew he'd been a guinea pig after he received a government letter two decades after the experiments, asking for his cooperation in a study of long-term LSD effects on "volunteers" such as he. The Supreme Court, in a 5 to 4 ruling, dismissed his complaint for damages under the Feres Doctrine. But it made clear that Stanley would have had a constitutional claim if not for the doctrine and Stanley's military status.

Among the dissenters was Justice William Brennan.

"The medical trials at Nuremberg in 1947," he wrote, "deeply impressed upon the world that experimentation with unknowing human subjects is morally and legally unacceptable. The United States Military Tribunal established the Nuremberg Code as a standard

against which to judge German scientists who experimented with human subjects. Its first principle was: the voluntary consent of the human subject is absolutely essential...."

Stanley, nonetheless, had no legal recourse. While citizens may complain about being second class, soldiers have the law to prove it.

A brief history of human experimentation in America

Military and civilian testing has been intertwined over most of a century in America. It dates most notably to 1931, when Dr. Cornelius Rhoads, a biomedical researcher under the auspices of the Rockefeller Institute for Medical Research (established in 1901 by John D. Rockefeller and today known as Rockefeller University, located on the Upper East Side of Manhattan), infected human subjects with cancer cells. He later established the U.S. Army Biological Warfare facilities in Maryland, Utah, and Panama, and was named to the U.S. Atomic Energy Commission. At the AEC, he began a series of radiation exposure experiments on American soldiers and civilian hospital patients. For years, the American Association for Cancer Research handed out an award in his name to promising young researchers. Then it belatedly began to review "serious allegations" in his background.

Rhoads had performed his cancer experiments at Puerto Rico Presbyterian Hospital where, San Juan doctor Hector Pesquera determined, Rhoads used Puerto Ricans as unwilling guinea pigs. Pesquera calculates that at least 13 people died as a result. In 2002, having become fully aware of the human testing, Puerto Rican activists began a campaign to have Rhoads' name dropped from the researchers' award. After reviewing the 1930s test data and other experimentation—human testing, willing and unwilling, was once more widely accepted than it is today, though it was nonetheless done mostly in secret to avoid widespread notice—the cancer research association suspended the Rhoads award in 2003 and has renamed it for 2004.

Pesquera and others who are part of the island nation's independence movement—the U.S. invaded Puerto Rico in 1898 and holds the island as unincorporated territory without a voice in U.S. affairs—were also outraged at disclosure of separate military experiments there, and outdoors biological and chemical weapons testing in the 1960s and 1970s at the Puerto Rico Rican island of Vieques. Vieques was also the site of a civil disobedience campaign against U.S. Navy bomb runs nearby, discontinued in 2003.

Activists such as Robert Kennedy, Jr., actor Edward James Olmos, and presidential candidate the Rev. Al Sharpton have been arrested during protests. Military experiments similar to the Vieques tests were also undertaken in Florida, Hawaii, Canada, Alaska, the Marshall Islands and Great Britain. The Pentagon admitted the testing after U.S. veterans linked their medical ailments to the experiments.[3]

Rhoads' "groundbreaking" cancer study was followed in 1932 by the notorious Tuskegee Syphilis Study. The United States Public Health Service initiated the study using 399 infected black sharecroppers from Macon County, Alabama, and 201 uninfected men as control subjects. They were told they were being treated for "bad blood" and were deliberately denied treatment—in fact, doctors prevented them from seeking any kind of medical therapy. For their service, the men received free meals, free medical examinations— and burial insurance. In 1972, the *New York Times* revealed how the men had been untreated for forty years, calling it "the longest nontherapeutic experiment on human beings in medical history." The study became the metaphor for medical racism and unethical conduct. In 1997, President Clinton apologized on behalf of the government, personally addressing the few survivors and noting that "what was done cannot be undone but we can end the silence. We can stop turning our heads away. We can look at you in the eye, and finally say, on behalf of the American people, what the United States government did was shameful and I am sorry." A $200,000 grant was given towards a bioethics center at Tuskegee University, unaffiliated with the study but whose reputation was stained because of it.[4]

There was the Pellagra Incident in 1935, in which millions— mostly impoverished blacks—died over two decades while the Public Health Service, once again, took no action yet knew that pellagra was caused by a niacin deficiency. In the1940s, 400 Chicago jail inmates were infected with malaria so they could be tested with experimental drugs and at the Nuremberg trials, Nazi doctors cited that study in a vain attempt to justify their Holocaust horrors. From 1942 to 1945, the U.S. Chemical Warfare Services tested mustard gas on 4,000 servicemen as well as members of the Seventh Day Adventists church who volunteered as guinea pigs in lieu of serving on active duty. During that same period, according to a historical timeline provided by Health News Network, the U.S. launched a research program on biological weapons at Fort Detrick, responding to a similar Japanese germ-research plan. The Navy also used human subjects to test gas masks and clothing, locking some victims inside a gas chamber. And the Atomic Energy Commission launched Program F, an extensive study on the effects of fluoride, a key chemical in atomic bomb production.[5]

After WWII, VA patients were used for an assortment of medical experiments. Aware of the growing concern over such practices, the VA began using the words "investigation" or "observation" rather than "experiment". Similar clandestine testing was done by the AEC, feeding intravenous doses of radioactive substances to victims, while the Department of Defense began its LSD testing along with the downwind experiments of setting off atomic bombs in U.S. desert regions. This continued into the 1950s. There was little the government wouldn't test on sometimes unsuspecting victims, and few regions they wouldn't test it in, including:

- Releasing disease-producing bacteria and viruses into the open air at military bases;
- Sending up clouds of zinc cadmium sulfide gas over Winnipeg, St. Louis, Minneapolis, Fort Wayne, and parts of Maryland and Virginia;
- Exposing tens of thousands of New Yorkers and San Franciscans to airborne germs;
- Releasing Army biological bacteria over Tampa Bay;
- Sending out mosquitoes infected with yellow fever over Savannah and over Avon Park, Florida, after which Army agents would pose as public health officials testing victims for after effects.[6]

Senate hearings later confirmed that 239 populated areas had been contaminated with biological agents between 1949 and 1969.

In the 1960s, prisoners at the Holmesburg State Prison in Philadelphia were subjected to dioxin, a component of Agent Orange. They were studied for development of cancer, suggesting the military had suspected Agent Orange was a carcinogen even as it was being used in Vietnam. Only occasionally did rational minds prevail over the outrageous, such as when the CIA toyed with, then opted *not* to, poison the drinking water of the Food and Drug Administration offices in Washington, D.C. in 1968.[7] But in 1970 at Fort Detrick, another extreme test by the CIA went forward, reportedly developing a molecular biology technique that could produce AIDS-like retroviruses. The U.S. also moved into such off-the-wall developments as "ethnic weapons" intended to target and eliminate specific ethnic groups by taking advantage of DNA variations. (South Africa's government, during its apartheid days, developed race-specific strains of biotoxins that, the *Washington Post* says, are today still available on the secret arms market.)[8]

In 1986, a U.S. congressional report listed the government's then-current generation of biological agents as including modified viruses, naturally occurring toxins, and agents that are altered through genetic engineering to change immunological character and prevent treatment by all existing vaccines.[9]

In an experiment intended in part to help military and space programs develop radiation-exposure preventions, 64 Washington state inmates were enlisted to participate in so-called reproductive tests. From 1963 through 1971, they were enticed into a makeshift prison lab where, one after another, they lined up, stripped down, and offered their genitalia to radiation. Some stood in front of a revved-up General Electric X-ray machine, while others lay down on a buzzing bedlike contraption, lowered their testicles through a small opening into a water-filled box, and were zapped for up to 10 minutes a session. Inmates later learned they had risked more than a little ball warming from the experiments. Some may have died and others suffered testicular cancer or life-altering medical conditions as a result of the University of Washington program, conducted by Seattle endo-crinologist Dr. C. Alvin Paulsen under a private contract with the Atomic Energy Commission (now the Energy Department). Paulsen's onetime college mentor, Carl G. Heller, administered similar experiments at the Oregon State Penitentiary in Salem during the same time period, exposing 67 inmates to testicular radiation. In 1995, a Clinton presidential commission on U.S. human experiments found some U.S. tests well-intended and even groundbreaking, but determined the captive Washington and Oregon subjects were coerced and not informed of the risks.[10]

Dr. Paulsen told me the tests were acceptable under the conditions of the time. "If our work was unethical, then you'd have to say that all the [federal and advisory boards] that approved it in those days were completely unethical, and so, no, that's not true."[11]

Senate Report: *Is Military Research Hazardous to Veterans' Health?*

Experiments such as these and concerns about the testing-on-the-run approach of inoculating Gulf War veterans brought about a comprehensive look into the use of military guinea pigs in 1994. A Senate Veterans Affairs Committee study, headed, notably, by a determined chairman, West Virginia Democrat John D. (Jay) Rockefeller IV, whose family's institute had been involved in the first such testing in 1931, found that for at least 50 years the government and particularly the Defense Department has intentionally exposed

military personnel to potentially dangerous substances. The exposures were regularly done in secret or failed to comply with ethical standards.[12]

Examples include two substances classified as investigational, and not fully approved by the FDA. Botulinum toxoid (BT) is a vaccine used to prevent botulism. Pyridostigmine bromide (PB) is a nerve agent in pill form that is intended to protect troops against nerve agents and other chemical weapons. They were given out prior to and during the Gulf War essentially using the military as a testing ground, the Rockefeller report found. PB, for example, is more commonly used to treat patients with neurological disorders. Chairman Rockefeller said that in 1990, Pentagon and FDA officials privately discussed the military's plan to use pyridostigmine and botulism vaccine for U.S. troops in the Persian Gulf. According to minutes of the meeting, the "FDA expressed some concern about liability and the need to comply with the regulations," and an FDA official "pointed out the need to establish an appropriate investigational framework to collect observational data and evaluate the military medical products in question." The major focus of the meeting was informed consent. The Pentagon did not want to abide by informed consent regulations, and FDA officials pointed out that both pyridostigmine and botulism vaccine were investigational and that there are laws regulating how they can be used. The Pentagon claimed it had authority to "dictate the use of unapproved FDA regulated products" in the Gulf, but would prefer to obtain a waiver from FDA.

The Pentagon insisted the products were safe for such use even though it could not support the claim. PB had earlier been tested on only small study groups, none of which contained women. Additionally, the Rockefeller study found that subjects were screened to determine whether they were hypersensitive to PB before allowing them to participate in the experiment. Individuals who already took medications, and even those who smoked, were excluded from the studies. Study participants were also told not to drink any alcoholic beverages. Yet even with all those precautions—and the freaky notion that non-smokers and non-drinkers somehow authentically represented our men and women in uniform—serious adverse reactions were reported for several of the studies, including respiratory arrest, abnormal liver tests, unusual electrocardiograms, gastrointestinal disturbances, memory loss and anemia.

All 695,000 U.S. troops in the Persian Gulf War were issued PB, the Pentagon says. About two-thirds took the drug at various times, some for several weeks. None had been screened beforehand,

some were on medication, and, it seems reasonable to assume, more than a few smoke and drank.

According to the Rockefeller report, studies showed PB helped animals survive exposure to one particular nerve agent, soman. But PB may also make soldiers more vulnerable to other nerve agents, such as sarin. So the Pentagon tried to restrict its use to soman. One catch: sarin, not soman, according to the one verified report of chem-weapon use in the Gulf War, was the only nerve agent actually used during the war. Indeed, its release was involved in what became the single largest chemical-weapons exposure to American soldiers ever recorded. (The Khamisiyah exposures are discussed later in this chapter.)

In 1999, the Rand Corporation released a report indicating pyridostigmine bromide could not be ruled out as a contributor to the development of some Gulf War veterans' unexplained or undiagnosed illnesses. The study also noted that uncertainties remain about the effectiveness of pyridostigmine bromide in protecting humans against chemical warfare agents. Yet, in 1998, with PB still under investigation, Congress established legislation allowing the president to authorize military use of the drug without informed consent if he's convinced its use would save the lives of troops facing exposure.

In a 2002 study by Kansas State University, the combination of PB with anthrax vaccine and other medications was found to have produced a debilitating effect on Gulf War vets' health. Though the testing was complicated because so many government medical records or vaccination records of veterans had been falsified or destroyed, K-State researcher Walter Schumm says that "Personally, I think the best guess is that the mix of pyridostigmine bromide pills, multiple vaccinations in a brief period of time, and high levels of stress combined to adversely affect the health of individuals with genetic susceptibility to such combinations." He adds: "I get angry sometimes because you hear on the news that the Gulf War illness symptoms are psychological, it's all in their heads. If it was all just psychological, I don't think we'd get these correlations with the exposures like we have."[13]

In February 2003, with war looming again in the Gulf, the FDA approved PB for combat use against soman. The drug therein obtained a special place in history, becoming the first drug approved under a new FDA rule, called the "animal efficacy rule," that allows use of animal data to show the drug's effectiveness whenever the drug can't ethically or feasibly be tested in humans.[14]

The Department of the Army submitted its own data from controlled trials and uncontrolled clinical tests to show PB "is well-

tolerated"…by pigs and monkeys. In its approval announcement, the FDA noted that correct usage of the drug requires that "military personnel must carefully follow instructions and use the drug only under specific circumstances." For example, if U.S. troops faced the threat of exposure to soman, "they would be given instructions to take pyridostigmine bromide [one 30 mg. tablet] every 8 hours prior to the anticipated exposure. Soldiers will be warned that *the drug is not effective* and should not be taken at the time of, or after exposure to, soman," (emphasis added). The drug is intended for use with other protective measures such as donning chemical protective masks and battle dress garments.

A leaflet explaining the usage, benefits, and side effects of PB is usually given to military personnel only when the drug is distributed. Apparently, it is at that crucial moment preceding a suspect nerve gas attack that a soldier will learn PB should not be used by persons who have a history of bowel or bladder obstruction, or sensitivity to certain medicines used during surgery. Side effects include stomach cramps, diarrhea, nausea, frequent urination, headaches, dizziness, shortness of breath, worsening of peptic ulcer, blurred vision, and watery eyes.

The thing is, should a solider actually encounter nerve gas, he or she then must immediately *stop* using PB. At that point, the solider must administer two other nerve-gas antidotes, atropine and pralidoxime chloride. A little grace under pressure is required. As mentioned earlier, soldiers are also required to hold their breaths and don their masks before injecting themselves with the two meds.

As of this writing, it's unclear whether any troops took the pill this time around in Iraq. There have been no recorded attacks with soman—hell, there's been no soman. But the military had only to think there might be some, and order the pill taken eight hours prior to the anticipated exposure.

Veterans who claim they were harmed by vaccines or PB frequently have no proof that they were injected or took pills, or that they had an adverse reaction. Some said PB marred their vision and rendered them unable to shoot at targets any distance away—like an oncoming enemy solider. The Pentagon claims that since its goal was treatment, the use of these investigational drugs did not constitute medical research. The government estimates that approximately 250,000 to 300,000 personnel took at least some PB during GWI and continues to defend its use.

According to a Pentagon statement, "During Operation Desert Storm, the threat of use of nerve agents by Iraq was very high. After careful deliberation by a specially constituted human-use

review committee of the Food and Drug Administration, it was determined that the pretreatment could help save the lives of many service members if nerve agents were used. Approval for the use of pyridostigmine bromide was based on extensive scientific information that supported the safety and effectiveness of pyridostigmine bromide as a preventive treatment."[15]

There was no effort to withhold information from the troops or the public, officials added. PB use was widely reported by the news media. But the Pentagon does concede that troops did not receive enough information about possible side effects. "Information was prepared for distribution in the field, but it did not arrive before hostilities began... We know that in some units, pyridostigmine bromide administration was carefully monitored, while in others, it was not. However, accurate assessments of actual pyridostigmine bromide use are difficult because no specific records were kept of self-administered medications. To date, the Food and Drug Administration has recalled none of the drugs or vaccines administered by the military."

Botulinum toxoid (BT), meanwhile, has been a suspect product for 20 years. In 1974, the Centers for Disease Control weighed a ban on the vaccine because of hypersensitivity and adverse reactions. It remains, today, an unapproved vaccine, but is used nonetheless to protect lab workers and others who could be exposed to botulism. On top of those questions, the vaccine was given too late to GWI troops to be effective if Iraq had used biological warfare. About 8,000 men and women got the shots, most receiving just one or two inoculations. Researchers found that even had the shots been timely given, the vaccine wouldn't have been effective against all botulism toxins anyway. In other words, as the report states, "99% of U.S. troops received no protections from botulism due to the shortage of toxoid, and the remaining 1% were probably not protected because the vaccine distribution started too late."

Missing records

Initially, the Pentagon refused to tell all its GWI troops of the risks of taking such medicines—the medical version of don't ask, don't tell. As a last-minute compromise on December 31, 1990, the Pentagon consented to at least inform—orally or when possible, in writing, as the FDA requires—soldiers about risks of vaccinations they were getting, and said the shots would be administered voluntarily. The military promised that soldiers would be observed for 30 minutes after receiving vaccines, and when possible, would be checked again within two days.

Despite these agreements, the Rockefeller study found that "many [Gulf] veterans claim that they were not told what vaccine they were being given, or what the risks were, either orally or in writing." Many reported that they were told not to tell medical personnel they'd received a vaccination, even if the shot caused pain or swelling. The study indicated no record of the vaccine's administration was available in medical records. As a result, physicians who were concerned about any local or systemic reactions often had no indication of possible causes.

The Rockefeller review determined that the safety of the botulism vaccine was not established prior to the Gulf War. It also concluded that records of anthrax vaccinations are not suitable to evaluate safety, and that Army regulations allowed doctors to skip informed consent for volunteers in some types of military research. The Pentagon and VA repeatedly failed to provide information and medical follow-up to personnel involved in military research and others who were ordered to take investigational drugs. Additionally, the government failed to research possible reproductive problems by veterans exposed to potentially dangerous substances and did not provide timely information to allow victims to seek compensation.

"Participation in military research is rarely included in military medical records, making it impossible to support a veteran's claim for service-connected disabilities from military research," the Senate study found. "And the DOD has demonstrated a pattern of misrepresenting the danger of various military exposures that continues today."

Back in 1994, the Rockefeller committee recommended that Congress deny the Pentagon's entreaty for a blanket waiver to use any investigational drugs when facing the threat, or actuality, of war. The committee also said the FDA should reject any applications from the military that do not include data on women, and long-term follow-up data. It recommended establishing a centralized database for all federally funded experiments that utilize human subjects and mandating all federal agencies to declassify most documents on research involving human subjects. It suggested additional protections and review, and perhaps most significantly, said the Feres Doctrine tort exemption preventing military personnel from suing it should not be applied for military personnel who are harmed by inappropriate human experimentation when informed consent has not been given. All these years later, most of those recommendations remain just that.

Attorney Mark Zaid, of the Madison Project, who reviewed the military's history of medical mistreatment and experimentation, found the record "not only quite clear, it is despicable." He says.

"Both the FDA and the Presidential Advisory Committee on Gulf War Veterans' illnesses criticized the Pentagon for its past history of using experimental drugs and vaccines during the Gulf War and exercises in Bosnia. The FDA criticized the Pentagon for failing to document immunizations in soldiers' permanent medical records and for touting the vaccine in handouts given to troops as 'very safe and extremely effective' when the FDA never authorized such glowing language."

And then there was Khamisiyah.

The Khamisiyah exposures

Bill Clinton's 1996-97 commission on Gulf illness tried to dig into one example of the Pentagon's most careless handling of medical and chemical risk in history—the question of whether U.S. forces were exposed to chemical munitions during the March, 1991 demolition bombing operations at the Khamisiyah chemical-storage depot in southeastern Iraq. Among the weapons destroyed were 122-millimeter rockets containing the nerve agent sarin, which was dispersed into the air during the depot's destruction.

The exposures were among those first probed by Sen. Don Riegle and detailed in a 1994 report, which said in part:

> On June 30, 1993, several veterans testified at a hearing of the Senate Committee on Armed Services. There, they related details of unexplained events that took place during the Persian Gulf War which they believed to be chemical warfare agent attacks. After these unexplained events, many of the veterans present reported symptoms consistent with exposure to a mixed agent attack. Then, on July 29, 1993, the Czech Minister of Defense announced that a Czechoslovak chemical decontamination unit had detected the chemical warfare agent Sarin in areas of northern Saudi Arabia during the early phases of the Gulf War. They had attributed the detections to fallout from coalition bombing of Iraqi chemical warfare agent production facilities...
>
> In September 1993, Senator Riegle released a staff report on this issue and introduced an amendment to the Fiscal Year 1994 National Defense Authorization Act that provided preliminary

funding for research of the illnesses and investigation of reported exposures. When this first staff report was released by Senator Riegle, the estimates of the number of veterans suffering from these unexplained illnesses varied from hundreds, according to the Department of Defense, to thousands, according to the Department of Veterans Affairs. It is now believed that tens of thousands of U.S. veterans are suffering from a myriad of symptoms collectively labeled either Gulf War Syndrome, Persian Gulf Syndrome, or Desert War Syndrome. Hundreds and possibly thousands of servicemen and women still on active duty are reluctant to come forward for fear of losing their jobs and medical care. These Gulf War veterans are reporting muscle and joint pain, memory loss, intestinal and heart problems, fatigue, nasal congestion, urinary urgency, diarrhea, twitching, rashes, sores, and a number of other symptoms.

They began experiencing these multiple symptoms during and after—often many months after—their tour of duty in the Gulf. A number of the veterans who initially exhibited these symptoms have died since returning from the Gulf. Perhaps most disturbingly, members of veteran's families are now suffering these symptoms to a debilitating degree. The scope and urgency of this crisis demands an appropriate response.

This investigation into Gulf War Syndrome, which was initiated by the Banking Committee under the direction of Chairman Riegle, has uncovered a large body of evidence linking the symptoms of the syndrome to the exposure of Gulf War participants to chemical and biological warfare agents, chemical and biological warfare pre-treatment drugs, and other hazardous materials and substances...

It is now the position of the Department of Defense that it has no other evidence that U.S. forces were exposed to chemical agents. Yet this report contains descriptions and direct eyewitness accounts that provide evidence which suggest that gas was detected, along with many other events which may have been actual attacks on U.S. forces.

> This report supports the conclusion that U.S. forces
> were exposed to chemical agents. The assertion
> that the levels of nerve agents detected by the
> Czechs and others were not harmful is flawed.[16]

The Pentagon has lied and changed its stories about how many of its troops were harmed by the exposures, and Khamisiyah has become another instance indicating why soldiers if not all Americans should have a healthy skepticism about the military version of honesty. It involves the same kind of cover-up used to mask unauthorized research, and, to many critics, the Khamisiyah release was effectively an experiment in combat survival and in the military's efforts to conceal it.

The depot was one of many hazardous sites the military destroyed during and after Storm, including al-Muthanna, Muhammadiyat, Ukhaydir, and the Fallujah chemical proving grounds all in southern Iraq. The stored agents included nerve and mustard gases and shells. Bomb damage assessments during the war showed that of the 21 sites bombed in Iraq—categorized by intelligence agencies as nuclear, biological, or chemical facilities—sixteen had been destroyed by bombing. Some of those bomb sites were near the areas where U.S. troops were located.

A GAO report later found that the DOD and CIA originally believed, or at least said, that coalition air strikes resulted in damage to filled chemical munitions at only two facilities in central Iraq—Al Muthanna bunker 2 and Muhammadiyat—and at the Ukhaydir ammunition storage depot in southern Iraq. At Muhammadiyat, munitions containing an estimated 2.9 metric tons of sarin and cyclosarin and 15 metric tons of the chemical agent mustard were damaged during the air strikes, the GAO says. At Al Muthanna, munitions containing an estimated 17 metric tons of sarin and cyclosarin were damaged during the air strikes.[17]

But the most significant releases were at two sites at Khamisiyah, the Khamisiyah Pit and Khamisiyah Bunker 73. As declassified documents now show, Army officials had been warned of exposure risks from nerve gases prior to the launch of the ground war in February 1991—the CIA had known of Khamisiyah's chemical weapons storage since the late 1980s. But that information supposedly was not relayed to Desert Storm commander Gen. Norman Schwarzkopf. Or so officials claim. Thus troops from the 82nd Airborne were ordered to demolish the depot in March 1991, following the end of major fighting

The Clinton commission found that the initial Khamisiyah

chemical warning information "did not pass from one command to another when responsibility for the Khamisiyah site changed hands," and that executive branch departments and agencies (under both George H.W. Bush and Clinton) made no serious effort to examine the possibility that troops had in fact been exposed. "Initially," the committee said, the Pentagon "forfeited opportunities to gain information with potential military significance and ultimately undermined its credibility with much of the American public."

Even though after the war—in November 1991—the CIA issued a classified message documenting that some Khamisiyah exposures likely took place, the Pentagon took no immediate action to notify soldiers or veterans of the risk. The issue of the possible exposure of troops to low levels of chemical warfare agents was first raised during the summer of 1993 by Gulf veterans, who had obtained documents through the Freedom of Information Act indicating there were exposures, and raised again more strongly in 1996 during the Clinton commission probe.

"Up until then, when we confronted them with the documents," says activist Steve Robinson, "they had lied to us. There's no other word for it. They knew." In his 1997 book, *Gassed in the Gulf*, ex-CIA analyst Patrick Eddington, the former executive director of the National Gulf War Resource Center, describes a conspiracy by top government officials to cover up the exposures, a claim for which he caught some hell. "I'd say he's been vindicated by history," says Robinson, his successor.

The DOD and the CIA undertook efforts to estimate the number of troops that might have been exposed to chemical agents by conducting field tests at Khamisiyah in 1996 and 1997. The government sought to gauge the size and path of the plume and the number of troops exposed to it. They came up with their first estimate: only 300 to 400 troops were exposed to chemical plumes.

Almost nobody believed that. The government went back to the drawing board, and back and back. The number was revised to approximately 5000 on September 1996, to approximately 20,000 on October 22, 1996, and to 98,910 on July 23, 1997.

In 2000, DOD gave it another shot. The estimate this time of soldiers exposed to the chemical plume—once officially zero—was now 101,752.

Did they finally get it right? Not quite. In 2000, DOD announced that as a result of ongoing scientific analysis, DOD's Directorate for Deployment Health Support had developed a *new* computer model that changed the location of the Khamisiyah plume footprint again.

The number of soldiers potentially exposed remained near 100,000.

But the newest calculations reclassified 32,627 troops as unexposed who were previously classified as exposed.

They also classified 35,771 troops as exposed who were previously classified as unexposed.

The DOD had to send out letters telling the first group they weren't exposed, and the second that they were. Which left the GAO shaking its head after it studied the Pentagon's Khamisiyah follies.

"Given the weaknesses in DOD [plume] modeling and the inconsistency of data," the agency said in a report, "there can be no confidence that the research conclusions based on these models have any validity."

Steve Robinson thinks there is more than enough proof today—scientific, not simply anecdotal—for the government to decide (given the exposure at Khamisiyah along with the other health hangovers of Gulf I) to declare Gulf War illness as a demonstrable treatment category, qualifying all those afflicted for benefits.

The VA and Pentagon so far aren't budging, and the CIA is still reviewing its figures. Its latest findings were interesting in more ways than one. In a 2002 Intelligence Update on the 1991 Gulf War chemical releases, the agency said that at all the sites except for the Khamisiyah Pit, the "releases did not reach US troops because they were too small, too slow, or too far from US troops. We also identified several suspect release sites—related to Iraq's declared unilateral destruction of chemical munitions—and we assess these also are unlikely to have been an exposure threat." The CIA concluded that Iraq did not itself use chemical weapons against coalition troops, and that any use of mustard or nerve agents against Shiite insurgents immediately after Desert Storm was also unlikely. As well, even though troops reported possible detection of or exposure to chemical weapons agents, the CIA found no conclusive proof.[18]

Hypocrisy at war

The U.S. tries to get around its double standard on global use or development of biological and chemical weapons—objecting when other countries follow in our WMD footsteps—by creating new delivery systems and calling them weapons of mass non-destruction. These are the supposedly non-lethal weapons of our future. The Sunshine Project, an international non-profit that watchdogs the hostile use of biotechnology in the post-Cold War era, has been tracking U.S. development of purportedly non-lethal chemical weapons and found some of them to be just the opposite. In 2003, it reported

that a Marine Corps program to develop non-lethal chemicals had begun development of a quite lethal rocket propelled grenade. It also discovered the Army was investigating use of tacrine, a close cousin of several nerve gases, as a potential non-lethal chemical weapons payload. According to a Sunshine Project report:

> The Marine Corps contracts were granted by the Joint Non-Lethal Weapons Directorate (JNLWD) in November and December 2002. Both are with AgentAI, a small company based in Victorville, California. One contract is for development of a new kind of rocket propelled grenade (RPG) to be fired from the US Army's standard M-203 grenade launcher. The chemical grenade is being designed for a 500-meter range. The RPG is designed to strike a person (or perhaps near a person) and then to disperse "chemical agents that can further incapacitate or maintain the incapacitation of the targeted individual." The company plans testing on a "simulated human target" under the current contract. The second JNLWD contract with AgentAI calls for development of non-lethal bullets that release a chemical payload upon striking a target. [Summaries of these contracts are available on the Sunshine Project website.]
>
> Another document, also available via the Sunshine Project website, reveals the interest of a senior US Army toxicologist in tacrine, a drug used to treat Alzheimer's Disease. The Army is not interested in the drug, however, for helping disease victims. Rather, it is assessing use of tacrine as a weapon. In February 2002, at Aberdeen Proving Ground in Maryland, the toxicologist ordered a literature review on its potential for weaponizing. Chemically, tacrine is a acetylcholinesterase inhibitor, a first cousin of the nerve gases sarin, tabun, and VX (among others).
>
> The discovery that the Army is investigating close relatives of extremely lethal nerve gases as "non-lethal" weapons heightens concerns previously raised that the Army's "non-lethal" chemical weapons program is practically indistinguishable from one with a fully lethal intent. The Army's interest

in tacrine should draw particular scrutiny from the Organization for the Prohibition of Chemical Weapons and governments who are members of the Chemical Weapons Convention.[19]

The Sunshine Project has published extensive documentation on what it calls the illicit U.S. chemical warfare program including testing of opiates in scenarios similar to that which resulted in the Moscow Theater tragedy. (On October 23, 2002, during a musical performance, Chechen terrorists rushed in and took 800 theatergoers hostage. They threatened to kill them unless Russia ended the war in Chechnya. After negotiations failed, Russian police released an incapacitating gas thought to be the opiate drug fentanyl which, in minute dosages, is used by cancer and surgical patients to relieve pain. The terrorists were killed, but so were 117 of the hostages, mostly by the gas.)

The U.S. has long conducted clandestine bioweapons research and, according to the Institute for Energy and Biological Research, produced weaponized anthrax spores in quantities beyond what is needed for research. The *Bulletin of the Atomic Scientists* says the U.S. is hoping also to perfect biological cluster bombs.[20] The Pentagon has expanded its budget for chemical and biological defense work and is planning to open several new biodefense labs. Army researchers are reportedly attempting to recreate parts of the 1918 Spanish flu pandemic, which killed more than 50 million worldwide and was fanned in part by sweeping transmissions through Army bases in the U.S. (while military officials initially refused to stop shipping soldiers from camp to camp, which helped spread the deadliest plague in history). Project Jefferson, as revealed by the *New York Times* in 2001, is another secret Pentagon experiment designed to genetically engineer a vaccine-resistant version of anthrax that, theoretically, could be used against an enemy.[21] Despite the likely domestic source of anthrax attacks on the U.S. Congress itself, there has been no widespread domestic outcry questioning the legitimacy of America's persistent involvement in developing the deadly biotoxin, or the excuse it gives America's haters to do their own Strangeglovian research.

Biowar endangerment of American civilians

It's not just soldiers and veterans who should be wary of the government claims about biological and chemical experiments, uses and releases. The U.S. is proposing to convert the Rocky Mountain

Labs in Montana into what is called a BSL-4 laboratory—a level 4 biological lab—which would be cleared to handle some of the most dangerous biological substances on the planet, including anthrax and ebola. The community of Hamilton, Montana and several other groups are banding together in opposition.[22] Also, environmental groups filed suit in San Francisco to block construction of biowarfare labs at two national nuclear weapons facilities, Lawrence Livermore National Laboratory in Livermore, California, and the Los Alamos National Laboratory in Los Alamos, New Mexico, claiming the labs' safety records deemed them unreliable in handling extremely dangerous materials such as anthrax. The facilities are designed to conduct research into various biowarfare agents such as anthrax, plague and botulism.[23]

In Herminston, Oregon, the Army is incinerating nearly 4,000 tons of chemical weapons, including sarin, VX and mustard gas. In 1999, several dozen construction workers said they were poisoned by the sarin while working on the stockpile. They tell of a chaotic aftermath when they realized what was happening, the exposure leaving workers gasping for breath and vomiting as they tried to escape outside, dragging some workers with them. They say they were not offered medical assistance for hours. Despite the event having occurred in the midst of all those stored chemicals, the Army claimed the leak wasn't chemically caused. In 2003, the site's operator, Raytheon—the contractor at three of the six chemical demilitarization sites the Army has under way—settled out of court with the workers.[24]

In Sauk Prairie, Wisconsin, a citizens' group is battling the Pentagon over the toxic wastes left behind at a former Army munitions plant. Among the contaminants seeping into the groundwater are the heavy metals mercury and cadmium and such carcinogens as carbon tetrachloride and trichloroethylene. It's one of *27,000* sites the Pentagon is tardy in cleaning up, and in many cases, is backing away from responsibility for, altogether. The shirking has the Bush-backed blessings of the Environmental Protection Agency, which calls the Pentagon move "appropriate." The Pentagon does clean up some things, however. *Mother Jones* magazine reports that a 2000 review commissioned by the Pentagon suggested the Defense Department was an environmental scofflaw—a charge that military censors sanitized from the review along with seven other critical pages.[25]

In 2004, the Army plans to burn more chemical weapons at its Pine Bluff arsenal (which Raytheon built and operates under a $512 million defense contract) although the military has asked for an extension on destroying all its stockpiles. In 2003, the GAO reported that the program is plagued with schedule delays and higher costs—

in three years, the price tag had risen dramatically, from $15 billion to a seemingly impossible amount to fund, $24 billion. Based on "schedule slippages," as the government likes to call delays, the GAO thinks costs will grow higher with ever more delays.[26]

The Army's setbacks include two incidents at the Tooele Chemical Agent Disposal Facility in Utah. On May 8, 2000, a small amount of chemical agent escaped into the environment, and the facility was closed for four months. On July 15, 2002, a worker was exposed to a low level of chemical agent and the plant was closed for almost a year. An Army spokesperson said, "Safety is paramount," adding, "and I'm delighted to report that [the injured worker] has recovered and gone back to work."[27]

In late 2003, the Army began destroying 800 gallons of sarin, drained from 900 M55 rockets, at its new $1 billion weapons incinerator in Anniston, Alabama, site of an Army depot. About 35,000 people live near the incinerator, operated by Westinghouse. It is the Army's first burner to be located in a populated area (as part of its agreement with the state, the Army agreed to provide gas masks to any local resident who felt they needed one). Some supported the facility because of the jobs it created; others feared the dark threat of sarin: one drop of it and you're a late Alabaman. "Even a small accident could be catastrophic," said county emergency management director Mike Burney. The military originally had to burn the gas in two batches weeks apart because, the Army said, the incinerator wasn't working correctly and it was still "fine tuning" the burner. "In no way, " said Army spokesman Mike Abrams, "would I characterize it as any failure or any problem. This is what we have characterized as a shakedown period." In February 2004, the Army had to temporarily shut down the facility after alarms sounded and a leak was reported. In March, Westinghouse admitted that excessive PCBs—polychlorinated biphenyls—had been emitted during earlier test burns. A chemical mixture, PCBs are thought to cause cancer. At last word, the Army's—and Anniston's—shakedown continued.[28]

Chapter Five

Squalene:
A Pattern of Deception
and Denial

Stonewalling the evidence

In June 1994, Pam Asa, an independent immunologist from Memphis, notified the Pentagon's Defense Science Board that symptoms being reported by ailing Gulf War vets were similar to autoimmune diseases she was seeing in her own patients. Asa believed the illness might be related to exposure to vaccine adjuvant formulations. She figured the Pentagon would want to know. An adjuvant is a pharmacological agent added to a drug to increase or aid its effect. Since 1926, the only FDA-approved adjuvant used in human vaccines licensed in the U.S. has been aluminum hydroxide, called alum, which safely increases a vaccine's antibody response. The DOD dismissed the immunologist's concerns, saying it used only alum as a booster. In 1996 and 1997, the immunologist told DOD her independent research had confirmed the findings of squalene in the blood of sick veterans who'd served in the Gulf. The DOD did not respond to her findings.

Questionable medicines are ok—The Pentagon says so.

Military doctors along with other medical researchers have long sought a better booster to optimize the effectiveness of vaccines and lower the number of required injections. Squalene is produced in the human body when cholesterol is converted to fat. It can also be artificially manufactured and is found in vegetable oils, shark liver oil, cosmetics and some health supplements. Of major concern in developing a new adjuvant is its safety, a determination needing cautious and lengthy testing. Squalene's ill effects on the body are not completely known although

it is suspected to be a cause of crippling arthritis, from which many Gulf soldiers suffer. For that reason, squalene is not approved for use as a booster.

In 1999, responding to a request by congressman Jack Metcalf, a Republican from Washington state, a Government Accounting Office investigation confirmed that prior to and following the Gulf War, the Defense Department and the National Institutes of Health tested formulations of squalene on humans. But the GAO couldn't confirm it was actually used to boost military vaccinations.[1]

Defense and NIH had performed or sponsored 28 clinical trials in which vaccines using squalene were tested on 1,749 subjects. The DOD did five of the trials, in which 572 human subjects volunteered and participated. Of the five trials, two began before the Gulf War. Defense officials didn't know if any of the subjects had been deployed to the Gulf . The Pentagon said more than 100 volunteers and a small control group were involved in a trial that tested both squalene and an experimental malaria vaccine in the early 1990s. A planned study using human subjects from Gambia was withdrawn because of concerns about the stability and quality of the synthetic squalene they had proposed to use. Defense also conducted several vaccine experiments using squalene on animals, testing for effects on such diseases as anthrax, toxic shock, and malaria. There are indications that squalene may also have been tested on human military subjects in the 1960s, under the nefarious MKULTRA project. A November 1960 invoice included in the declassified MKULTRA papers lists squalene as among the chemicals ordered by the project.

But was squalene included in injections given to Gulf soldiers, as Pam Asa suggested, posing an unrevealed threat to their health? Remember, many GWI troops were given a super shot of the anthrax vaccine, cutting down the number of necessary inoculations. Was squalene used to boost the vaccine? A study by Dr. Robert Garry of Tulane University would later back Asa's squalene suspicions. It concluded that all but two of 38 sick Gulf veterans that he tested, who received at least one vaccination, were found to have elevated squalene antibodies—indicating an earlier presence of squalene. Also, 59 of 86 Gulf War-era veterans, military civilian employees and military contractors who were vaccinated tested positive for squalene antibodies. "Squalene," said Garry, "has been used as a component of several different vaccines and it's been shown to cause some of the same problems that many of the Gulf War veterans had."[2]

Garry allowed that the results were not conclusive. He hoped the Pentagon would settle the question. The GAO backed that notion. "Time is critical for many Gulf War-era veterans who continue to

suffer from illnesses and have been waiting for the past 7 years for an explanation about the nature of their illnesses," the GAO noted in its report. "It is therefore important that DOD takes advantage of any opportunity to obtain and evaluate additional information…" Garry's research, the GAO added, "cannot be ignored."

The military ignored it. The Pentagon insisted there was no basis for believing veterans were exposed to vaccines containing squalene. Further testing wouldn't resolve anything, the military said.

Purely scientific lies

That was the beginning of Congressman Jack Metcalf's crusade against what he called the DOD's "stonewalling and obfuscation" and his effort to alert troops and the public to the potential risk. It is an eye-opening chapter in the military health saga, illustrative of what troops and veterans are up against in their quest for disclosure.

Metcalf immediately wrote Secretary of Defense William Cohen—a fellow Republican holding a cabinet seat in the Democratic Clinton administration—objecting to the department's refusal to carry out the GAO recommendations. Cohen's department reacted with more refusals and various sneak attacks, including one by a Walter Reed researcher who asked Garry for a draft of his scientific manuscript, promising not to release it publicly, then posting it on the DOD website where it was subjected to scathing reviews.[3]

In the summer of 1999, an anonymously written DOD memo was obtained by the defense team representing five young Marines at Twenty-Nine Palms, California who were being court-martialed for refusing the anthrax vaccine. The six-page document detailed the recommendations of two military doctors that squalene research such as Garry's was worthwhile. "There is," it quietly concluded, "an obvious need for independent in-house research by the Army to examine the issues and implications, if any, of antibodies to squalene." Attached was a chart outlining how the DOD could undertake a three-year study costing $1.2 million.

Metcalf sought congressional intervention, and successfully pushed through legislation instructing DOD to conduct the test. President Clinton signed the bill in 1999. The DOD danced around it anyway. Cohen wrote Metcalf that "The Department's position has been consistent and remains unchanged"—law or no law.

In fall, 2000, Metcalf fired off his biggest rounds. He released a congressional report that said squalene had in fact been found in the anthrax vaccine itself, warranting an immediate halt to the anthrax

vaccination program. Congress, Metcalf said, must get to the bottom of the labyrinth of this and other possible causes of Gulf War illnesses. "We have an obligation to pursue the truth, wherever it may lead us," he told his fellow legislators. "To do less would be to act dishonorably toward the dedicated men and women who stand between us and a still dangerous world."[4]

Then, a military concession. In October 2000, Michael Kilian of the *Chicago Tribune* wrote: "After years of denials, the Pentagon admitted yesterday that the chemical agent squalene has been found in some of the anthrax vaccine it has been administering to military personnel...Defense Department spokesman Kenneth Bacon, who made the disclosure at a regular Pentagon news briefing, insisted that the amounts found were 'minuscule' and that the substance 'occurred naturally' in the vaccine and had not been added to increase the potency of the injections..."[5]

A moral victory

Feeling the Pentagon now would be forced to undertake more conclusive testing, Jack Metcalf retired from Congress at the end of that year, 2000, while William Cohen has gone on to a career in poetry as well as corporate consulting, currently seeking a piece of the action in the government rebuilding of Iraq. Metcalf could feel good about having held the Pentagon's feet to the fire, and forcing the military to come somewhat clean. He showed us the extent to which, even for public officials in power, it's the Pentagon's way or the highway. And he made it clear that, for all its lip service, the Pentagon would rather protect its rear than its soldiers.

Which is what it's still doing. The Pentagon is now operating under Republican oversight. But the Bush administration has effected no change. In 2002, a group of veterans and activists wrote Donald Rumsfeld asking that the anthrax vaccinations be halted in part due to the unanswered questions about squalene. They asked that each lot of the vaccine also be tested for the illegal presence of squalene. "After months and years of Pentagon denial about its use of squalene," they noted, "it is no longer sufficient simply to take the word of government officials that this long-known, arthritis-triggering substance is not in the shot."[6]

Rumsfeld did not act.

Chapter Six

Better Soldiers Through Chemistry

Murder, suicide, rape and—doping?

In a six-week stretch of summer, 2002, four Army soldiers stationed at Fort Bragg, N.C. killed their wives. Two then turned their guns on themselves. A third hanged himself in his jail cell. The three suicides were elite Special Forces and Delta Force troopers, schooled in the most effective ways to attack and kill the enemy. At least two of them had taken a "safe" anti-malaria drug given by the Army, called Lariam.

Special Forces Sgt. 1st Class Rigoberto Nieves, 32, returned home from Afghanistan on June 9th and two days later shot his wife, Teresa, 28, and then himself, to death.

Master Sgt. William Wright, 36, who served with the 3rd Special Forces Group in Afghanistan, returned home in June and two weeks later reported his wife, Jennifer, 32, missing. She was later, on June 29, found strangled and buried in a shallow grave.

> **Medicine's role in helping GIs stay alert and alive: Take 2 of these and kill someone in the morning.**

Charged with first-degree murder, Wright, who authorities said confessed to the murder, hanged himself in jail on March 23, 2003. The couple had three children, ages 6 to 13.

On July 19th, the same day that William Wright was arrested for the strangulation of his wife, Sgt. 1st Class Brandon Floyd, said to be a member of the secret Delta Force, shot his wife Andrea and himself to death. He had earlier been in Afghanistan, too.

Army Sgt. Cedric Griffin, 28, who worked in the Fort Bragg commissary, is accused in the July 9th murder of wife Marilyn, 32, stabbing her 50 times and then setting her on fire. He awaits trial.

Nieves and Wright for certain were given Lariam as part of their Afghanistan deployment, the Army said. Griffin, a stateside cook, wasn't, officials said, and apparently neither was Floyd although Lariam pills are routinely given to soldiers in Afghanistan. An effective anti-malarial drug for those who tolerate its side effects, Lariam—the product name for mefloquine—is produced by Swiss pharmaceutical giant Hoffmann-La Roche (Roche Pharmaceuticals in the U.S.) and has long been known to cause psychotic reactions in some of its users. Side effects include psychosis, hallucinations, delusions, paranoia, aggression, tremors, confusion, abnormal dreams and sometimes suicide.

In August, *The Fayetteville Observer* reported that the four wives all had wanted out of their marriages. Jennifer Wright told her parents she was "tired of being a military wife" and wanted a divorce. Marilyn Griffin had earlier separated from her husband, the third time in eight years of marriage, and investigators said they believed that Teresa Nieves and Andrea Floyd told their husbands in June that they wanted to separate.[1]

The Army sent in a 17-member team to sort it all out at Bragg, home of the 82nd Airborne Division, a city unto itself with 40,000 soldiers located seven miles outside Fayetteville along Bragg Boulevard, a long drag of car lots, electronic stores and strip joints.

According to a 2002 news report by the American Forces Press Service, which goes out to military members and the public, the team determined that the contributing causes were "martial discord, high personnel tempo and fear of counseling"—the reluctance of a solider to show weakness by undergoing therapy. The press service said the study "eliminated" Lariam as a cause.

Mainstream news reports also said Lariam was not a factor. Actually, the Army's review—the Fort Bragg Epidemiological Consultation Report—said that while the drug was apparently not a direct cause, it could not be totally ruled out, either. As the Army report concludes: "Mefloquine does not explain the [homicidal] clustering. Mefloquine (Lariam) was not prescribed at all for two of the four active duty index cases. The other two index cases did receive prescriptions for mefloquine, but there was no reported history of antecedent changes in personality or unusual behavioral symptoms documented."[2]

Why Lariam?

The Army would have to be taken at its word. It did not spell out which soldiers got Lariam—although readers of the report could deduce who may have—nor reveal whether it was possible the other two received shots that might not have been recorded, which has

frequently been the case, soldiers and veterans say. As even the report notes, concerns raised by the Army personnel interviewed included "medical documentation sufficiency," or more clearly, the insufficiency of documenting visits and procedures on med charts and the military's electronic pharmacy system. Soldiers also told investigators there was inadequate screening for possible psychiatric reactions and a lack of informed consent about the drug's risks.

Two United Press International reporters, Mark Benjamin and Dan Olmsted, reported on the controversy in depth.[3] They revealed concerns that the military was covering up problems with a drug it had both invented and licensed. A congressman was among the accusers. "Our military said there is no problem with [Lariam] because they developed it," said Rep. Bart Stupak, a Michigan Democrat. "The hardest thing to do is develop a drug and then admit there is a problem."

Lariam was developed in the 1970s by the Walter Reed Army Institute of Research after U.S. troops in Vietnam took the then-prevailing preventive medication, chloroquine, but still contracted malaria. UPI quoted a U.S. security expert in Afghanistan claiming that the Army was ignoring side effects he had seen first hand. The reason for the stonewalling, said Tony Deibler, deputy director of U.S. embassy security in Kabul and a security expert for 26 years with the U.S. diplomatic staff, was "If we admit this, we are opening ourselves up to a multi, multi, multi-billion dollar lawsuit. I love my country, but this is what drives that train." Deibler recalled a number of Lariam-related incidents including an hallucinating embassy Marine who imagined he was being attacked and shouted "Get back, they're coming!"

Experts say there are two preferable, effective and safer antimalarial drugs—doxycycline and Malarone. Some Marines in Kabul reportedly insisted on taking doxycycline because of its fewer side effects. But military doctors say Lariam provides better protection in some situations and has to be taken only weekly rather than daily, as other treatments require. Despite Lariam's neuropsychiatric side effect, the Pentagon says that's still their drug and they're sticking to it, although, under pressure, it has agreed to launch a study of its complications and has curtailed its use in Iraq. "The military is ignoring this drug's known side effects," says Gulf veterans' leader Steven Robinson.[4]

Doping up for America

A more cynical view is that any chemical reaction that could turn a passive trooper into a fierce if not dangerously psyched up

warrior could go a long ways toward reducing any troop reluctance to fight. What's the harm of a synthetic goose, the Pentagon argues, if it helps win the war or save a soldier's life? And if Lariam doesn't always quite fulfill what might be an unspoken Pentagon desire in using it—to medically induce aggressiveness (the creation of which, after all, is among the primary goals of basic training in order to overcome most human beings' natural aversion to killing other humans)—another military medical staple, amphetamine, does.

Anti-fatigue medications, or "Go pills" (typically Dexedrine, but uppers such as Cylert, Ritalin, methamphetamine and modafinil are being "investigated' for use), are doled out to military pilots to keep their eyes open during drawn-out duty or long-range missions. Despite what can be lasting adverse complications from the drug's use, pilots are fed go pills to fight fatigue and then given "no go pills"— sedatives such as Restoril or Ambien—to bring them down mentally so they can sleep (thereby posing a new set of side effects, such as sleep-aid hangovers and short-term amnesia). Pilots supposedly are not required to take Dexedrine, but a refusal to initial a signed informed consent form doesn't go over well. Abstainers become known as non-team players, and can be immediately grounded, with their careers sent into a tailspin. Pill popping is seen as integral to some missions as an oxygen mask or optical bombsight.

The Pentagon's Defense Advanced Research Projects Agency in fact envisions doping as a crucial strategic element of modern warfare and thinks it should be more widely used. "In short," the agency says in a planning document, "the capability to operate effectively, without sleep, is no less than a 21st Century revolution in military affairs that results in operational dominance across the whole range of potential U.S. military employments." And if there is to be a revolution, something more effective than the merely "linear, incremental and …limited" booster effect from drugs such as caffeine and speed are needed, the agency thinks. Something like, say, a racehorse stimulant. According to a memo obtained in 2002 by the *Christian Science Monitor* from the U.S. Special Operations Command, the pilot or solider of the future could expect to rely on "ergogenic substances" such as those used by athletes—non-pharmacological "foods" or nutritional supplements such as creatine, amino acids, whey supplements and Dimethyl glycine (DMG), a natural cellular product that can delay fatigue. Though generally considered harmless, DMG is given by some thoroughbred trainers to their horses to induce stamina and speed. Like any supplement, it can be dangerous to humans, posing risks through incorrect dosage and duration of use, by combining it with other substances, and through

its interaction with an individual's general state of health. There is also the risk, sports-medicine doctors caution, that such regimens create a gateway to using the harder stuff, such as muscle-boosting steroid drugs.

The Pentagon indeed has a host of off-the-wall concepts to keep a soldier's eyes peeled for the enemy, including blood doping (removing and infusing blood, then restoring it to the body) to help reset the brain's circadian rhythms that tell us when we're tired. Retired Rear Admiral Stephen Baker told the *Monitor* that, "Futurists say that if anything's going to happen in the ways of leaps in [military] technology, it'll be in the field of medicine."[5]

There are some obvious caveats to a war literally on drugs, among them the April, 2002 friendly fire bombing by a U.S. F-16 in Afghanistan that left four Canadian soldiers dead and eight others wounded. The Air Force accused the two pilots—Maj. Harry Schmidt and Maj. William Umbachof –of manslaughter and negligence. But at a 2003 hearing, the pilots—facing up to 64 years in prison if they were court martialed—said they had been issued amphetamines before the mission to stay awake and that the medicine likely impaired their judgments. The Air Force ultimately opted not to court martial the pilots and instead offered them administrative discipline, to the outrage of some Canadians.

Several other friendly fire fatalities in Gulf II, including the killing of civilians, have also been described as possible "speed kills" incidents. "A combat sortie that's seven or eight or nine hours is very challenging. You have highs and lows," said Gen. Daniel Leaf, a two-star general and former combat pilot who defended the Air Force use of amphetamines. "The American public should be very concerned if we were not providing every opportunity to counter the demonstrated fatal potential impact of fatigue."

The extent of such required drug use by the military is hard to measure, but the Pentagon is at work trying to make doping even more readily acceptable. A 2000 military study urged more defense leaders to "consider this type of intervention" as part of their war-management strategies, saying, "the appropriate use of anti-fatigue medications today is in the role of `performance maintenance.'" That may be true if the medicines are used sparingly and in low doses—USAF pilots during Desert Storm say five mgs of Dexedrine helped them maintain alertness without causing mood or perception changes. But as with all drugs, there are those nagging little drawbacks such as abuse and addiction. In Dexedrine's case, that can lead to anorexia, euphoria, hypertension, depression and other, even deadly, complications. Additionally, there's a risk of harmful interaction with

standard military medicines and vaccines as well as the recreational self-doping by troops who use weed, speed and sometimes narcotics for entertainment or coping with war (as Vietnam soldiers did with uppers and heroin, to their lasting damage).

Though doping of U.S. combat pilots is well known, amphetamine is also available to foot soldiers, at least unofficially. The Pentagon is not handing out uppers (other than caffeine) to ground troops as was done in Vietnam, requiring consent forms, but soldiers and veterans say that and other drugs are readily available through military medical sources and Iraq's black market. A reporter from the *Shanghai Star* visited one Iraqi open air market where a buyer could purchase amphetamines, Viagra, diazepam, valium, or high-dose painkillers for just 250 dinars—12 cents—each. (Memorably, at least one group of soldiers *arrived* in Iraq on drugs. In November 2003, 21 Iowa National Guard troops tested positive for drug use on the eve of their deployment but were sent overseas anyway, despite the Army's supposed zero tolerance policy. Those who tested positive included two methamphetamine users, two cocaine users and one soldier who tested positive for both meth and amphetamines).

Writer Ernesto Cienfuegos, who has researched wartime amphetamine use, points out that "The highly illegal and dangerous type of speed called methamphetamine [now being tested for possible doping use by the U.S. military] was originally synthesized by the Nazis and given to their Panzer Divisions and the Luftwaffe in order to give them more endurance in the battlefield; however, even the Nazis stopped this practice after noticing bizarre and unpredictable behavior in their soldiers." He thinks some speed-addicted U.S. soldiers are already returning from Afghanistan and Iraq, and suggests "the rash of murders of the four Army wives by returning Special Forces from Afghanistan at Fort Bragg may be explained by taking into account the damaging effects of the abuse and addiction to speed."[6] John Pike, a defense expert with GlobalSecurity.org, raises the same point. "It is quite obvious that someone needs to pose this [speed] question in the context of the business at Fort Bragg," he says.[7]

Psycho Tuesday, and a fear of Nazis

The Fort Bragg murders present the possibility of a confluence of military drugs and their after-effects. The Defense Department isn't conceding any connection between the killings and Lariam, amphetamines or any other drugs. But the military is aware how claims of irrational reactions to mefloquine in particular have grown in recent years. An internal safety report from Lariam's

manufacturer, for example, revealed the drug-maker and the FDA have been logging reports of violent behavior related to Lariam for nearly a decade. They include a woman who experienced "aggression, compulsion to [stab] attack boyfriend and to use obscenities," a man who destroyed a hotel room while in the grip of a paranoid "fear of Nazis" that led to him being imprisoned and hospitalized, and a reference to a patient who became psychotic "in U.S. military/ Somalia," where Lariam was first widely distributed by the military in the early 1990s. Though U.S. Army officials said they never saw any problems among U.S. soldiers taking Lariam in Somalia, Canadian Army soldiers there used to refer to the day of the week they took Lariam as Psycho Tuesday. Also, activists from Lariam Action USA, a drug information service, said they were contacted by 120 Somalia veterans who claimed they still had drug reactions, including 11 who considered or tried suicide. Since January 1997, thousands of Lariam users including Peace Corps volunteers and military personnel have reported significant side effects from the drug. Reactions are often severe, lasting for months and sometimes years.[8]

The military buys the denials of Lariam-maker Roche, which calls such reports anecdotal and insists there is no conclusive medical or scientific evidence the drug can cause violent or criminal behavior. Its product insert says that while Lariam may cause psychiatric symptoms in a number of patients, only "rare cases" of suicidal ideation and suicide have been reported. And any relation between those suicides and Lariam, Roche insists, are unconfirmed.

Like the anthrax vaccine, Lariam is another of the service's lesser-of-two-evils choices. The Pentagon maintains that, despite its risks, Lariam clearly saves more soldiers from illness or death than it may harm. But the military refuses to even give its troops the option to choose one of the safer alternatives, doxycycline and Malarone, which the Centers for Disease Control says are as effective as Lariam—and Malarone is safer to store, according to the FDA.

Among the lingering questions about Lariam is its possible relation to the high rate of troop suicides in Iraq—of which there were at least 23 victims in 2003-04, most using their own guns, others taking an impulsive exit: one took his life by biting into an unfortunately handy cake of C-4, the plastic explosive. There were also at least six cases of suicide by soldiers after they returned home. Many others have attempted suicide, suffering from the gamut of responses every soldier endures in war, a myriad of effects ranging from loneliness, revulsion and fear to shame and betrayal, in the case of a Stryker solider who tried to kill herself in the aftermath of a rape by fellow male soldiers in Kuwait in late 2003.

The military evacuated 1,000 troops (some reports say twice that) from Iraq for mental health problems in the first nine months of the war. Dr. William Winkenwerder, the assistant secretary of defense for health affairs, says the Army's suicide death rate is almost a third higher than peacetime rates, numbers so elevated that the Pentagon sent a team to assess the counseling and preventive measures used by the nine combat stress teams and divisional psychiatrists, psychologists and social workers in Iraq. The military also began an expanded counseling program on the home front in response to the Fort Bragg murder/suicides. Still, Winkenwerder told Pentagon reporters that "We don't see any trend there that tells us that there's more we might be doing."[9] Army Col. Thomas J. Burke, an Army mental health director, similarly denied suicides were epidemic in Iraq, saying the Army's suicide rate "is well within the range of variation" when compared to the suicide rates for the Army over the last decade. He cited such risk factors as depression, alcohol or drug abuse, problems with relationships and finances, and easy access to firearms. He also noted that 75 percent of Marines who had committed suicide had not seen a mental health care provider within the previous year—which seemed to say a lot about military mental-health practices and helping troops deal with the horror and moral conflicts of war.

If the 2003-04 Gulf toll reaches three dozen or more suicides, death by their own hands could account for anywhere from ten to 20 percent of American soldiers' non-combat fatalities in Iraq. Do prescribed drugs have *no* role in that? The military doesn't think so, and puts the blame squarely on stress. Martha Rudd, an Army spokeswoman, says "When war is actually going on, behavioral experts say the soldiers aren't as likely to commit suicide during that period. While they're fighting, they're not thinking about their problems. But once open hostilities cease and the peacekeeping part begins, for some soldiers that can be very rewarding work but for some [others] it can be very stressful." In general, war and peacetime, the Army and Navy average about 11 suicides per 100,000 personnel, the Air Force about 9.5 per 100,000 and the Marines about 12.6 per 100,000, according to military figures.[10] Referring to the Army rate, Rudd said, "I don't think the suicides we've had in Iraq are going to seriously skew the numbers."

That could be true, especially when the military doesn't count suicides that occur *after* Iraq, but may be related to it. A number of such cases have already been reported, including the strange incident of Spc. Kyle Edward Williams, who spent seven months in the Middle East as part of the 507th Maintenance Company with Jessica Lynch,

the soldier famously rescued from an Iraqi hospital who became the subject of a book and TV movie. Williams, 21, was found dead on a rural road outside San Diego on Oct. 2, 2003, where authorities believe he committed suicide with a .380 caliber handgun, one of seven firearms he had been carrying. There was no note. But officials believed he had murdered a young Arizona man, Noah P. Gamez, who allegedly had tried to steal an ice chest from Williams' Jeep while it was parked outside a Tucson hotel a day earlier. Six bullets were fired. Williams was reported to be simply passing through Arizona to his California home. Officials told the *Arizona Daily Star* that Williams did not have disciplinary or mental health problems before he left Fort Bliss, Texas, on leave. What happened outside the hotel? Was Williams so remorseful at murdering Gamez that he killed himself? Had he undergone a mental break? Was Lariam, speed or any other drug a factor? In the end, nobody had answers.

Similar questions were raised about the suicide of an embedded military reporter from *The Virginian-Pilot*, Dennis O'Brien, 35. He died in early 2004. His family and even his newspaper refused to release information that might have shed more light on the cause. Sig Christenson, vice president of the Military Reporters & Editors association, thought that was a mistake. "People should try to know why it happened," he said, "and if it had anything to do with the war."[11]

Domestic Violence, the other bitter pill

Ultimately, the Army classified the murders as well as the suicides at Fort Bragg as the result of domestic violence, with contributing factors. Among the conclusions:

> All of the soldiers were experiencing marital discord including recent or threatened separation. Two of the three soldiers who had deployed to Afghanistan were returned from the operational theater early to address their marital problems, however they did not access available resources for support. Marital discord at Fort Bragg was a prevalent theme among all focus groups. The lack of reimbursement for marital and domestic abuse treatment is an obstacle to assisting distressed military families.
>
> There also exists evidence through focus groups that high operational mission demands

requiring time away from home…may have been a contributing factor, including inadequate time for family re-integration, unpredictable work schedules, and problems with leave management. The possible link between intimate partner violence and deployment experiences is also supported by published literature.

The tragic events involving the two soldiers who returned early from deployment speaks to extant voids in soldiers' help seeking or access to needed support services when they most needed assistance. Programs do exist to support families, including ones that address pre/re-deployment transition challenges inherent in the disruption of marital/family continuity. However, the current variable resourcing, organizational stove-piping, and inconsistency in applying tailored programs and processes to facilitate the marital reintegration requirements for soldiers and their spouses in the context of operational missions is of significant concern.

The current model of delivering services for domestic violence, substance abuse, and behavioral health care prevention and treatment efforts as expressed in Army policy, structure, and resourcing is perceived by experienced active duty medical professionals and consumers as flawed and counterproductive thereby discouraging early identification and therapeutic engagement.[12]

Service marriages are as bumpy as those in civilian life— bliss followed by reality. But the risks of discord or violence are obviously steeper in a marriage where one partner may be armed and taught to kill, gone for long periods, and enmeshed in a militaristic system that sees weakness in those who can't "control" their spouses (not to mention the stress of sometimes poverty-level living conditions and trying to make a home in one of what officials concede are 120,000 "inadequate" military family housing units across the U.S.). "I think the nature of their training," said Sheriff Earl Butler of Cumberland County, N.C. (home to Fort Bragg) in the midst of the murder probes, "has a lot to do with these types of killings." Penny Flitcraft, the mother of Andrea Floyd, one of the slain wives, said of her late son-in-law, Brandon Floyd: "I truly in my heart believe that

his training was such that if you can't control it, you kill it." Add to that the little time allowed for a mental health break when returning from a war that required a tough mental state to stay alive and perhaps the taking of drugs with psychotic side effects, and you do not have a typical spouse coming home from the office at 5.[13]

Conversely, in this system, wives are supposed to minimize their responses to abuse, and understand they have to share their partner with the Army—that husbands are wed not only to them, but perhaps more so to their units. Especially in young marriages, the solider may spend more time eating, sleeping and socializing with his buddies than with his wife. An unidentified military wife who'd been abused, appearing on an Oprah Winfrey show discussing service marriages, said "I mean, they [the services] make it very clear to the solider 'We didn't issue you a wife, and we didn't issue you a family.'" Another said that when she tried to report abuse, an officer told her "Well, if you report it and have him arrested again…he's going to get kicked out and you'll be out on your butt, too, and your kids will have no support."

At Fort Lewis, on the other side of the country from Fort Bragg, a solider murdered his wife and child in 2003 then committed suicide by driving head-on into a semi-truck and trailer. The Army wouldn't say—and outside police investigators could not determine—whether Larium or other drugs were involved in the case of Thomas Robert Stroh Jr., 21, or whether he had undergone any vaccinations. The Army also wouldn't say if he was due to be deployed overseas. The murders were particularly heartbreaking because one victim was a 2-year-old child. As well, detectives from the civilian Pierce County Sheriffs Office tell me, the Army hadn't known that the bodies of Stroh's wife of four months, Brittany, 17, and the boy, Dylan, from another father, were buried under clothing in the closet of the Army housing unit when they began cleaning it out and carting off furniture. They assumed she had simply run off somewhere, and hadn't bothered to make a full search of the unit. A Fort Lewis spokesman said Stroh had been a good solider with a clean record and was due for a promotion board hearing. But in fact, as detectives learned, Stroh was about to be confined to his barracks for having been abusive to his wife and drunk on duty. The case remains another military mystery.

With their records already badly blemished by the Taillhook and Air Force Academy scandals, among others, in which female service members were physically and sexually assaulted, the services say they are doing their best to prevent DV on their bases. The Army, for one, initiated a number of new programs following the Bragg murders. Among them were medical and psychological tests to detect

health complications. The service also set up new classes for dealing with anger and stress. The overwhelming majority of men and women in leadership who are appalled by violence within the military are striving to tame the abuse.

Retired Col. David Hackworth, the scrappy author and commentator, says one obvious contributor to DV is the sometimes-instant reunion of a battlefield soldier with his family today. There "has to be some kind of decompression," says Hackworth. "We had that in World War II. When I came home, it was by ship, lost in a replacement depot, on a train. It was three months from the time I left the front line until I got home. Same in Korea. And I was with my buddies all along. If I had problems, they brought me down. We talked our way through it." Today, you can be on a killing field and, 24 hours later, be greeting someone you haven't seen for a year.[14]

Overwhelmingly, military couples work out these unique problems and celebrate long marriages together, studies indicate, while a lesser number fail. That point was made in a candid 2003 Associated Press story that chronicled the homecoming of several soldiers of A Company, 3rd Battalion, 7th Infantry Regiment. It reported on the instant decompression required by a unit that left Iraq, crossing into Kuwait (some kissing the ground), hopping onto a commercial airliner, cheering when they entered U.S. airspace, and reuniting back home with families. One soldier, Spc. Choice Kinchen of Friendswood, Texas, wasn't sure if his wife would be there. They'd been having problems. She showed up, and they retired to a posh hotel to try to patch up their differences. They had a memorable night. The next day Kinchen learned she was seeing another man. "I don't even know where to find her to get her to sign the papers," he said later. "Everything was great that first night...now it's over for good." He went to a tattoo parlor and, across the original "forever hers" written on his chest, he had the artist cover it with one large bald eagle, spreading its wings for flight.

Rape, another military 'drug'

In the increasingly coed military, relationship trauma extends to the barracks too, of course. In one of the Department of Defense's most important military sex-and-violence studies, in 2003, researchers found that out of 556 women interviewed, *30 percent* were either raped or victims of an attempted rape while in the military. In 2004, an Air Force study of personnel in the Pacific turned up 92 accusations of rape between 2001 and 2003. Similarly, female soldiers stationed in the Gulf, along with others troops returning home, began to reveal

past assaults by male soldiers. The Department of Defense in February 2004 said it had logged 106 reports of sexual assaults of troops deployed in the Middle East over the previous 14 months. At least three dozen sought sexual-trauma counseling and other assistance. Victims claim they received poor medical treatment, and some said they were threatened with punishment after reporting the assaults. A Fort Lewis solider who said she was raped in Iraq also later attempted to commit suicide. Her mother, Barbara Wharton, told the Senate Armed Services subcommittee in 2004 that her daughter awoke stripped, bound and gagged, and that doctors had confirmed she'd been raped.[15] Like some other victims, she continued to serve with or near the soldier she accused of attacking her—who, in such instances, often suffer few repercussions. According to a *Denver Post* study, twice as many accused Army sex offenders are given administrative punishment as are given court-martials. Nearly 5,000 accused sex offenders in the military, including rapists, have avoided prosecution and prison time since 1992, according to Army records. "The military system is like a get-out-of-jail-free card," says Jennifer Bier, a Colorado Springs therapist who counseled victims. During congressional hearings in 1991, witnesses estimated that up to 200,000 women had been sexually assaulted by servicemen.[16]

In Seattle, KING-TV interviewed 52-year-old Kathleen and 22-year-old Kori, two women who had never met but shared the bond of having both been raped shortly after joining the military two decades apart. "About a month after my 21st birthday I was raped by the Army chaplain who I worked with on the surgical ward," said Kathleen. Said Kori, referring to her fellow sailors: "They lured me into a room … and they raped me. And they were just, like they do it all the time." Both suffer from PTSD, and say they have little respect for the VA system, which encourages rape victims to apply for disability benefits but makes it difficult to do so. "Many of these women need to be in treatment for years. On various medications, anti-depressants," said Trauma specialist Bridget Cantrell, who counsels victims of military sexual assault and says many of them are repeatedly turned down for benefits, as were Kathleen and Kori.[17]

The Pentagon thinks the sexual attitude of the modern military male is successfully evolving. But who is setting the example? At Fort Campbell, Kentucky (which incidentally lost more than 60 soldiers in Iraq by early 2004, the most of any single U.S. military installation), base commanders were accused of failing to take action when soldiers repeatedly threatened to kill their wives or girlfriends, as three of them in fact later did. Yet fort commander, Maj. General Robert Clark, said "that even looking back I wouldn't have done

anything differently." That indifference didn't surprise too many Clark watchers. He was commanding general at the base in 1999 when Pfc. Barry Winchell, 21, was beaten to death with a baseball bat by a fellow soldier who believed Winchell was gay. Clark issued no disapproving statements and refused to meet with Winchell's parents. Nor did he initiate any new training or policy endeavors. Nonetheless, President Bush nominated Clark for his third star in 2002 and asked that he be promoted to commanding general of the Fifth United States Army at Fort Sam Houston, Texas.[18]

The military has a big investment in its soldiers, especially elite units like Special Forces, says University of North Carolina social anthropologist Catherine Lutz. "That makes them very reluctant to take any action, knowing that the military would have to shrink quite a bit if they got rid of all the known abusers."

Chapter Seven

The Fortunes of War Production

User-deadly weapons

Guns have been blowing up in American soldiers' faces since the Revolution. But to the military, that was simply a hazard of the job. And troops can't say they weren't warned. As Gen. Dwight D. Eisenhower said: "In the councils of government, we must guard against the acquisition of unwarranted influence, whether sought or unsought, by the military-industrial complex. The potential for the disastrous rise of misplaced power exists and will persist."[1]

The MIC produces fighter planes that fall to earth, cannons that explode in the turret, and bombs that detonate in the hand. Pick a war and you'll find a faulty weapon, sometimes the same one. Soldiers in Vietnam often discarded their jammed M-16s in favor of the AK-47s they took from the bodies of the North Vietnamese. In Iraq, soldiers, including Jessica Lynch, complained their M-16s and M-4s jammed, too—and some were favoring the AK-47s taken from dead Iraqis.

In a hurried-up war, caution gets pushed aside. Just months before they were to enter the battle in Iraq, the Army's new state-of the-art, 19-ton Stryker troop carriers were found to have faulty armor plating that could leave troops vulnerable to heavy artillery, caused by a General Dynamics subcontractor that didn't follow specifications. There was also concern about the Stryker's road ability and the lack of driver training. Just a week after landing in Iraq, a Stryker vehicle rolled over into a canal near Baghdad, killing three soldiers.

> # War—huh—what is it good for? Business!

The Harrier attack jet: a "widow maker"

Often, it's outside agencies like watchdog organizations, the independent GAO and the media—not the Pentagon—that inform

troops and the public about flawed weapons. A 2002 report by *The Los Angeles Times* described the Marines' Harrier attack jet, with its vertical takeoff and landing capabilities, as a widow maker and the most dangerous plane in the U.S. military. Supplied initially by Hawker Siddeley Aviation Ltd. and British Aerospace Inc., both of the UK, and then by McDonnell Douglas, the Harrier has been involved in 143 major non-combat accidents during its 31 years of service, killing 45 Marines and destroying a third of the jump jet fleet. The toll had previously been overlooked by the public and media because the Harrier tends to kill pilots one at a time, the *Times* found. In contrast, the V-22 Osprey, a problem-plagued troop transport plane that was making headlines, has killed as many as 19 Marines in a single crash. Ironically, the Harrier's advertised ability to take off vertically has never been used in combat but only in demonstrations and, most notably, the 1994 film *True Lies*, when actor-turned-governor Arnold Schwarzenegger commandeered a Harrier to save Miami from a terrorist attack. The *Times* reported that in the 1991 Gulf War, the jet's thrust-producing nozzles that allow the Harrier to ascend and level turned the jet into a magnet for heat-seeking missiles. Five Harriers were shot down and two pilots died.

"The officers who died in it [over 31 years] ranked among America's most accomplished aviators," the paper reported. "They typically finished near the top of their flight school classes, often aspiring to become squadron commanders, generals or astronauts. Many of their deaths were preventable. The Marines have known for years they were flying a plane bedeviled by mechanical problems and maintenance mistakes. Yet they moved haltingly to fix known shortcomings that threatened pilots' lives."[2]

In 2003 *Newsday* reported that "hundreds and possibly thousands" of Iraqi civilians had been killed or maimed by outdated and defective U.S. cluster weapons that lack the safety features that other countries had added to their weapons. Soldiers in the battlefield also faced dangers from the unexploded ordnance. The weapons—bombs, rockets and artillery shells that open up like clams—disperse small grenades that are designed to explode in clusters, but failed to do so about 15 percent of the time, remaining on the battlefields where they were picked up by civilians.[3]

Defense officials said they are planning to equip the grenades with secondary fuses that would blow up or neutralize them, but the U.S. won't fully achieve that goal until 2005.

Not that any of this was news to the Pentagon. The clusters were first broadly used in the 1991 Gulf War where a high dud rate left the battlefields littered with live sub-munitions. A subsequent

General Accounting Office review found that 25 U.S. military personnel were killed and many others injured by the friendly fire. An estimated 1,200 Kuwaitis and 400 Iraqis were also killed and 2,500 injured by grenades in the first two years after the war was over.

The lingering question is whether there are necessary safeguards and incentives in defense contractor partnerships with the government, and whether the solider and the taxpayer get what has been promised. The dark world of defense contracting is the legendary birthplace of the $437 hammer, the $640 toilet seat and breathtaking cost overruns—the F-22 fighter has been on the drawing boards since 1981, and is not yet airworthy although its costs soared from $35 million a copy to $200 million, four times the price of the F-15 it is to replace. The Air Force now promises the new Raptor will become operational "early this century".

The Boeing Chinook's non-conforming gears

Of course, no one intentionally uses or makes faulty weapons that can cause harm to those who use them. Right? Brett Roby, for one, wishes he could say that's not true. After years of trying, he finally forced the government to act against the Boeing Co. for producing a faulty helicopter. Boeing is the nation's second largest defense contractor ($17.3 billion in contracts in 2003), trailing Lockheed Martin ($21.9 billion). As it continues to lose passenger-jet business to Airbus and grow its now predominant defense operations, it is determined to become the military's No. 1 supplier. But in racing to the top, Roby said, Boeing knowingly supplied faulty equipment to the military, resulting in troop deaths.

And federal prosecutors agreed with him.

Roby felt he had to get the Boeing choppers down from the sky before they fell out of it and killed someone—else. His passion to correct a fatal flaw drove the 44-year-old Ohio engineer to do something the government wouldn't do: under the federal Whistle-blower's Act, which allows an accuser to right a government wrong and share in any settlement that results, he took Boeing to federal court. His citizen actions led to the partial grounding of Boeing's Chinook chopper fleet while mechanics painstakingly inspected each of the 800 troop transports for cracked rotor parts that Roby first brought to the military's attention in 1993.

Laid off in 1994 by a Boeing subcontractor because of his whistle blowing, Roby says he made his point and then some in 2000. He earned $10.5 million for himself and $43.5 million for taxpayers in a record $61.5 million settlement with Boeing, which was accused of trying to hide the flawed parts.

Boeing insisted it settled to avoid further litigation—and not because the company wanted to avoid a court ruling on whether Boeing knowingly approved the use of defective parts on Army helicopters for 10 years and abetted the deaths of five U.S. Army soldiers.

"Right," one of Roby's private attorneys, Frederick Morgan of Cincinnati, told me, "it's just coincidence" that Boeing decided to suddenly settle, after five years of legal wrangling, rather than face an Ohio judge in the following month when a public trial was to begin.

Was Boeing so corporately callous that it hid production flaws even at the risk of soldiers' lives? That was the basic legal posit of Roby, who now lives in Florida and suffers from an unrelated life-threatening spinal disease. A partial answer for him comes from Justice Department official David Ogden, who says the alleged fraud "demonstrates the tragic consequences that can occur when faulty parts are sold to the Defense Department. The lives of our service members, not only dollars, are at stake."[4]

The out-of-court settlement concluded what began as a *David v. Goliath* clash. Roby's attorneys took 400 depositions and engaged Boeing corporate lawyers in endless motion-to-motion combat that left another Roby attorney, Jim Helmer, reeling over "one of the hardest-fought cases we have seen. Boeing was represented by dozens of lawyers who did everything they could to defeat us."

The case involved two False Claims Act lawsuits: one filed by Roby alone in 1995 under a law that dates back to Abraham Lincoln and allows citizens to sue for government fraud on behalf of all taxpayers, the other filed by the U.S. government in 1997 after it joined Roby to charge Boeing with civil fraud. The suits claimed Boeing knowingly supplied cracked gears made of faulty material for the Army's CH-47D Chinook helicopters in the 1980s and 1990s

In at least one instance, it was a deadly error, prosecutors said. According to an amended claim filed just before the settlement, the U.S. alleged that Boeing in 1985 knowingly installed faulty parts on a Chinook that later crashed in the midst of the undeclared war against the Sandinista government of Nicaragua. Exploding in flames December 8, 1988, while airborne, the transport fell onto a hillside near La Ceiba, Honduras, killing five soldiers on board.

An investigation determined the cause was Boeing's faulty parts, said prosecutors, asserting Boeing delivered the chopper to the Army "knowing it contained nonconforming transmission gears."

At least two other (non-fatal) military crashes were also cited in the suits. Although Chinook crashes during the Gulf War and training exercises left 15 soldiers and two Boeing engineers dead,

none were directly linked to faulty parts. The D model Chinook can carry 33 soldiers and has been around since 1982.

Roby claimed Boeing was aware of the faulty Chinook gears for at least five years; the U.S. later alleged the company had known for 10 years. The gears were manufactured by two Boeing subcontractors, Speco Corp. of Ohio where Roby worked and Litton Precision Gear of Illinois, later bought outright by Boeing.

A quality control engineer, Roby says he discovered the flaws in 1993 following a series of crashes that included the 1988 Honduras explosion of a Chinook with Boeing/Litton parts and 1991 and 1993 crashes in Saudi Arabia and Fort Meade, Maryland (Chinooks with Boeing/Speco parts), in which two people were injured. The causes were tracked to faulty transmission gears crucial to setting the chopper's tandem rotors spinning.

Roby worried more choppers faced similar fates. But the company and Boeing, he says, hushed up the imperfections by concealing documents and threatening Speco with retaliation if it didn't keep quiet. Boeing denied it had advance knowledge of the cracked gears. But Justice Department lawyers said they had documented proof the company knew the parts were bad before approving them for flight.

In a statement Boeing says it "continues to deny the allegations in these cases. Boeing believes that it acted not only legally but also ethically and responsibly in addressing the issues covered by this litigation." The company emphasizes that the parts company was a subcontractor and decisions were being made locally. It settled the lawsuit, Boeing says, "in the best interests of both Boeing and the Army."[5]

"They did the right thing in settling the suit—with their largest customer of course [the U.S. government]," attorney Morgan notes wryly. But "Boeing is, let's just say, no white knight."

In 2003, Boeing appealed some leftover issues from the whistleblower case to the United States Supreme Court. Even though it had settled with Roby and taxpayers who claimed the company acted recklessly, Boeing challenged a payment of $19 million it still owed the government. It claimed it was protected by its contract from having to pay for defects in its own helicopter, and that taxpayers should pay its bill. The company lost.

Boeing says, and the Pentagon agrees, that military systems are hardly infallible, especially newer ones. They're complicated, ever advancing weapons "platforms" as some are called, and overwhelmingly this stuff works. The F/A-18 Hornet, a newer version of the McDonnell Douglas attack jet that dates back to 1983,

was used extensively and successfully by American and British pilots to hit enemy targets in Afghanistan and Iraq (Boeing inherited much of its modern war hardware production from McDonnell in a 1997 buyout). Also active in the Gulf region were Boeing's B-1B Lancer (built with Northrop Grumman), the B-52 Stratofortress, Apache helicopters, Chinook troop transports, Avenger air-defense system, refueling tankers, and SLAM and Cruise missiles, all made by Boeing. The company also manufactures tank and aircraft cannons up to 50 millimeters. Several Boeing-made C-17 transports airlifted equipment and troops to the Gulf region, while others dropped food and supplies in a humanitarian airlift to refugees.[6]

Founded in 1916 by ex-lumberman William E. Boeing of Seattle, the company has preferred to be known more as a builder of commercial jetliners than, say, a war profiteer. But the Lazy B, as some Seattleites still call it, has a rich military history dating back to at least 1919, when it made the MB-3 fighter for the U.S. Army Air Service. "Considering the company's long-standing reputation for building large aircraft," says aircraft historian Robert Guttman, "it is often forgotten that Boeing was ever in the fighter business."[7] Among its innovations was the P-26 Peashooter, a lightweight fighter less than 24 feet long that became the forerunner of WWII fighters. It was the B-17 and B-29 bombers that brought Boeing war fame in the 1940s and 1950s. But with the acquisition of McDonnell, Boeing became a diverse military empire of new helicopter, missile, and weaponry production.

Today, Boeing maintains major defense plants and research operations in Pennsylvania, Arizona, Missouri, Washington and California, among others. Boeing is also the United States' major supplier of military weapons to allied countries and its potential new military programs include the ground missile-defense system, Star Wars II, with a price tag of more than $200 billion. War or the threat of it has its rewards.

One of Boeing's vice presidents, Patrick Gill, told me he resented any implication that the corporation ever knowingly broke the law. "If you're talking about the ethics of Boeing," Gill says, "the Boeing Company by policy and action adheres to the absolute highest standards. Even things that would not have been considered a violation perhaps in other companies we disclose because we are under the microscope [of oversight agencies]. We stay under the boundaries even if that means walking away and losing a contract. *That's* Boeing."

Forgive and forget

In 1990 there were almost 50 major defense contractors.

Today, mergers and closings have winnowed that to five, severely limiting the Pentagon's options.

A contractor's sins—overcharges and eternal delays—are quickly forgiven and forgotten when only that supplier can fill the military's needs. Ultimately, troop lives depend on less accountable suppliers to provide reliable products.

At the same time, defense spending is rising—from about $366 billion in 2001 to a White House-requested $421 billion for 2005. That doesn't include the billions spent to fight in Iraq and Afghanistan that are tucked into supplemental budget requests. Nor does it include more than $10 billion Bush has requested to continue research and development of Star Wars II, the missile defense system that almost no one but the generals and the contractors think is workable or necessary in this brave new world of terrorists with purse-sized bombs.

The waste is compounded by a purely political process: the never-ending quest for pork in our times. In all but a few states, the Pentagon's spending accounts for the majority of federal dollars doled out. The biggest recent giveaway was the proposal by Rep. Norm Dicks and fellow Washington state Democrat Sen. Patty Murray, in 2003. At the bidding of Boeing, they pushed a plan for the Air Force to lease, rather than buy, 100 or more K-767-A in-flight refueling tankers from Boeing, whose commercial 767 production line had slowed badly after 9/11. Dicks first goosed the deal with a post-9/11 plea to President Bush, using the tragedy as a cause to aid Boeing. The terror attacks and resulting airline crisis "had a dramatically negative impact on the nation's sole commercial airframe manufacturer, the Boeing Co.," he wrote in an Oct. 4, 2001, letter to Bush, later released during congressional hearings. "At this time, we have a unique opportunity to address the problems affecting Boeing while also meeting urgent requirements to modernize Air Force and Navy aircraft."

The lease deal that evolved from that letter, according to the Congressional Budget Office, would cause the Air Force to pay Boeing an extra $1.5 billion to $2 billion. Each plane would cost roughly $161 million rather than the $131 million to purchase it outright.[8] GOP Sen. John McCain called it what it was, skyway robbery, angrily charging "America's security and fiduciary responsibilities are apparently being subordinated to what's in the best interest of the Boeing Company." The resulting stink finally produced a scaled-down deal in which 20 of the planes will be leased, and up to 80 bought outright, although by 2004 even that deal was being reconsidered. For sure, taxpayers got taken for an expensive ride. There is also an

ongoing criminal investigation involving a former Pentagon official who is suspected of providing Boeing with insider information and who later went to work for Boeing. The scandal led to a major shakeup at Boeing in 2003, including the resignation of chairman Phil Condit. In 2004, Air Force Secretary James G. Roche withdrew his name as Bush's nominee to become the powerful Secretary of the Army, after his appointment stalled in the Senate because of the Boeing scandal.

The Project on Government Oversight (POGO), a taxpayer/ military watchdog group in D.C., selected what it called Five Weapons That Bilk The Taxpayer and which, in some cases, unnecessarily put military lives at risk. The five, totaling $125 billion in wasted spending, are:

- The V-22 Osprey, $26 billion (grounded after a series of crashes that killed 30 Marines);

- The F-22, $42 billion (to be the most expensive fighter ever built with little increase in capacity over F-15's and F-16's);

- The Crusader Howitzer, $9 billion (the Crusader is nearly twice the weight of the system that it replaces—too much for the military's largest transport plane to lift without waiving flight rules);

- The Comanche chopper, $48 billion (now in its sixth program restructuring, the Comanche has become one of the General Accounting Office's poster children for bad weapons development, its many problems include being too heavy to exit hostile battle environments);

- The B-1 bomber fleet: $130 million if one-third of fleet is retired (the B-1 is so plagued with spare parts shortages that much of the fleet is grounded anyway).[9]

In April 2003, the Marines performed a review of how its equipment and weapons were functioning after a month of war in the dust and sand of Iraq. Many worked fine. And no one expected perfection.

Nor did they get it. A few excerpts from the field survey:

• Mine Detectors: These received poor reviews. They were labeled "flimsy" and "inaccurate."

• Line Charge Trailers: This equipment is "flimsy" and "unreliable." On rough terrain the trailer can be towed barely over 5 mph before breaking.

• M249 Squad Automatic Weapon: The SAW's are worn out and apparently beyond repair. They have far exceeded their service life. Many Marines are duct taping and zip tying the weapons together.

• M9 Pistol Magazines: The magazines are not working properly. The springs are extremely weak and the follower does not move forward when rounds are removed. If the magazine is in the weapon, malfunctions result. If out of the weapon, remaining rounds fall out of the magazine.

• M203 Load Bearing: Grenade bearing vests don't hold enough ammunition. Rounds don't fit into many of the pockets, so grenadiers aren't able to carry as many rounds as the vest is designed to carry. They aren't able to fit rounds into all of the pouches. Grenadiers are coming up with several different "band-aid" solutions to carry enough ammunition, most of which are not working.

• Weapon Take-Down Pins: Many weapons, M16 and M249 in particular, were having problems with takedown pins breaking and/or falling completely out of the weapons. Marines held weapons together with duct tape and/or zip ties.

• Goggles: The current goggles used by Marines received very poor feedback. They were too large, did not seal properly, and the lenses often popped out of the frame.

• MOLLE Gear [modular, lightweight backpack]: Marines uniformly and strongly DISLIKED this item. The pack was considered too loose from the frame,

allowing it to move too much while the Marines were hiking...The plastic frame was labeled "cheap" and broke on numerous occasions.

• MPAT 120mm tank round: Had problems with rounds sticking in gun tube after 1 hour of battle carry. Rounds had to be fired off or manually extracted. In one instance, a gun tube was inoperable due to a stuck round. The warhead of that round is still in the gun tube as the report this written.[10]

Most weapons fared better, especially, in at least one memorable instance, the Kevlar Helmet, which the report says got "Very positive feedback... During urban fighting in Iraq, a Marine Corporal was struck in the front of his helmet by a 7.62 x 39mm round. The Kevlar PASGT helmet absorbed the impact of the round with no injury to the Marine."

The Pentagon insists it won't push its equipment beyond the bounds of safety, that it rides herd on outlaw contracting, and, importantly, hits hard when faulty weapons are produced. That last claims seems supported in figures compiled by POGO, which keeps a database on defense contractor violations and fines. In 2003, General Electric ranked first on the list with 87 instances of misconduct and alleged misconduct and payouts of $990 million in the last decade. Lockheed was second with 84 instances and payouts of $426 million. Boeing was third with 50 instances and $378 million. Adding up the fines, penalties, and costs of restitution or settlement, POGO analyst Eric Miller told me the top 10 federal contractors racked up 280 instances of real or alleged misconduct and paid out $1.97 billion dollars.

What Miller didn't have was a guess at how many billions the contractors made in the process of breaking laws. It's a cost-effective way of doing business: the feds fine you millions for cheating to win a contract that brings in billions.

Even when the Pentagon says it is coming down hard, it may be kidding us. In a 2003 case of corporate espionage among fellow defense contractors, for example, Boeing was hit with big penalties after its engineers were found in possession of 25,000 pages of stolen military-satellite documents from rival Lockheed Martin. The documents were presumed to have given Boeing an edge on winning a nearly $2 billion satellite-launch contract in 1998. Lockheed later sued Boeing, claiming its thievery amounted to

racketeering. Boeing took out newspaper ads to defend its integrity.

Of course, it was only a few years earlier that Lockheed was defending its own corporate ethics, or lack thereof. In April 2000, federal prosecutors charged the company with 30 violations of the arms export control act. Lockheed subsequently later paid the U.S. government $13 million to settle claims that it had passed secret missile technology to China.

The Air Force, following an investigation into Boeing's heist of Lockheed papers, reassigned much of Boeing's launch work to Lockheed and indefinitely suspended three Boeing space subsidiaries from competing for new defense contracts, costing the company what could be a record $1 billion in lost revenue.

That was a big hit. Headlines around the world reported Boeing's comeuppance, and huge potential penalty.

What wasn't reported with any intensity were the comments of Air Force Undersecretary Peter Teets, a former Lockheed CEO: "If they [Boeing] immediately start to put in place corrective actions—training of employees, employee hot line—and drive up the integrity down through the organization of these units, I would think that their suspension could be lifted" in 60 to 90 days. That quick turn-around could cut the advertised penalty.[11]

What the Air Force did a week later also was mostly unreported. It quietly awarded Boeing a contract to develop new airborne warning systems. For $1 billion.

The business of war is...

War, if good for anything, is great for business. It means more than just the production of weapons and equipment—sometimes faulty and overpriced. It promises billions in government revenues for increasingly privatized military training, recruiting, laundry and even KP services. That in turn is good for Congress and the White House. A war economy—including the $87 billion being doled out to rebuild Iraq—generates the grateful political donations from corporate America that puts money in the pockets of those now in office. For example, Vice President Dick Cheney's former corporation Kellog, Brown & Root (KBR), a division of Halliburton Companies, has been providing Army logistic services since the 1990s. Cheney headed the company from 1995 to 1999, arriving as the former Secretary of Defense under the elder George Bush and leaving to join the younger Bush's campaign, taking a $34 million severance package with him. Cheney headed the Pentagon in 1992 when the Army paid Halliburton almost $9 million to study how more military duties and services

could be privatized. His Dallas Fortune 500 company reaped some of the benefits after Cheney became CEO, with the Pentagon paying KBR $2.2 billion for logistic support services in Kosovo.

According to a General Accounting Office report, some of those payments were overcharges. KBR overstaffed its operations, ordered such an excessive amount of furniture that it cost almost $400,000 just to process the order, and supplied twice the electricity needed by the Army. In actuality, many KBR employees often had nothing to do, said the GAO. But their offices were cleaned four times a day.[12]

That kind of underperformance didn't stop KBR from winning a new contract for Iraq in 2003. The pact to rebuild Saddam's destroyed state infrastructure, awarded by the Pentagon without a competitive bid, is worth $7 billion. Specifics of this and other multi-billion-dollar contracts were withheld by the Pentagon. Congress partnered in the cover-up, stripping the $87 billion Iraqi funding bill of provisions requiring GAO oversight and competitive bidding. Senate leaders also rejected language offered by Vermont Democratic Sen. Patrick Leahy to penalize war profiteers for defrauding American taxpayers.

Once he leaves the White House, Cheney is most likely to return to Halliburton. He will have left his mark, if not politically, then economically. The policies he and his running mate pushed will likely have earned the company a $500 million profit from taxpayers on the Iraq contract alone. Though Cheney claimed on "Meet the Press" that he'd "severed all my ties with the company, gotten rid of all my financial interest" in Halliburton, Sen. Frank Lautenberg, a New Jersey Democrat, contends that's not true. By Lautenberg's calculations, Cheney continues to rake in hundreds of thousands of dollars in deferred salary and retains $433,333 in unexercised stock options. If he were to exercise those options before 2008, he could make another $5.4 million.[13]

War rewards in other ways, to other politicians. After Congress finalized the Defense Department's $401 billion budget in late 2003, the Center for Responsive Politics called it "welcome news for the country's top defense contractors, who diligently re-enacted their annual battle for increased military spending." The defense industry's arsenal included a massive lobbying effort and an onslaught of glossy, inside-the-Beltway ads. And a few campaign contributions. The CRP said defense companies gave candidates and leadership PACs more than $3.5 million in the first six months of the year. Because appropriations bills are first drafted in the House, the industry directed much of its money to members of the House Defense

Appropriations Subcommittee and the House Armed Service Committee, two panels with considerable influence over the defense budget, according to CRP's Sheryl Fred. Among the top recipients: Defense Appropriations Subcommittee Chair Jerry Lewis (R-Calif.) $44,500 and ranking member John Murtha (D-Pa.) $68,000. On the House Armed Services Committee, the defense sector gave $98,600 to Chairman Duncan Hunter (R-Calif.) and $48,500 to ranking member Ike Skelton (D-Mo.). Lockheed Martin, Boeing, Northrop Grumman, Raytheon, General Dynamics and United Technologies, the Defense Department's six largest contractors, spent close to $19 million on lobbying.[14]

With similar political help, U.S. manufacturers have helped us become arms supplier to the world. In 2002, the nation's arms makers exported $54 billion in weapons and defense services to Afghanistan, Zambia, and every country in between.[15] There are 35,000 American manufacturers licensed to export defensive and lethal merchandise. About $3 billion of the defense equipment went to officially-disarmed Japan, which seems to be preparing for its first ground war since WWII, ordering $1.5 million in night vision goggles, $3 million in handguns, $15 million in rocket launchers, and $12 million in military vehicles and parts from U.S. makers. After WWII, Japan's army and navy were dissolved and a new constitution renounced war; a subsequent constitutional interpretation allowed for a self-defense buildup, and Japan now ranks second only to the U.S. in defense spending—$46.7 billion in 2002. Says University of Hawaii history instructor Jonathan Dresner, "Japan today could easily produce chemical, biological and nuclear weapons in large quantities in short order, but it has not done so. The Japanese population is deeply opposed to such weapons, owing to its unique experience as the targets of the only nuclear weapons ever used in war and to its suffering from conventional bombing. As a result, Japanese politicians have found alternative methods of defense through alliance and diplomacy."[16]

Japan may be feeling increasingly threatened by its neighbors, some of whom are also armed by the U.S. While American firms are prohibited by law from supplying arms to North Korea or China, for example, there's not a nation in existence that can't obtain U.S. war products clandestinely from international dealers. We also directly supply China with dual-use equipment and technology, such as missile spare parts and space tools, that are in fact officially classified by the State Department as defense articles and services.

In March, 2003, *LA Weekly* reported that U.S. and British troops entering Iraq should expect to face weapons systems largely developed and supplied by American as well as European, Russian

and Chinese companies. A Berlin newspaper, *Die Tageszeitung*t, named 24 American-based corporations and 50 American subsidiaries of foreign corporations including Rockwell, Hewlett-Packard, and Bechtel as directly and indirectly contributing to Iraq's war effort.[17] The U.S. has also transferred technology that officials think was converted to military use, such as metal fabrication equipment McDonnell Douglas once used to make its B-1 bombers and sold to China for supposedly prosaic purposes—but which ended up in a Chinese missile factory.[18]

According to Howard Teicher, a member of Ronald Reagan's National Security Council, CIA Director Bill Casey was instrumental in seeing Iraq was well armed in its war against Iran, helping steer third-country arms to Iraq and providing intelligence and billions of dollars in sales credits to buy such arms as American-made bombs supplied by Saudi Arabia. Teicher, in a sworn 1995 affidavit, said, "The United States also provided strategic operational advice to the Iraqis to better use their assets in combat. For example, in 1986, President Reagan sent a secret message to Saddam Hussein telling him that Iraq should step up its air war and bombing of Iran. This message was delivered by Vice President Bush who communicated it to Egyptian President Mubarak, who in turn passed the message to Saddam Hussein."[19] In 2003, the National Security Archive at George Washington University released a series of declassified U.S. documents it obtained detailing the government's embrace of Saddam in the early 1980's. While Saddam was using chemical weapons on Iranians and his own people, the U.S. sent then-envoy Don Rumsfeld to shake Saddam's hand as the U.S. renewed its ties and made its devilish pact with Iraq to ensure the defeat of Iran.

This free flow of arms, advice and technology shouldn't be too surprising. The State Department gets its overseas sales counsel from a government panel called the Defense Trade Advisory Group, headed by a private U.S. consultant on international trade and financing. DTAG's membership includes officials from both the military and from Lockheed, Boeing, Raytheon, General Dynamics and other major exporters. The group is currently lobbying to obtain more federal funding to finance arms sales efforts in addition to the $15 billion U.S. taxpayers pony up under the Defense Export Loan Guarantee program to aid foreign buyers.[20]

Ultimately, the heady rush to profit from war promotes war. It's one thing to manufacture equipment for defense, quite another to huckster it to adversaries who are thus increasingly equipped and likely to fight, destroying their armor in battle and then in need of more. Most importantly, it increases the chance that soldiers and

civilians will be exposed to battle and its consequences, with many of them wounded and killed, while others suffer long-term effects.

It's not necessary to imagine all of this—weaponry that breaks or is marketed for profit—as an evil plot to start wars in the name of greed. No plotting is required. This is in part how government and the war industry naturally function today. The question is why we aren't asking for our money, if not our Constitution, back?

The Unkindest Cuts: Government Giveth and Taketh Away

Yesterday's promises

It should be remembered that late author and Merry Prankster Ken Kesey was inspired to write *One Flew Over The Cuckoo's Nest*— his mad novel of overmedicated patients and abusive psychiatric-hospital practices—based on his experiences working in a VA medical facility in California. Step out of line, as Kesey's rebellious Korean War vet Randal McMurphy did, and you got strapped down and gurneyed off to Lobotomy. The message from officialdom was to go along and believe what you were told. Dr. Dean Brooks, who was superintendent at Oregon State Hospital where the movie version of *Cuckoo's Nest* was filmed—and who played ward doctor to Jack Nicholson's McMurphy in the film—says that besides medical incompetence, the weakest links in any health system are the bean counters and politicians far removed from patient needs. They cut services and close facilities, Brooks told me, without really asking, "What will happen? Where would these people go?"

Benefits shrink in tandem with fading memories. Did we promise that? No, that was the last administration.

I thought about that after watching George Bush speak on TV one day in March 2003. The war on Iraq was ten days in, and Bush had summoned leaders from the nation's veterans' organizations to attend his live-TV speech praising America's latest military assault in the Gulf of Arabia. The veterans were arrayed around him at the podium and sat before him in rows of chairs in the

East Room. They sported the colored caps of the American Legion, the Veterans of Foreign Wars, and the Disabled American Veterans, among others.

Bush thanked them for their patriotism and told them he had asked for a nearly $75 billion wartime supplemental appropriations bill to provide fuel for the war machinery in Iraq, plus supplies for troops and replacing the high-tech munitions already fired off in the desert. "People serving in the military are giving their best for this country," Bush said, "and we have the responsibility to give them our full support."[1]

It was similar to what he'd said during his election campaign, and the day before he became president. During a salute to veterans hosted by vice-president-elect Dick Cheney, Bush made a surprise guest appearance. One writer called the moment "electric" as the Supreme Court's newly elected commander-in-chief walked on stage. "In order to make sure that morale is high with those who wear the uniform today, we must keep our commitment to those who wore the uniform in the past," Bush said. "We will make sure promises made to our veterans will be promises kept."[2]

The veterans applauded that day, as did the veterans' leaders later at the March 2003 gathering. It seemed Bush had kept his promise. In addition to paying the war tab for Iraq, the president was pushing a $63-plus billion VA budget for 2004. He called it a spending record that would pay for veterans' monthly pensions, provide comprehensive health care, rehabilitative and vocational training, job placement services and other benefits. Health care funding alone would rise from $23.9 billion to $27 billion for the 2004 fiscal year. Secretary of Veterans Affairs Anthony J. Principi said veterans and their families, including our newest generation of veterans, "should rest secure in the knowledge that a grateful nation honors their service to America" with such spending. There was, Principi added, no truth to talk that the VA's budget was being cut.

To accept all this as true, it might help to be medicated. Or as Kesey's McMurphy said: "And you really think this crap that went on in the meeting today is bringing about some kinda cure, doing some kinda good?" The president was promising more vet and defense money while in fact veterans' health services, soldiers' pay and military benefits were quietly being slashed, starting with a Bush proposal to immediately cut $150 million in Impact Aid to schools attended by the dependents of soldiers, sailors, fliers and marines, some of whom had already shipped out to Iraq and Afghanistan.[3]

The president's sweeping national 2003 tax cut was also directly affecting military families. According to the Children's Defense Fund, a million children living in military and veteran families were

being denied child tax credit help due to the cuts tilted toward the rich. The defense fund's analysis found that more than 260,000 of the children have parents on active military duty. A provision to provide those families an additional $151 on average per child was proposed in Congress, but GOP House and Senate leaders dropped it, with concurrence from the White House. Yet each of America's 190,000 millionaires got their $93,500 tax bonuses.[4]

The hardest thing of all was to follow Bush's health care bouncing ball. On January 17, 2003, the president and the first lady met with American soldiers wounded in the Afghani Operation Enduring Freedom. "Having been here and seeing the care that these troops get is comforting for me and Laura," Bush said at Walter Reed hospital. "We are—should and must provide the best care for anybody who is willing to put their life in harm's way."

On that same day, Bush's VA came up with a solution to its medical-patient backlog problem: it would limit new enrollments. The "VA would avoid very significant additional medical benefits costs and begin to bring demand in line with capacity, which will reduce the number of veterans on wait lists," the department said in a statement. A few days later, Secretary Principi announced his budget and said he was suspending medical services for our "better off" vets. Those were the Priority 8 veterans with "high" annual incomes, meaning $35,000 or so (vets are ranked in descending tiers for treatment, the highest priority being indigent and combat-wounded veterans).

Principi's new budget also imposed a $250 annual enrollment fee for medical care on nonservice-connected Priority 8 veterans as well as Priority 7 vets (an income of $24,000 if single, $28,000 if married, which is about $10,000 above the poverty level for a family of four, says the department of Health and Human Services). That would likely more than triple the number of veterans denied health care by fiscal year 2005, bringing the total to half a million. The VA also anticipates that 1.5 million veterans enrolled in the health care plan may be unable to continue participation due to the new $250 fee. Congressman Bob Etheridge of North Carolina, who voted against the measure, said angrily, "Our troops fighting overseas today should know that when they come home the country that they served will not turn its back on them. [The VA cuts break] the solemn promise made to the very men and women who fight for our freedom."[5] Another congressman, John B. Larson of Connecticut, undertook a detailed study to determine how the cuts would affect the veterans of just his state, whose population ranks 29th in the U.S. He discovered that 21,000 Connecticut veterans alone could be denied VA health care or would have to drop out of the VA system entirely.

Not only that—the administration wanted to tack on a $1,500 deductible for some vets. The Paralyzed Veterans of America said that would put some services out of reach of vets, and the American Legion and Veterans of Foreign Wars called it a whole new approach to breaking promises. In the call-up to Iraq, members of non-regular units worried most about loss of private medical coverage. Army National Guardsman Eric Mueller, whose wife needed surgery, said the military advised him to invest in Cobra coverage—interim medical insurance—which, at $750 a month, he couldn't afford. "Here we're putting our lives on the line for our country," he said. "I think the government owes [coverage] to guard and reservists who have served on active duty. It's a small thing to ask."[6]

The veterans groups were also being faced down by Bush on an old and touchy issue: concurrent pay. Though he later softened his stance in the face of war and policy failures in Iraq, the president, while loudly claiming big budget boosts, quietly threatened to veto any bill Congress approved that eased a century-old law banning concurrent receipt of full military retired pay as well as VA disability compensation. A veteran could have one benefit but not the other, although collection of both is allowed if a vet becomes a federal government employee. Vet groups said many retirees were unable to work and had to live at near-poverty level. The Pentagon argued that giving money to disabled veterans would take away money the nation needed to fight its wars. American Legion leader Ron Conley called that an unholy pitting of patriots, past and present, against each other. (Disability benefits are distributed to vets with service-connected disabilities; the benefit is the equivalent of a worker's compensation program for the armed forces.)

Currently, 2.3 million veterans are receiving the tax-free disability benefit, based on the severity of the disability. It can be meager for some. In 2003, the basic monthly payment ranged from $104 for a 10 percent disability rating to $2,193 for a 100 percent disability rating, the VA said. Many veterans receive additional amounts for having dependents, severe disabilities, or being housebound.

To leverage a Capitol Hill settlement, Bush threatened to disqualify two-thirds of the country's retired military by changing the definition of service-connected disability. In late 2003, Congress and the administration met in the middle, agreeing to a $22.1 billion deal over 10 years that would ease the concurrent ban, aiding up to 200,000 disabled retirees.[7]

During all this time, legislation was also in the works to reverse a 2001 legal decision, *Allen v. Principi,* which allowed substance abuse to be considered in certain situations when weighing

a service member's disability. A reversal by Congress could cut the government's veterans-benefits spending by $1.6 billion, affecting tens of thousands of disabled veterans (see next chapter).

Then there was that $28.8 billion reduction in vet spending planned for the next ten years. The very same month that Bush addressed the vets groups, the U.S. House of Representatives approved the staggered reduction plan. That was followed, however, by an outpouring of angry letters and e-mails from the veterans' organizations, which succeeded in reducing the cut by a House-Senate conference committee to $6.2 billion—for the moment, anyway.

"In an age when we talk about smart bombs, smart missiles and smart soldiers," says Sen. Robert Byrd, the quotable West Virginian, "any talk of smart budgets goes out the windows."

The $63 billion 2004 VA budget—about $27 billion of it for health care—calls for a $3.4 billion increase over the 2003 budget— on paper. But as Rep. John Tierney says, it was $1 billion to $2 billion short of just staying even with the rising costs and service demands. In 2002 for example, the VA was treating increased medical enrollments with 20,000 fewer employees than it had in 1996. Some Senate members hoped to add at least $1.3 billion in funding for veterans health care and to extend reservist benefits, but both were "strongly opposed" by the Bush White House, as Josh Bolten, director of the president's Office of Management and Budget, said in a strong letter to senators.[8]

Florida Sen. Bob Graham, the top Democrat on the Senate Veterans Affairs Committee, sees the same kind of funding games in Bush's prospective VA budget request for fiscal year 2005. It "fails to reflect the needs of our troops tomorrow, after they are done fighting the war," Graham says. The budget contains cutbacks that will result in the elimination of 540 staff to process veterans' benefit claims (further slowing that backed-up process). It will also force the removal of 4,000 veterans from nursing homes—*where* will they go?—and eliminate 3,000 medical staffers despite an increase of 100 percent in the number of veterans 85 and older in the last five years.

Few seem to notice that the "war president" was moving relentlessly in the opposite direction to that recommended by a 2003 government panel reviewing VA performance—a group he had appointed to make such recommendations. Theoretically, said the President's Task Force To Improve Health Care Delivery For Our Nation's Veterans:

> Enrolled veterans have full access to the
> VA health care system. In reality, however, long

waiting times for appointments with health care providers continue to be a problem for a significant number of veterans. In 2003, nearly a quarter-million veterans were on a waiting list of six months or more for a first appointment or an initial follow-up— clearly indicating that VA, despite its claims of quality and quantity of services, lacks either sufficient capacity or resources to provide necessary care. The problem of not being able to meet demand is already serious—but it will only get worse if it is not addressed soon. A key point to understand about this problem is that, while the overall number of veterans eligible for care in VA facilities is expected to decrease over the coming years, the actual number of beneficiaries *seeking* VA care is projected to grow. A variety of events over the past decade— economic, budgetary, and structural—has created increased demand for, and pressures on, the VA and DOD health care systems. With the rising cost of civilian health care and insurance premiums, veterans have been searching for alternatives. This phenomenon, along with the absence of an outpatient pharmacy benefit under Medicare and the soaring increases in prescription drugs appears to be causing a growing number of veterans to seek health care from VA.[9]

The commission, noting its recommendations matched those of earlier bureaucratic reviews, wished out loud that this time changes actually would be made.

A major recommendation of the [President's Task Force's] *Final Report* is that, in addition to improving various administrative and functional activities in VA and DOD, the Federal Government should provide full funding to ensure that enrolled veterans who form VA's traditional constituency are provided comprehensive benefits, according to VA's established access standards. For some veterans, VA may be their only health care option. As more and more veterans with incomes above VA's means test threshold and no compensable service-related disabilities choose to

receive their health care in VA medical facilities, VA faces the challenge of providing quality care for its traditional population, especially those with disabilities that are the result of military service.

Our Nation's commitment to those who have served should not waver. Improving health care delivery to our Nation's veterans will require action by the President, Congress, VA, and DOD. The recommendations made in the PTF's *Final Report* provide a place to start in fulfilling the obligation to those who have sacrificed to defend our country. [10]

Ultimately, Congress, with the president's blessings or lack thereof, decides who will receive veterans benefits. As the VA tells its vets—those who bother to wade through the department's hefty handbook—they will be enrolled to the extent congressional appropriations allow. If appropriations are limited—and they *always* are—enrollment occurs on a sliding scale. Any active-duty veteran who was discharged under honorable conditions has basic eligibility for VA care in two categories: 1) Vets to whom the VA "shall" furnish hospital, outpatient care, and nursing home care. These include veterans with service-connected disabilities, former POWs, World War I veterans, low-income veterans, and some veterans exposed to environmental contaminants. 2) All remaining vets, to whom the VA "may" provide care to the extent facilities are available and if they agree to co-payments.[11]

The VA's No. 1 priority is veterans with service-connected disabilities who are rated 50 percent or more disabled. Second are veterans with service-connected disabilities who are rated 30 or 40 percent disabled. Then come former POWs or veterans awarded a Purple Heart, veterans with disabilities rated 10 and 20 percent, and veterans awarded special eligibility for disabilities incurred in treatment. Vets receiving aid or housebound benefits and those who are disabled on a lesser scale are the next eligible group, followed by veterans who are unable to defray the expenses of needed care. At the bottom are veterans whose coverage depends on their income and net worth and willingness to make co-payments of $15 to $50.

At least, that's how it's supposed to work.

Rescuing Sergeant Turner

Five months after Bush's March 2003 speech to the vet groups, Army Sgt. Vannessa Turner of Boston returned home from

Iraq to, in effect, discover the VA had no room for her at its hospitals. So far, she had beaten another one of those strange war maladies— she couldn't name her ailment and said doctors never could diagnose it, but they did tell her it could kill her. Overcome by Iraq's mystery pneumonia, she had fallen into a coma and was rushed to a hospital. Once recovered, she was medically retired and sent home. Though she felt better, Turner needed additional care. Yet, despite her severe nerve damage, the VA in July told her she could not see a doctor at Boston's VA hospital until mid-October. Sgt. Turner thus became one of those thousands of veterans who must wait six months or longer to gain a hospital visit.

She didn't get the Jessica Lynch treatment. But Turner did get some notice—obtaining help from the office of Sen. Ted Kennedy, who alerted the media; she then got her visit. The VA said it was just a case of misclassification. As Turner remembered it, "I was told [on July 12th] that I would have to go every day to the emergency room until October 12, in order for my leg to be seen. So I called my—I called Kennedy's secretary, Melissa, and in 10 seconds she got an appointment." During an MSNBC interview, cable host Joe Scarborough, a conservative former congressman, kept shaking his head in disgust. He told Turner that "When I served on the Armed Services Committee for almost four terms, I saw firsthand how our troops, our men and women in uniform, lived on food stamps in many instances. I learned also firsthand of how Congress and the president would make one promise on health care, and then do something completely different...It's a national disgrace." He added that, only two weeks earlier, he had interviewed families of soldiers killed in Iraq who were not given enough money to bury their sons.[12]

Vet leaders such as American Legion head Ron Conley called Turner's case typical. "I spent 11 months touring the United States and visiting some 60 VA medical centers. And we have over 300,000 veterans that are trying to access health care. In some places they were waiting up to two years to see a primary care doctor."

Throughout the Turner case and others like it, the name Jessica Lynch continued to arise. When it comes to post-war benefits and services, Lynch has become something of the gold standard for comparison, arguably through no fault of hers. The media first erroneously reported that Lynch suffered knife and bullet wounds while fighting off her attackers, leading to her fame and fortune. But the injuries had actually resulted from the grenade attack on her Humvee. Lynch, critical of the military for hyping—and videotaping— her rescue by Special Operations Forces, said she didn't fire a shot because her gun was jammed.

Jessica Lynch suffered the traumas of battle, but so did others. The *Philadelphia Inquirer* reported, for example, that one of Lynch's fellow soldiers in the 507th Maintenance Company, Shoshana Johnson, was wounded as she valiantly fought off her captors, yet was largely ignored back home. As the *Inquirer* noted, many African Americans thought that was because Johnson, who is black, didn't have the right "face". A Panamanian American who was shot in both ankles, Johnson has a 30 percent disability. Lynch, who suffered a head injury and broken bones in her arm, leg, thighs and ankle, gets 80 percent. Vietnam vet William Smith, an adviser for the National Association of Black Veterans, said "There before you is the American dilemma: we are unfair in treatment and view when it comes to people of color." The Army said an evaluation board put Lynch on temporary disability, allowing her to remain in the Army for up to five years; she can thus be reevaluated and her disability lowered. Because Johnson's injuries were found stable but permanent, she was discharged at the 30 percent level.[13]

Lynch undoubtedly was the military and media favorite, used to put a bright face on the war. Her poster-girl status was underscored by a contrasting newspaper story in the *Baltimore Sun*, revealing how Pfc. Patrick Miller, also a member of Lynch's company, saved lives with heroic actions that went unnoticed by a media intoxicated with the rescued female GI. After their convoy mistakenly drove into an enemy nest near Nasiriyah in March and crashed, leaving Lynch unconscious among her dead and dying comrades, Miller, a 23-year-old Army welder from Kansas, single-handedly took on several Iraqis, forcing rounds into his balky rifle by slamming the loading mechanism in a load-and-shoot rhythm. He killed the enemy before they could lob mortar rounds onto the crashed vehicle, which likely would have killed Lynch, Johnson and the others still alive. Said Johnson: "He's one of my heroes…His actions may have saved my life." Ultimately, other media picked up the story and Miller got his due in addition to his Silver Star. On *60 Minutes*, Mike Wallace asked Miller if he was bothered by Lynch's book deal and TV movie. "Mmm, somewhat," he said. But would he turn down a $1 million book offer? "Oh no—I'd have to think about it," he said with a laugh.[14]

While a few wounded were getting high-profile attention, UPI's Mark Benjamin reported that up to 600 sick and wounded U.S. soldiers at Fort Stewart, Georgia—many who served in the Iraq war—were languishing in hot cement barracks while they waited, sometimes for months, to see doctors. The National Guard and Army Reserve soldiers' living conditions were so substandard, Benjamin reported, and the medical care so poor, that many soldiers believed the Army

was trying push them out the door with reduced benefits for their ailments. Benjamin wrote that, "One document shown to UPI stated that no more doctor appointments were available from Oct. 14 through Nov. 11—Veterans Day." Said Sgt. 1st Class Willie Buckels, 52, a reserve 27 years who also served in Gulf War I and had had an undiagnosed pain in his abdomen for six months: "I have loved the Army. I have served the Army faithfully and I have done everything the Army has asked me to do. Now my whole idea about the U.S. Army has changed. I am treated like a third-class citizen."

The troops described clusters of strange ailments, including heart and lung problems—some of them suspected complications from anthrax vaccinations—and said the Army was claiming their injuries and illnesses were due to pre-existing conditions. The situation surfaced just one month after President Bush had greeted soldiers at Fort Stewart, home of the famed Third Infantry Division, as heroes on their return from Iraq. After UPI reported the conditions, Pentagon officials in 2004 told Congress they had been "unaware" of the problem, or had "temporarily lost sight of the situation," but promised to do the right thing.[15]

Gerald Lechliter, a retired Army colonel and former Marine from Delaware, tells me that, as one who has experienced the system's faults, "It's even worse than depicted." After Congress passed a law in 1999 to provide severely disabled military retirees more compensation, the government constructed the rule for implementing this statute so narrowly, says Lechliter, that it had only one purpose: "In effect, they want to pay as few disabled retirees as little as possible."

Be kind enough to die

Anthony Principi, the VA secretary, is of course a war vet and has two sons, Anthony and Ryan, who served in Iraq. He promises to do more, and vet groups are pressuring legislators to vote down those predictable post-war funding cut proposals—whenever, down the line, post-war finally comes along.

Principi says the VA is more healthy thanks to Bush, noting that in late 2003 the president signed the VA Long-Term Care and Personnel Authorities Enhancement Act that extends and expands the VA's mandate to provide long-term care to veterans (it includes new provisions for nursing home care to veterans with lower disabilities ratings). Principi has his own set of figures disputing what every else calls budget cuts. "Let me assure you," he wrote a vet who e-mailed him in an online chat just before Veterans Day 2003, "that there have

been NO cuts in VA benefits. I regret this misinformation is being perpetuated for political gain. Since President Bush came into office in 2001 my budget has increased from 48 billion to 65 billion in a short three years. That is the largest increase in the history of the VA. WE are well prepared for the men and women who are serving in combat in Iraq and Afghanistan."

The VA has 1,300 care facilities that include 163 hospitals, 850 ambulatory care and community-based outpatient clinics, 206 counseling centers, and 137 nursing homes. It evolved from a hospital-based system to a primarily outpatient-focused system in recent years, expanding its clinic and home-care service. Officials point proudly to a 2002 Institute of Medicine report that recognized the VA as a world leader in quality medical care. The VA and Defense Department have dedicated programs to research and review mysterious battle-related illnesses and have collected some medical data during fighting in Afghanistan and Iraq to aid their efforts. The VA is undertaking new efforts to upgrade its budget and financial management, staffing and assignment, and medical information and information technology systems, as mandated by the 2003 National Defense Authorization Act. The VA is also finally catching up to modern automation as it increasingly computerizes its records system. (It still looked like the 1940s in some facilities, where stacks of paper files had to be retrieved from warehouses; since veterans tend to apply for increased benefits decades after their military separation, the VA says, the location and quality of these records are often difficult to establish.) Principi, responding to another veteran's question during that Veteran's Day online Web interview, claimed the VA's management and procurement reform has "saved billions of dollars over the past decade." The department also said it was making historical advances in scientific research, which represents a large portion of VA health care operations.

Repeatedly, many vets will tell you how they love their doctors, nurses and VA workers—the thousands who don't make policy but give care and services. There's widespread agreement the VA helps veterans live better and longer lives—that's one of the reasons they fight so hard to stay in the system. Taken together, such developments suggested that the soldiers we support in battle aren't being forgotten after the smoke clears.

Yet it remains the case that, as enrollments increase, the VA hospital system is shrinking. Facilities are being closed despite the real and emotional toll on veterans. The plan is to move further towards out-patient services, shuttering seven VA hospitals across the nation and opening two new ones under a multi-billion-dollar plan

the government calls—honest!—the CARES Initiative. Sen. Patty Murray, the first woman to sit on the Senate Veterans Affairs Committee, says the Capital Asset Realignment for Enhanced Services effort may have been nobly intended to save the taxpayers money, but it "now appears to be an effort to simply close facilities."

At an August 2003 rally of Pittsburgh veterans against possible closure of the VA facility at East Liberty, Navy vet Joe Netisco said the excuse for shuttering the hospital is "the same type of rhetoric I've been hearing since I came from Vietnam in 1968."[16] That same month veterans rallied on the other side of the country outside the Vancouver, Washington VA Center, which could be closed within a year. "They need this facility here very, very bad," said Craig Burns, who wore a black hat declaring him a World War II veteran. The medical center hosts a pharmacy, a nursing home and a primary-care center, employing 450 and treating more than 13,000 veterans a year.

"Maybe if some of you would be kind enough to die before you get service, we could save a whole lot of money," Rep. Brian Baird told the crowd in sarcasm directed at the VA. "But that is not a valid cost-saving measure, my friends. And neither is closing this facility."[17]

Maybe there'd be more money for such facilities if the VA would stop paying its doctors for not working. According to its own inspector general, Richard Griffin, the VA pays 5,100 part-time government doctors $400 million a year. Griffin says an examination of the schedules of 100 doctors found that 70 did no work during their mandatory four-hour shifts. The work schedules of 153 surgeons showed 70 of them spent less than 25 percent of their time on direct patient care. One general surgeon, according to Griffin, was paid for working 250 hours during a 10-week period, but performed just one surgery and treated another patient for three hours. Also, a neurosurgeon was paid for working 127.5 hours but, in actuality, worked 23. In a separate probe done jointly with the General Accounting Office, Griffin found numerous instances of VA employees using their positions to defraud the government and funnel money into their pockets or those of accomplices. Employees of the Nashville VA Medical Center, for example, used their positions to divert narcotics with an estimated street value of $3.5 million from the VA pharmacy. In 2001, an employee of the Atlanta VA Regional Office, resurrecting the files of deceased veterans, diverted claims into her co-conspirators' bank accounts, stealing more than $6 million. She also stole an additional $5 million through a separate con.[18]

The VA is also under new scrutiny for failing to deliver responsible health services to veterans, including questionable

treatment for heart disease and unethical test procedures that may have led to the deaths of patients in at least eight U.S. VA hospitals. According to the *New York Times*, an internal probe by the VA found that a cumulatively huge overdose of a prescription drug caused one death during a clinical trial at a Detroit hospital in 2002. The patient, Cyril Krcmarik, who had prostate cancer, died after a series of medical errors that included an overdose of dexamethasone, a steroid used to combat the side effects of chemotherapy treatment. The overdose resulted from an incorrect prescription and change in dosage instructions that caused Krcmarik to use a nine-month supply of the drug in under three weeks.[19] Federal prosecutors were also conducting a criminal investigation of two New York VA researchers who may have fabricated data that contributed to one or more deaths in studies.

In Kansas City, conditions at the VA hospital were plain creepy. Filth, rodents and insects were in abundance. Nurses even found maggots growing in the noses of two comatose patients. Both patients, as the *Kansas City Star* pointed out in 2002, were, astoundingly, in the intensive-care unit. Hospital officials quibbled over the severity of the problems, disputing, for one, the contention that mice actually ran over the feet of people at a conference in the hospital director's office. One administrator also said the maggot infestation had "no adverse effect on the patients." As the *Star* editorialized: "Maggots in patients should be considered, by definition, to be an `adverse effect.' For many people, the problem sounds like something out of a nightmare."[20] In an April 8, 2004 report, Diane Sawyers on ABC's Primetime found sickening conditions in VA hospitals: bathrooms filthy with human excrement, veterans left unattended and unfed for days, aging vets who spent up to eight hours in hospital waiting rooms, and patients whose VA treatment effectively killed them. Trying to control an infection in one hospitalized vet, the VA reverted to the extreme use of maggots to eat the infected flesh. But "Some of the maggots got out and they were in the bed with him, you know?" said his granddaughter. "He could feel them in the bed."

According to the Centers for Disease Control and Prevention, respiratory infections, the most common cause of acute infectious disease in U.S. adults, similarly are the leading cause of outpatient illness and a major cause (up to 30 percent) of infectious disease hospitalization in U.S. military personnel. The CDC says crowded living conditions, stressful working environment, and exposure to respiratory pathogens put military trainees and newly mobilized troops at particularly high risk. Though disease control has improved, "epidemics continue to occur, and respiratory disease in military trainees continues to exceed that in U.S. civilian adults." We can

expect more respiratory disease epidemics in military populations, the CDC adds, some fatal.[21]

With recorded increases in drug and alcohol use in the military, we can also expect the need for more addiction treatment for veterans. Already, at a Baltimore VA clinic, for example, 400 heroin addicts line up daily for methadone. Doctors there say they are treating four times the addicts they treated just a few years ago. While once it was mostly Vietnam veterans, now those from Bosnia, Somalia and Gulf I are coming in. This growing census is in addition to daily health caseloads that some doctors call overwhelming. Joel Kutnick, a Corpus Christi VA mental health specialist, says his personal caseload is 2,000 patients, and rising. Many need intensive counseling but get no more than a monthly visit.[22]

Among the VA's critics are VA doctors. "What's bugging us," says Dr. Tom Horvath, chief of staff at the Houston VA hospital, "is that people who served their country, went to combat when a lot of the other people in the country did not go, are not getting the first-class service they deserve." Mental health patients in particular are "getting better service that they did 30 years ago, but nowhere near enough to put them back to real productive lives." Unless the VA does something dramatic, says Horvath, who heads up a VA advisory committee, Gulf II veterans will face similar challenges. The budget has been cut 30 percent for mental health and 40 percent for drug treatment, he says. There's an attitude among some VA doctors and officials that such patients are not really ill, that boozers do it by choice and some level of cowardice is behind PTSD complaints. "The mentally ill are not popular" in the VA, says Horvath.[23]

Brian Callan's personal tragedy underscores that point.

'Heal me'

In 2002, the alternative weekly Phoenix *New Times* wrote of Gulf War Marine vet Brain Callan, 44, who, unhappy with a car lease he had signed a day before, fired a 12-gauge shotgun into the ground outside a Toyota dealership, then marched in and, holding the gun at the face of a sales manager, ordered him to redo the lease. A police officer who arrived quickly remembered that when he pulled his own gun and ordered Callan to drop the weapon, he pointed it to his chest, said "They fucked me here," and pulled the trigger. Except it didn't discharge. The office shouted, "Hey, man, it's just a car. It's not worth it." Callan then chambered a round. "No, they fucked me here." This time the gun went off.

In Callan's pocket, police found a laminated list of his VA medications for anger, anxiety and depression. Though the story

had dropped out of today's fast-wheeling news cycles, *New Times* reporter Paul Rubin dug deeper, discovering that Callan was a vet of Operation Desert Storm and Somalia who'd been diagnosed with severe PTSD and major depression, but got little of the VA's time other than the moments it took to write out prescriptions for poor-quality mood-altering drugs. "Special services for those diagnosed with PTSD have been cut to the point of virtual extinction in some" VA facilities, said Ohio psychologist Dr. Fred Frese, himself a Vietnam veteran. Joy Ilem of the Disabled American Veterans noted, "Over the past five years, there has been a continuing erosion of specialized services for veterans suffering from severely disabling conditions [such as] PTSD, mental illness and substance-abuse disorders." Callan was obviously aware of this. He had recently written a note to his doctor, saying: "I have a proposal to make to you and your staff. As a 100 percent disabled veteran, the proposal is to treat me pro bono. It would be our goal to heal me, documenting this to the VA, and winning a contract to provide medical services to other disabled veterans. As you well know, the VA only treats the symptoms and not the ailment. I want to get better and heal, to become a functioning and contributing member of our society again." The letter was never acted on. By the time it was sent up through channels, Callan was dead.[24]

In late 2003, the GAO issued its newest review of how the VA handles its disability cases and concluded the administration "remains mired in concepts from the past. VA's disability programs base eligibility assessments on the presence of medically determinable physical and mental impairments. However, these assessments do not always reflect recent medical and technological advances, and their impact on medical conditions that affect potential earnings." The VA continued to have, as well, significant problems with its quality assurance and timeliness of services, the GAO said.[25]

Broken promises then and now

Ex-POW George "Bud" Day also tried to get Washington's attention, working first within the system and then, frustrated over his rejection in the hallways of government, gathering up 23,000 fellow military defendants and petitioning federal court. They sought to remind the U.S. of its historic vow to provide decent and lasting medical services—and prod George Bush to remember his own inaugural-day claim to make sure "promises made to our veterans will be promises kept." Day is a retired Air Force colonel who was shot down over North Vietnam in 1967 and spent 67 months as a

war prisoner (he escaped once, but was recaptured in the south). He is also credited with living through the first "no chute" bailout from a burning jet fighter in England in 1955. Now, Day is an attorney, not a vet in need. But many of his fellow vets are. That's why Day calls this "the crusade of my life"—his attempt to hold the Navy to its 1914 promise that "During your life, you receive free medicine, medical attendance, and hospital service whenever required."

Day contends the Pentagon breached its contract to continue to provide hospital care for military retirees over 65, forcing them to buy supplemental insurance such as TRICARE (for active duty and retired members of the uniformed services, their families, and survivors) whose costs are prohibitive for many elderly military or surviving spouses, Day says. His group's legal bid fell short. In 2003 an appeals court ruled the veterans had no legal standing to challenge the government, and the U.S. Supreme Court refused to hear the case. They are now again petitioning Congress for relief.

Even top Pentagon officials such as former Joint Chiefs Chairman Henry H. Shelton agree with Day. "I think that the first thing that we need to do is make sure that we acknowledge our commitment to the retirees for their years of service," Shelton told a congressional hearing in 2000, "and for what we basically committed to at the time they were recruited into the armed forces." The 1914 promise was fulfilled until 1956, when the government tacked on a caveat of when "space is available" in VA hospitals, rendering the commitment no longer absolute.[26] To some, that reversal was matched (or exceeded) for promise-breaking only by the dishonorable Recession Act, signed by President Truman in 1946, revoking the full military benefits that had been granted to some 300,000 Filipinos when they were drafted in 1941 to fight the Japanese in WWII. Survivors continue to campaign for restoration of that promise.

Even today, some think the military misleads its newest recruits into thinking that medical care is a sure thing down the road. Marine Corps recruiting brochures, for example, still say that "Should you remain in the Marine Corps through retirement, your health care benefits will extend throughout your lifetime and throughout the lifetime of your spouse."[27]

What that doesn't say is that those benefits can be cut or not funded at all. Or sometimes given back and taken away again. As you'll see next.

Chapter Nine

The Other Cocktail Effect

William Allen's bar brawl

If there's a "medicine" that many soldiers are not reluctant to take, it's alcohol. A 2004 Department of Defense health report found that military personnel ages 18 to 25 showed significantly higher rates of drinking (27.3 percent) than the public at large (15.3 percent).[1] Drinking can also grow into a disease that plagues veterans long after their separation from service. Ask William Allen of Massachusetts. From1965 to 1969, Allen was a United States Marine. He left Vietnam suffering from post-traumatic stress disorder, which he dealt with in part by drinking heavily. Eventually, the boozing itself became a disability. Not that the bottle was necessarily his choice. In the words of one doctor, Allen's was "a disease contracted in the line of duty." He was in fact one among thousands of vets who drank not because of the war, but as a result of trying to deal with the effects of it.

Allen wasn't trying to make a federal case out of his disability. But that's what he was forced to do.[2]

A Marine wounded by stress and booze won a landmark court ruling. Now the VA is seeking to prevent other veterans from sharing in it.

In 1993, the Boston VA office granted Allen a 30 percent disability rating for service-connected post-traumatic stress disorder. A year later, Allen filed a claim for a higher disability rate. A year later that bid was rejected. Allen said he really needed more help, and appealed.

In 1996, after an examination to determine the severity of Allen's PTSD and its relationship to his drinking, a VA doctor, Victoria Russell, wrote that the "reason for [Allen's] alcohol admissions had to do with his rapidly accelerating symptoms of [PTSD]." The doctor diagnosed Allen with severe PTSD along with chronic alcohol abuse and

dependence that was secondary to PTSD. The VA disability judges were unmoved. But in 1997, following a psychiatric hospitalization, his disability rating was finally upped to 50 percent. The VA turned down his bid for a higher, 70 percent rating, and Allen appealed but was again denied.

The VA was basing its decision on an interpretation of a 1990 law passed by Congress that placed limits on disability applications linked to drinking. According to historical record, the law replaced a 1965 VA administrative decision that made a distinction between disabilities that are the primary result of drinking—such as accidents—and the organic, secondary effects of alcohol, such as liver disease. The VA also specifically ruled that, in either case, addiction shouldn't be considered when evaluating the severity of service-connected PTSD.

To Allen, that was wrongheaded. With the help of the Disabled American Veterans organization, he eventually found himself in federal court. In part, he asked the court to interpret Congress' intent in disallowing alcoholism as a related disability, and decide whether legislators intended to distinguish between willful and involuntary acts. Willful misconduct referred to a *conscious* wrongdoing. As the court outlined it:

> Allen's alleged disability…is quite different from one in which the veteran consumes alcohol willfully (causing a primary alcohol abuse disability) or one where a veteran later develops a disability as a result of the willful consumption of an alcoholic beverage (*i.e.*, a secondary disability arising from a primary alcohol abuse disability). In contrast to these two other situations, an alcohol abuse disability arising as a direct result of a psychiatric condition fits within [congressional] words of authorization for compensation.

Simply put, if PTSD *itself* led to alcoholism, then drinking can be considered a disabling factor, too.

In September, 2001, the court decided that the 1990 law passed by Congress allowed Allen to file a full-disability claim, stressing that "such compensation would only result where there is clear medical evidence establishing that the alcohol or drug abuse disability is indeed caused by a veteran's primary service-connected disability, and where the alcohol or drug abuse disability is not due to willful wrongdoing."

Allen had made his case for a higher rate of disablement. Importantly, he had also earned an opportunity for others like him. Veterans could begin to apply for compensation for alcohol or drug disabilities when the abuse arose from a service-connected condition. In addition, the substance abuse could be used to consider whether a service-connected condition was growing worse, thus resulting in a higher disablement rating for that condition.[3]

A legislative dental extraction

What was the VA's reaction? To try to weasel out of the law. It went to its friends in Congress seeking to overturn Allen's hard-won victory. Thereby, House Resolution 850 was born. Its sponsor is an Idaho congressman named Mike Simpson, a representative from Idaho's 2nd District. His fellow Idaho Republican, Sen. Larry Craig, introduced a companion bill in the Senate.[4]

Both politicians like to tell voters they're great supporters of a stronger national defense. Craig is especially in favor of a strong defense for Idaho. He made a stink in 2003 over the military's reluctance to send some federal pork to his state. The powerful Craig, whose committee appointments include Appropriations and Veterans Affairs, held up the military promotions of 850 Air Force personnel, from fighter pilots who flew in Iraq to four-star generals, insisting the Air Force must first agree to his demand that four additional C-130 cargo planes be assigned to an Air National Guard base in Boise. He eventually relented under pressure.

The two legislators' companion bills appear to be more military-friendly. At first glance, anyway.

Entitled the Former Prisoners of War Special Compensation Act of 2003, the bills direct the VA to pay special added monthly compensation to each veteran who is a former prisoner of war and was detained or interned for at least 30 days.

The legislation has a weird, time-served credit for the nation's 42,781 living former POWs as of January 2002. It proposes a sliding scale to determine what a prisoner's life is worth. Payments would range from $150 for those detained for between 30 and 120 days to a maximum of $450 for those detained more than 540 days. A former POW held for 540 days, for example, would receive 55 cents for each day of confinement, compared with $5 per day for a POW held at least 30 days. If a POW was held 541 days or longer, he would receive 83 cents for each day of confinement, the rate dropping with each additional day of confinement after 541 days. Like I said, weird math—the kind that maybe only Enron could appreciate.

As skimpy as all that sounds, who wants to be known as the senator or representative who voted against benefits for prisoners of war? The proposed law also removes an odd requirement, earlier passed by Congress, declaring that former prisoners of war must have been detained or interned for at least 90 days in order to be eligible for veterans' outpatient dental care.

That's unfair to our men and women in uniform, declares Simpson, who happens to be a dentist. "The recent rescue of Private Jessica Lynch once again brings to light the horrific ordeals our military men and women often endure as POWs," he noted. Of course, Lynch, wealthy from her book and other media deals, can have her teeth encased in gold if she wishes. But, said Simpson, "Although we can never hope to fully compensate these brave men and women for their suffering, H.R. 850 recognizes and pays tribute to the real sacrifices made by our former POWs who were forcibly detained by the enemy." It was, he suggested, a bill with bite.[5]

But if you search through the legislation, you'll find another proposal tucked between those two POW measures. In summary, it states: "Prohibits the payment of veterans' disability compensation for any alcohol- or drug-related disability even if the abuse is secondary to a service-connected disability."

It's the Anti-Bill Bill. It is meant to eliminate a benefit needed by Bill Allen and thousands of deserving military disabled in part by a war-related disease. The proposal is drawn up in such a way that legislators can say they approved more help for our deserving POWs, while not having to mention they reduced benefits for some of our most unstable veterans.

Rick Surratt, a legislative director of the Disabled American Veterans, chided the VA during a 2003 D.C. hearing on the legislation.[6] Having had its erroneous interpretation against veterans set aside by the court and having apparently determined that further appeal would be unsuccessful, said Surratt, "the VA now looks to Congress to reinstate its incorrect view of the law. Congress should reject VA's recommendation." He then gave congressional members a lesson on war, post-traumatic stress disorder, and substance abuse:

> Although the Veterans Health Administration is a recognized leading authority in research on and treatment of PTSD, and thus possesses extensive information and insight into the relationship between PTSD and alcohol abuse, VA's leadership and its Veterans Benefits Administration apparently understand little about the subject, despite much

puffing about the "One-VA" concept. Even before the American Psychiatric Association recognized PTSD as a distinct psychiatric disorder in 1980, those counseling Vietnam veterans suffering from its symptoms recognized alcohol abuse as a frequent component. Studies from the 1970s and later revealed that Vietnam combat veterans exhibited substantially higher levels of alcohol consumption than other veterans and non-veterans and that many combat veterans appeared to use alcohol as an anti-anxiety agent to induce a form of "psychic numbing." It was observed that many combat veterans appeared to be "self-medicating" with alcohol to suppress PTSD symptoms. Numerous studies about the relationship between psychiatric disorders, particularly PTSD, and alcohol abuse have been conducted, and VA's own National Center for PTSD recognizes the relationship.

Surratt noted that the VA's figures show that 60 to 80 percent of Vietnam veterans seeking PTSD treatment have alcohol-use disorders. Veterans over the age of 65 with PTSD are at increased risk for attempted suicide if they also experience problematic alcohol use or depression. The *Vet Center Voice*, published by VA's Readjustment Counseling Service, lists "self-medicate" as the escape of choice by stress sufferers.[7]

Withdrawal of the Allen benefits does not recognize medical principles, Surratt told legislators. "Regrettably, this recommendation reflects very negatively upon the agency that is charged with understanding and having insight into the effects of trauma and severe disabilities upon veterans. It evidences a narrow-minded insensitivity to the real nature of the effects of severe trauma and severe disability..."

Or an insensitivity to common understanding. Since 1956, the American Medical Association has recognized and defined alcohol addiction as a *primary disease*, not a secondary symptom of an underlying psychological or medical illness.

At last word, in early 2004, the Simpson/Craig bills were still in committee.

The heroes' war at home

It's hardly just unknowns such as Bill Allen who were disabled by alcohol. Notable examples include one of his fellow Marines, Ira Hayes, one of the figures in Joe Rosenthal's legendary photograph

of warriors raising the flag on Iwo Jima in WWII. A Puma Indian from Arizona, Hayes refused to think of himself as a hero, especially, he said, after only five of the 45 men in his platoon survived Iwo. Addicted to alcohol in the service, Hayes had his moment in the sun afterwards, with parades and speaking engagements and, always, it seemed, someone buying a drink for the hero. He eventually escaped back to the reservation where visitors asked to see "the Indian who raised the flag." He became a fulltime drifter and drinker, arrested more than 40 times for public drunkenness. He had moments of recovery, but more of failure.

In 1955, ten years almost to the day after he helped raise the flag, and ten weeks after a bronzed Iwo memorial was dedicated in D.C., Hayes was found dead of exposure and acute alcohol poisoning. A song by the late Johnny Cash recalled the end: "He died drunk early one morning—alone in the land he'd fought to save. Two inches of water in a lonely ditch—was the grave for Ira Hayes." He was 32.[8]

Like Hayes, but for different reasons, Vietnam hero Joe Hooper was still at war long after he left the front with a chestful of decorations and regret. He armed himself with bourbon and, now and then, a gun he carried around. He was 60 percent disabled from his wounds, but 100 percent dysfunctional if you counted the addiction. Which the VA didn't.

Retired Maj. Gen. Patrick H. Brady, a fellow Washingtonian who also earned the Medal of Honor in Vietnam (as a chopper pilot who regularly flew rescue missions under fire), says the word "hero" hangs hard on many medallists. "One of the negatives of being a Medal of Honor recipient is that people attribute something to you that's simply not there. People think you're a Superman. They have expectations of you that you can only fulfill if you went back into combat."[9]

The Superman tag may be understandable. The citation for Joe Hooper's Medal of Honor reads:

> For conspicuous gallantry and intrepidity in action at the risk of his life above and beyond the call of duty. Staff Sergeant (then Sgt.) Hooper, U.S. Army, distinguished himself while serving as squad leader with Company D. Company D was assaulting a heavily defended enemy position along a river bank when it encountered a withering hail of fire from rockets, machine guns and automatic weapons. S/Sgt. Hooper rallied several men and stormed across the river, overrunning several bunkers on the opposite shore. Thus inspired, the rest of the company moved to the attack. With utter disregard for his own safety,

he moved out under the intense fire again and pulled back the wounded, moving them to safety. During this act S/Sgt. Hooper was seriously wounded, but he refused medical aid and returned to his men. With the relentless enemy fire disrupting the attack, he singlehandedly stormed 3 enemy bunkers, destroying them with hand grenade and rifle fire, and shot 2 enemy soldiers who had attacked and wounded the chaplain. Leading his men forward in a sweep of the area, S/Sgt. Hooper destroyed 3 buildings housing enemy riflemen. At this point he was attacked by a North Vietnamese officer whom he fatally wounded with his bayonet. Finding his men under heavy fire from a house to the front, he proceeded alone to the building, killing its occupants with rifle fire and grenades. By now his initial body wound had been compounded by grenade fragments, yet despite the multiple wounds and loss of blood, he continued to lead his men against the intense enemy fire. As his squad reached the final line of enemy resistance, it received devastating fire from 4 bunkers in line on its left flank. S/Sgt. Hooper gathered several hand grenades and raced down a small trench which ran the length of the bunker line, tossing grenades into each bunker as he passed by, killing all but 2 of the occupants. With these positions destroyed, he concentrated on the last bunkers facing his men, destroying the first with an incendiary grenade, and neutralizing 2 more by rifle fire. He then raced across an open field, still under enemy fire, to rescue a wounded man who was trapped in a trench. Upon reaching the man, he was faced by an armed enemy soldier whom he killed with a pistol. Moving his comrade to safety and returning to his men, he neutralized the final pocket of enemy resistance by fatally wounding 3 North Vietnamese officers with rifle fire. S/Sgt. Hooper then established a final line and reorganized his men, not accepting treatment until this was accomplished and not consenting to evacuation until the following morning. His supreme valor, inspiring leadership and heroic self-sacrifice were directly responsible for the company's success and provided

a lasting example in personal courage for every man on the field. S/Sgt. Hooper's actions were in keeping with the highest traditions of the military service and reflect great credit upon himself and the U.S. Army.

In the end it was Joe Hooper needing to be rescued. From the day he left the service in 1974 with a $12,000 retirement check carried around in his shoe, his war was with himself and the bottle. The average solider doesn't have these agonizing head problems. But Hooper wasn't average, nor was his war. Between bouts, the VA gave him a desk-job counseling vets on benefits. Ultimately, they fired him, his commander told me, due to "problems adapting to the bureaucratic environment."

"Management at the regional office knew Joe was more suited to working the Public Information Office," says Mike Sallis, a close friend and former VA co-worker. "Joe and I, along with the other Vietnam veterans in the division, tried to conform to the quasi-military management techniques used by many of the supervisors, but we couldn't help seeing similarities between what we had experienced in Vietnam and what was happening at the VA. With the fall of Saigon in April 1975, a new era began for Joe and I. We were totally crushed. The U.S. had bailed out of Vietnam and then when the expected invasion came, this nation failed to life a finger. We noticed a change in attitudes by many of the employees. We were already feeling like losers, but the negative comments and actions by some employees only served to deepen the wound."

Hooper, says Sallis, was finally given the option of transferring to the VA's Field Services Division, where he feuded with a supervisor and was accused of absenteeism. "John Taylor, a Vietnam veteran who is also now deceased," says Sallis, "told me he and others overheard Joe's immediate supervisor tell his [the supervisor's] wife, who was working in Adjudication, that he 'finally caught' Hooper. There were many VetReps on campus and Joe was not the only one who from time to time could not be found in his office. Yet management chose to single him out. They gave Joe two options. Either quit on his own or be fired."

Hooper left, and his family eventually relocated to the Midwest where he took a fancy to breeding racehorses. On May 6, 1979, preparing to attend the Kentucky Derby, he was found dead in a bathroom at the Fort Knox bachelor officers quarters. He suffered a massive brain hemorrhage and fell over dead on his face. His Kentucky state death certificate lists him as an Army Reserve officer. The

national media never reported his death then, or since.

Joe Hooper's passing was officially an accident, the result of natural causes, and that's what scares everyone to this day.

"He was a casualty of war, and you can expect more of the same after Iraq," says Hooper's pal David Willson, a retired community college librarian and Vietnam vet who worked with Hooper on a collection of war literature. "Look at the history," Willson tells me, "this is a country made by war, on the backs of veterans, who have never, ever, been treated as promised."

After his death, Hooper's buddies attempted to have the Seattle VA Medical Center renamed for Hooper, and enlisted considerable support. I wrote several stories about the effort. Then-Rep. Rod Chandler, a Republican, and then-Sen. Brock Adams, a Democrat, both launched bills to back the renaming. Petitions were signed and letters rolled in. But in the end, the renaming effort was derailed. By the VA.

The administration had created San Antonio's Audie L. Murphy Memorial Veterans Hospital in 1973 after the WWII hero who died in a 1971 airplane accident, and in 1985 had named the VA Medical Center in Murfreesbor, Tenn., after the late WWI hero Alvin York. But in 1990 it had a new policy. It no longer named a complete facility after a veteran.

It would name a wing for Hooper, though. The substance abuse wing.

His friends were angry. As Larry Frank put it, supporters wanted the whole enchilada for Joe, "no wings, no rooms, no walls, no floors."

The VA wasn't kidding. A wing or forget it.

There was a small ceremony and a plaque was hung. Joe Hooper ended there, a name on a wall in a drug ward.

While visiting the VA hospital one day in 2003, I went looking for Hooper's plaque. I had attended the unveiling ceremony a decade earlier but couldn't find the ward amid the ever-sprawling regional campus on Beacon Hill. I queried hospital switchboard operators and chatted with administrators on the courtesy phone. I rode elevators and roamed a mile of hallways unsuccessfully. A hospital publicist later told me the plaque was in the Addictions Services Wing, as they now called it. I'd have to take her word for it. The area, she said, was off-limits to me.

What I'll remember most, though, was the man at the Information Desk, the first one I asked for help.

"Joe who?" he said.

.

Epilogue

Lest We Forget

> "You may be willing to die for your country,
> but your country's not willing to die for you."
> Chuck Pfarrer, ex-Navy SEAL
> and Author of *Warrior Soul*, 2004.

I've hung on to a letter I got from a war widow who contacted me after I wrote about Hooper.

"My husband," it begins, "First Lieutenant Mark R. White, fought in Vietnam in 1968-69. He was awarded a Bronze Star for meritorious achievement in battle. After he was discharged, he drank, fought, and eventually ended up in a mental hospital because of his uncontrollable behavior, usually against me and his family.

"On April 30, 1975, he killed himself.

"April 30, 1975 is the day the United States pulled out of South Vietnam.

"The turmoil we all remember from that day was what he felt every day. Mark left a young, confused and angry wife and a six-month old son.

"Our son is now thirteen and wonders why his father's name isn't on the Wall in Washington, why no one can tell him what happened to the brave solider that was his father."

There is at least a place for the names of soldiers like White and Hooper now. An "In Memory" list is kept at a park rangers' kiosk near the Vietnam Veterans Memorial in D.C. The program honors those who died years and miles away from the war that may have ultimately killed them, but who do not fit the Department of Defense criteria for inclusion on the great black wall. Many of the In Memory deaths are belated victims of Agent Orange. An annual gathering is held in April at the kiosk, and in 2003, Army Lt. Gen. John Caldwell Jr. gave the keynote address.

He made a point of reminding everyone that the "environmental hazards of the modern battlefield [are] sometimes as dangerous as direct and indirect fire." And he hit the bottom line of what the solider, the sailor, the flier, the marine, and the veteran give to their country: everything they have.

"Not just today," Caldwell said, "but every day, let us remember the sacrifice and valor of those who paid the ultimate

price for freedom. Let's remember those who are paying that price right now, too."

Ironically perhaps, it is Joe Hooper's former hospital, the VA facility in Seattle, that has given new hope to some ailing war veterans. Dr. Murray Raskind, a University of Washington vice chair of psychiatry, has developed a drug regimen that could help veterans from Vietnam to Iraq who suffer from post-traumatic stress disorder. In his ongoing VA study, the drug prazosin is already helping transform the lives of some veterans. "It changed everything," said Don Hall who was the first to take the drug in 1998. "It was like being born again."[1]

Let's hope. As for Hooper, he's buried in Arlington National Cemetery, near the Tomb of the Unknowns. I watched on TV as George W. Bush silently passed by him while laying a wreath at the tomb on Veterans Day, 2003. On the cemetery's website, there are photos of Hooper with a story I wrote about him and other veterans in 2003. Below Joe's photo is this quote:

> The willingness with which our young people are
> likely to serve in any war, no matter how justified,
> shall be directly proportional to how they perceive
> the veterans of earlier wars were treated and appre-
> ciated by their nation.

That was our first commander-in-chief, George Washington, 1789. Today, I'd guess the guy would be sorry he ever crossed the Potomac.

Endnotes

Introduction

1 Rumsfeld press briefing, Jan. 7, 2003.

2 King County, Washington, Medical Examiner reports.

3 Federal Practitioner, Tim A. Bullman and Han K. Yang, March, 1995; "Nam Vet," Chuck Dean, Multnomah Press, 1990; data survey at www.suicidewall.com.

4 Series, Tiger Force Killings, Michael D. Sallah, Mitch Weiss; Toledo Blade, Oct. 22, 2003. Medic In U.S. Tiger Force Tells of Killings, Reuters, Oct. 22, 2003.

5 Nethercutt Alleges P-I Distorted Speech, Neil Modie, Seattle Post-Intelligencer, Oct. 28, 2003.

6 Murray S. Waas, The American Prospect, March 8, 2004.

7 U.S. to Call Up Thousands of Troops for Iraq Duty, Seb Walker, Reuters, Nov. 5, 2003.

8 Remarks by the President Upon Arrival From Camp David, The South Lawn, April 13, 2003.

9 Seattle Times, July 4, 1991.

10 Sen. Schumer's statement, Veterans Day, 2003.

11 DOD news release, Sept. 4, 2003; www.buglesacrossamerica.org.

12 Info at www.militarybenefit.org/mbalifeonline.htm.

13 Washington Times, Aug. 4, 2003.

14 Newsweek, Sept. 2, 2002.

15 Jimmy Breslin column, Newsday, Oct. 14, 2003.

16 Curtains Ordered for Media Coverage of Returning Coffins, Dana Milbank, Washington Post, Oct. 21, 2003.

17 Armed Forces Press Service, Oct. 28, 2003.

18 Snark Attack, Seattle Post-Intelligencer, Nov. 15, 2003.

19 Todd S. Purdum, The New York Times, Feb. 28, 2004.

20 Personal Wars, LA Weekly, Sept. 20, 20002; Draft Dodger in Chief, Christian Dewar, Democraticunderground.com, April 3, 2002; Military Record May Gain Role in 2004 Presidential Race, Lois Romano, Washington Post, May 25, 2003.

21 Pentagon may punish GIs who spoke out on TV, Robert Collier, San Francisco Chronicle, July 18, 2003.

22 TV Man Is (Shock) Gay, And (Horror) Canadian, Antonia Zerbisias, The Toronto Star, July 19, 2003.

23 Sandra Jontz, Stars and Stripes, Sept. 12, 2003.

24 Military Pay, GAO report, November, 2003.

25 Daniel Redwood, Intervention Magazine, March 4, 2004.

26 Eric Schmitt and Thom Shanker, Big Pay Luring Military's Elite to Private Jobs, The New York Times, March 30, 2004.

27 Stars & Stripes, Sept. 9, 2003.

28 Dehydrating Soldiers, letter from Carla J. Hitz, Operation: We Love Our Soldiers, posted July 21, 2003, sendyoursupport.org.

29 Reservists On Call, Sonya Crawford, ABC News, Nov. 9, 2003.

30 Talk of a Draft Grows Despite Denials by White House, Charles Pope, Seattle Post-Intelligencer, Nov. 8, 2003.

31 Richard Sisk, Knight-Ridder-Tribune, Sept. 29, 2003; KIRO-TV Seattle, Nov. 12, 2003.

32 Daily Mislead, misleader.org, Oct. 15, 2003, and "Is the Pentagon
 Shortchanging Soldiers in Iraq?" CNN, 10/15/03.
33 Sara Corbett, The Permanent Scars of Iraq, The New York Times,
 Feb. 15, 2004.

1. The Cocktail Effect

1 House Government Reform Committee hearing, Oct. 3, 2000.
2 VA statistics, 2003, various reports, at va.gov.
3 Author interview, Steve Robinson, NGWRC, Aug. 25, 2003; VA
 estimates, federal health study, Hartford Courant, Aug. 20, 2003.
4 Mortality among US veterans of the Persian Gulf War: 7-year follow-
 up. Kang H.K., Bullman T.A., American Journal of Epidemiology,
 National Library of Medicine, Sept., 2001.
5 Richard Leiby, Washington Post, Dec. 30, 2002.
6 Chemical Warfare Agent Issues During the Gulf War, CIA Update,
 April, 2002.
7 Gulf War illnesses: Preliminary Assessment of DOD Plume Modeling
 for U.S. Troops. GAO, June 3, 2003
8 Is Military Research Hazardous to Veterans' Health, Senate Committee
 on Veterans Affairs report, May 1994.
9 Army Audit Agency, Nov. 9, 2001.
10 Where Desert Storms Still Blow, Erin Fitzgerald, Revolution magazine,
 August-September 2003.
11 Francis A. Boyle, Chapter 3, The Court Martial of Dr. Yolanda Huet-
 Vaughan, in Destroying World Order: U.S. Imperialism in the Middle
 East Before and After September 11, Clarity Press, Inc., Atlanta,
 2004.
12 Australian Institute of Health and Welfare, Dec. 2, 1999.
13 William Triplett, Access Denied, the VVA Veteran, February/March
 2002.
14 Alan R. Cantwell Jr., The Gulf Bio War, Paranoia Magazine, Issue 16.
15 Eric Schmitt, The New York Times, March. 5, 2004.
16 Ian Bruce, US troops suffering more brain injuries, The Herald, UK,
 Dec. 5, 2003.
17 Marines Corps Liaison Team field report, April 20-25, 2003, Solders
 For The Truth.
18 Hal Bernton, Seattle Times, Feb. 28, 2004.
19 Erik Eckert, Springfield (Mo.) News-Leader, July 28, 2003.
20 Vernon Loeb, Washington Post, Sept. 2, 2003.
21 Armed Forces Press Service, by Austin Camacho, Oct. 6, 2003.
22 MSNBC, March 27, 2003.
23 Associated Press, April 9, 2003.
24 Redflagsdaily.com, March 5, 2003.
25 Individual's Briefing, DOD, May 13, 2003.
26 Mark Benjamin, UPI, Aug. 18, 2003.
27 Vinaya Garde, MD; David Harper, MD; Mary P. Fairchok, MD, Tertiary
 Contact Vaccinia in a Breastfeeding Infant, JAMA, Feb. 11, 2004;
 Candace Heckman, Alert on anti-smallpox vaccina, Seattle Post-
 Intelligencer, Feb. 17, 2004.
28 2002 Survey of Health Related Behaviors Among Military Personnel,
 Department of Defense, March 8, 2004.
29 Sharyl Attkisson, CBS Evening News, May 7, 2003.
30 Naval Health Research Center, Jan. 18, 2002.

31 Madigan Army Medical Center study, Journal of the American Medical
 Association, Jan. 27, 2002.
32 Kristin Dizon, Seattle Post-Intelligencer, April 26, 2003.
33 Greg Seigle, Denver Post, Jan. 24, 2003.
34 Rumsfeld on This Week, ABC, March 30, 2003.
35 Lawsuit, filed Aug. 19, 2003, U.S. District Court, Brooklyn, NY.
36 Senate Banking Committee, The Riegle Report, May 25, 1994.
37 U.S. Chemical and Biological Warfare-Related Dual Use Exports to
 Iraq and Their Possible Impact on the Health Consequences of the
 Persian Gulf War. A report of Chairman Donald Riegle, and Ranking
 Member Alfonse D'Amato, United States Senate, May 25, 1994.
38 Fiscal Year 2002: Section 655 Report, Federation of American
 Scientists, May 8, 2003, www.fas.org.
39 Jimmy Breslin, Newsday, April 24, 2003.
40 Report, Center For Research on Globalization, Aug. 18, 2003.
41 Mark Pazniokas and Thomas D. Williams, Chicago Tribune, Oct. 23,
 2001.
42 Robert Gehrke, Associated Press, Jan. 16, 2004.
43 FDA press release, July 29, 1997.
44 Environmental Exposure Report, DOD, April 17, 2003.
45 Testimony, House Armed Services Committee, Feb. 25, 2004; UPI
 report, Feb. 26, 2004.; Malaria Rates, 2000, by World Health Organi
 zation.
46 CNN Dec. 21, 2002.

2. Death by Friendly Fire

1 A.J. Evenson and Tim Martin, Lansing State Journal, Sept.
 28, 2000.
2 House Government Reform Committee hearing, Oct. 3, 2000.
3 Ibid.
4 Rugo et al v. BioPort et al, U.S. District Court, Washington D.C.
5 BioPort, FDA news releases, Jan. 31, 2002.
6 Mike Wyn and Johnny Edwards, The Augusta Chronicle, Sept. 16,
 2003.
7 Rod Hafemeister, Belleville (Ill.) News-Democrat.
8 Dave Eberhart, Stars and Stripes, May 15, 2001.
9 Ibid.
10 IOM, March 7, 2002.
11 GAO, Anthrax Vaccine, Sept. 2002.
12 FDA BioPort Inspection Report, Nov. 15-23, 1999.
13 Office of Inspector General, DOD, issued an audit report D-2000-105,
 March 22, 2000.
14 Within weeks after BioPort's purchase of MBPI, BioPort received a
 $29.4 million dollar contract with the DoD to supply 8.7 million doses
 of the AVA at a price of $4.36 per dose. In 1999, at BioPort's
 request, the DoD restructured BioPort's contract, providing BioPort
 with $24.1 million in relief, reducing the number of doses demanded to
 4.6 million, and agreeing to raise the price per dose to $10.64.
15 Laura Rozen, Salon, Oct. 13, 2001.
16 Anthrax: A Deadly Shot in the Dark, Tom Heemstra, 2002.
17 Ibid.
18 Faye Fiore, Los Angeles Times, Oct. 25, 2001.

19 The Neutral Zone Surf Club, Gregory M. Smith, 1995.
20 Gulf War Syndrome, Tip Of The Iceberg, American Patriot; The Wind,
 American Patriot Friends Network, Jan. 1, 1998.
21 How Special Is Cipro? Science Now, Oct. 24, 2001.
22 CDC Special Report: Emerging Mechanisms of Fluoroquinolone
 Resistance, March-April, 2001.
23 Anthrax Vaccine, GAO, Oct. 12, 1999.
24 Rugo et al v. BioPort et al, U.S. District Court, Washington D.C.
25 Biohazard: The Chilling True Story of the Largest Covert Biological
 Weapons Program in the World—Told from Inside by the Man Who
 Ran It. Ken Alibek and Stephen Handelman, Delta, 2000.
26 Ibid.
27 Ray Rivera, Seattle Times, Oct. 21 2001
28 House Committee on Government Reform testimony, March 24, 1999.
29 Rugo et al v. BioPort et al, U.S. District Court, Washington D.C.
30 Military Vaccine Education Center, www.milvacs.org
31 Ibid.
32 House Government Reform Committee testimony, Oct. 3, 2000.
33 Mike Hamilton, Scandal of the Anthrax Vaccine Babies, London
 Sunday Mirror, March 1, 2004.
34 Anthrax Vaccine, GAO, Oct. 11, 2000.
35 Military Vaccine Education Center, www.milvacs.org.
36 FDA Statement, Dec. 30, 2003.
37 Bioport press release, Jan. 9, 2004.

3. Depleted Uraniun/Depleted Forces

1 Available at the National Gulf War Resource Center, ngwrc.org.
2 Scott Peterson, Christian Science Monitor, Dec. 20, 2002.
3 Maternity deaths in Iraq have nearly tripled since 1990, UN survey
 finds, UNFPA report, Nov. 4, 2003.
4 Gulf War Veterans Coalition Leadership Breakfast, U.S. Senate
 Caucus Room. Nov. 10, 2000.
5 Frida Berrigan, In These Times, June 27, 2003.
6 Hustler magazine, June 2003; Children of the War, March 2003.
7 Is The Pentagon Giving Our Soldiers Cancer? Hillary Johnson, Rolling
 Stone, Oct. 2, 2003.
8 The Associated Press, Seattle, Jan. 9, 2003.
9 Is The Pentagon Giving Our Soldiers Cancer? Hillary Johnson, Rolling
 Stone, Oct. 2, 2003.
10 Government Accountability Project, whistleblower.org, Nov. 8, 2002.
11 BBC News Online, April 23, 2003.
12 GOP unity is strained by attacks, Geoff Earle, The Hill, Oct. 29, 2003.
13 NPR Talk of the Nation, Science Friday, March 14, 2003.

4. The Rat Brigade

1 Edgewood documents, obtained by American Citizens for Honesty in
 Government; Seattle Times, July 22, 1979.
2 Bob Egelko, San Francisco Chronicle, July 14, 2002.
3 Puerto Ricans Outraged Over Secret Medical Experiments, Carmelo
 Ruiz-Marrero, Imagen magazine, Nov. 1, 2002.
4 Tuskegee Syphilis Study Legacy Committee Final Report, May 20,

1996; Clinton remarks, White House ceremony, May 16, 1997.

5 A History Of Secret Human Experimentation, the Health News Network, www.healthnewsnet.com, March 25, 2003. Also, http://www.informationclearinghouse.info/article3511.htm

6 Ibid

7 A History Of Secret Human Experimentation, the Health News Network, www.healthnewsnet.com, March 25, 2003.

8 Joby Warrick and John Mintz, The Washington Post, April 20-21, 2003; and Salim Muwakkil, In These Times, June 6, 2003.

9 A History Of Secret Human Experimentation, the Health News Network, www.healthnewsnet.com, March 25, 2003. Also, http://www.informationclearinghouse.info/article3511.htm

10 Advisory Committee on Human Radiation Experiments, October 1995.

11 Interview, reported in Balls at the Walls, Seattle Weekly, Dec. 15, 1999.

12 Is Military Research Hazardous to Veterans' Health, Senate Committee on Veterans Affairs report, May 1994.

13 K-State release, May 6, 2002.

14 FDA media release, Feb. 5, 2003.

15 Pentagon news release, http://www.ngwrc.org/I ssues.cfm?NewsTopicID=13

16 U.S. Chemical and Biological Warfare-Related Dual Use Exports to I raq and Their Possible Impact on the Health Consequences of the Persian Gulf War. A report of Chairman Donald Riegle, and Ranking Member Alfonse D'Amato, United States Senate, May 25, 1994.

17 Gulf War illnesses: Preliminary Assessment of DOD Plume Modeling for U.S. Troops. GAO, June 3, 2003

18 Chemical Warfare Agent Issues During the Gulf War, CIA Update, April, 2002.

19 The Sunshine Project, Sept. 9, 2003. www.sunshineproject.org.

20 Rooting Out Evil, expanding the search for weapons of mass destruction, 2003, www.rootingoutevil.org

21 Michael Scherer, Outfront, Mother Jones, March/April 2004; John M. Barry, The Great Influenza, 2004.

22 The Military Vaccine Education Center, www.milvacs.org.

23 Andrea Orr, Reuters/Yahoo News, Aug. 27, 2003

24 Umatilla lawsuit, Gillian Flaccus, The Associated Press, Oct. 21, 2003.

25 Toxic Immunity, Jon R. Luoma, Mother Jones, November-December, 2003.

26 Better Strategic and Risk Management Tools Needed to Guide DOD's Stockpile Destruction Program, GAO reports, Oct. 30, 2003.

27 American Forces Press Service, K.L. Vantran, Oct. 1, 2003.

28 Associated Press and Environmental Network News, March 5, 2004.

5. Squalene: Pattern Of Deception

1 GAO, Gulf War illness, March, 1999.

1 Antibodies found in sick soldiers, Judith Zwolak, Look@tulane, Sept. 21, 1999.

3 Metcalf report on Gulf War illnesses to the House Subcommittee on National Security, Veterans Affairs, and International Relations, Sept. 27, 2000.

4 Ibid.

5 Michael Kilian, Chicago Tribune, Oct. 4, 2000.

6 The National Organization Of Americans Battling Unnecessary
 Servicemember Endangerment, letter, May 20, 2002.

6. Better Soldiers Through Chemistry

1 The Fayetteville Observer, Aug. 4, 2002.
2 Fort Bragg Epidemiological Report, U.S. Army Surgeon General's
 Office, Oct. 18, 2002.
3 UPI, various dates. See series: http://www.upi.com/lariam.cfm
4 UPI, Feb. 26, 2004.
5 Military looks to drugs for battle readiness, Brad Knickerbocker,
 Christian Science Monitor, Aug. 9, 2002.
6 Pentagon is Doping U.S. Armed Forces With Speed, Ernesto
 Cienfuegos, 2003, aztlan.net.
7 Military looks to drugs for battle readiness, Brad Knickerbocker,
 Christian Science Monitor, Aug. 9, 2002.
8 http://lariaminfo.homestead.com/
9 Suicide rate among soldiers up in Iraq, Associated Press, Jan. 14,
 2004.
10 Will Dunham, Reuters, Oct. 16, 2003.
11 L. Anne Newell, Arizona Daily Star, Oct. 3, 2003; Joe Strupp, Editor &
 Publisher magazine, Feb. 3, 2004.
12 Fort Bragg Epidemiological Report, U.S. Army Surgeon General's
 Office, Oct. 18, 2002.
13 Oprah Winfrey show, Sept. 25, 2002.
14 Ibid.
15 Barbara Wharton, testimony, Senate Armed Services subcommittee,
 Feb. 25, 2004.
16 Miles Moffeit and Amy Herdy, Betrayal In The Ranks, Denver Post,
 Nov. 16, 2003
17 Military rape, Linda Byron, KING-5 News, Seattle, July 29, 2003.
18 Nomination of Former Fort Campbell Commander in Limbo, Nancy
 Zuckerbrod, Associated Press, Oct. 26, 2002.

7. The Fortunes of War Production

1 Dwight D. Eisenhower, Farewell Address, Jan. 17, 1961.
2 Allen C. Miller and Kevin Sack, Los Angeles Times, Vertical Vision
 series beginning Dec. 15, 2002.
3 Thomas Frank, Newsday, June 22, 2003.
4 Seattle Weekly, Aug. 16, 2000.
5 Ibid.
6 Seattle Weekly, Oct. 10, 2001.
7 Ibid.
8 CBO report, Sept. 4, 2003.
9 Report, Feb. 4, 2002, at Pogo.org.
10 Marines Corps Liaison Team field report, April 20-25, 2003, Solders For
 The Truth.
11 Seattle Weekly, Aug. 6, 2003.
12 Contingency Operations, GAO, Dec. 2000.
13 Dick's Special Interest in $87 Billion, The Online Beat, The Nation Online,
 Oct. 15, 2003.
14 Center for Responsive Politics, A Guide to the Interests Driving the
 Defense Budget, Sheryl Fred, Oct. 1, 2003.

15 Fiscal Year 2002: Section 655 Report, Federation of American Scientists, May 8, 2003, www.fas.org.

16 Can Iraq Learn to Live in Peace? Jonathan Dresner, History News Service, March 28, 2003.

17 Made in the USA, Jim Crogan, LA Weekly, March 21, 2003.

18 Beijing's missile connection, Seattle Weekly, July 22, 1998

19 Sworn "Iraqgate" declaration of Howard Teicher, January 31, 1995, US District Court, Southern District of Florida

20 Industry Suggests Improvements for Exports, Benjamin Stone and Dennis Kennelly, National Defense, May 2003.

8. The Unkindest Cuts: Government Giveth and Taketh Away

1 President Salutes the Military, March 28, 2003.

2 Salute to American Veterans, Jan. 19, 2001, George Washington University.

3 Rep. Rick Larsen, Feb. 25, 2003.

4 CDF Legislative Council Action Update, June 5, 2003.

5 The Daily Mis-Lead, Nov. 10, 2003; Etheridge: Budget cuts veterans, Ned B. Hunter, Rocky Mount (N.C.) Telegram, April 1, 2003.

6 Guard, reservists plead case for health care plan, Mike Barber, Seattle Post-Intelligencer, Oct. 8, 2003.

7 Jim Abrams, Associated Press, Sept. 12, 2003.

8 House vote backs loans as Iraq bill confronts new woes, Peter Cohn, Govexec.com, Oct. 22, 2003.

9 Final Report, President's Task Force To Improve Health Care Delivery For Our Nation's Veterans, May 2003.

10 Ibid.

11 Federal Benefits for Veterans and Dependents, VA handbook, 2003 edition.

12 MSNBC, Aug. 13, 2003.

13 Two POWs, One an American Icon, the Other Ignored, William Douglas, Philadelphia Inquirer, Nov. 8, 20003. Jessica Lynch's Hero, Mike Wallace, 60 Minutes, Nov. 9, 2003.

14 A famous fight, an unsung hero, Tom Bowman, Baltimore Sun, Sept. 28, 2003.

15 Mark Benjamin, UPI, Oct. 17, 2003 and Jan. 21, 2004.

16 Veterans Rally, Luis Fabregas, Pittsburgh Tribune-Review, Aug. 27, 2003.

17 News report, KGW-TV, Portland, Aug. 4, 2003.

18 IG Criticizes Oversight Of Part-Time VA Docs - Stephen Spotswood, US Medicine, June 2003.

19 Robert Pear, The New York Times, April 13, 2003.

20 Editorial, Kansas City Star, May 27, 2002.

21 Respiratory Diseases among U.S. Military Personnel: Countering Emerging Threats, CDC, May-June 1999.

22 Interview with Daniel Zwerdling, NPR, Feb. 25, 2004.

23 Ibid

24 Paul Rubin, Phoenix New Times, Nov. 21, 2002.

25 Fundamental Changes to VA's Disability Criteria Need Careful Consideration, GAO, Sept. 23, 2003.

26 Info at Bud Day's website, classact-lawsuit.com

27 George Coryell, Tampa Tribune, June 9, 2003.

9. The Other Cocktail Effect

1 Department of Defense, 2002 Survey of Health Related Behaviors Among Military Personnel, issued March 8, 2004.
2 Allen v. Principi, U.S. Court of Appeals, Washington D.C., 1999.
3 Ibid.
4 H.R. 850, the Former Prisoners of War Special Compensation Act of 2003.
5 Ibid.
6 House Committee on Veterans Affairs, April 10, 2003.
7 Identifying the PTSD paradox, Vet Center Voice, April 2003.
8 Ballad of Ira Hayes, by Peter LeFarge, 1962.
9 On the meaning of heroism, John Marshall, Seattle Post-Intelligencer, Nov. 11, 2003.

Epilogue

1 J. Patrick Coolican, Old drug quiets the nightmares of war, Seattle Times, Dec. 29, 2003

Selected Bibliography

Alibek, Ken; Handelman, Stephan; *Biohazard: The Chilling True Story of the Largest Covert Biological Weapons Program in the World—Told from Inside by the Man Who Ran It;* Delta, 2000.

Atkinson, Rick; *Crusade: The Untold Story of the Persian Gulf War.* Houghton Mifflin Co., 1999.

Bloom, Saul; *Hidden Casualties: Environmental, Health and Political Consequences of the Persian Gulf War.* North Atlantic Books, 1994.

Boyle, Francis A.; *Destroying World Order: U.S. Imperialism in the Middle East Before and After September 11.* Clarity Press, Inc., 2004.

Burkins, Lee; Soldier's Heart, lstbooks.com, 2003.

Cronkite, Walter; *LIFE, The War In Iraq*, Time, 2003.

Eddington, Patrick G.; *Gassed in the Gulf: The Inside Story of the Pentagon-CIA Coverup of Gulf War Syndrome.* Insignia Publishing, 1997.

Fried, Stephen; *Bitter Pills.* Random House, 1999.

Fulco, Carolyn; *Gulf War and Health.* National Academy Press, 2000.

Gordon, Michael R; Trainor, Bernard: *The Generals' War: The Inside Story of the Conflict in the Gulf.* Little Brown & Co., 1995.

Hackworth, David; England, Eilhys; *Steel My Solders' Hearts.* Rugged Land LLC, 2002.

Hasan, Heather; *American Women in the Gulf War.* Rosen Publishing Group, 2003.

Hartnet, John; *Always Faithful: A Memoir of the Gulf War.* iUniverse.com, 2003.

Heemstra, Tom; *Anthrax: A Deadly Shot in the Arm.* Crystal Communications, 2002.

Hersh, Seymour M.; *Against All Enemies: Gulf War Syndrome: The War Between America's Ailing Veterans and their Government.* Ballantine Books, 1998.

Huchthausen, Peter; *America's Splendid Little Wars.* Viking Penguin, 2003.

Johnson, Alison; *Gulf War Syndrome: Legacy of a Perfect War.* MCS Information Exchange, 2001.

Marlowe, David H.; *Psychological and Psychosocial Consequences of Combat and Deployment with Special Emphasis on the Gulf War.* Rand Corp., 2001.

Miller, Judith; *Germs: Biological Weapons and America's Secret War,* Touchstone Books, 2002.

Murray, Williamson; Scales, Robert H. Jr.; *The Iraq War: A Military History.* Harvard University Press, 2003.

Regis, Ed; *The Biology of Doom: The History of America's Secret Germ Warfare Project,* Owl Books, 2000.

Sciolino, Elaine; *The Outlaw State: Saddam Hussein's Quest for Power and the War in the Gulf.* John Wiley & Sons, 1991.

Sifry, Micah L.; Cerf, Christopher; *The Gulf War Reader: History, Documents, Opinions.* Times Books, 1991.

Smith, Hedrick; *The Media and the Gulf War / the Press and Democracy in Wartime.* Seven Locks Press, 1992.

Stanton, Martin: *The Road to Baghdad: Behind Enemy Lines.* Presidio Press, 2003.

Swofford, Anthony; *Jarhead: A Marine's Chronicle of the Gulf War and Other Battles.* Scribner, 2003.

Tucker, Jonathan B.; *Scourge: The Once and Future Threat of Smallpox.* Grove Press, 2002.

Turpinseed, Joel; Kelly, Brian; *Baghdad Express: A Gulf War Memoir.* Borealis Press, 2003.

Ursano, Robert J.; Norwood, Ann E.; *Emotional Aftermath of the Persian Gulf War: Veterans, Families, Communities and Nations.* American Psychiatric Press, 1996.

Vidal, Gore; *Dreaming War: Blood for Oil and the Cheney-Bush Junta.* Thunder's Mouth Press, 2002.

Vernon, Alex; et al; *The Eyes of Orion: Five Tank Lieutenants in the Persian Gulf War.* Kent State University Press, 1999.

Wheelwright, Jeff; *The Irritable Heart: The Medical Mystery of the Gulf War.* W.W. Norton & Co., 2001.

Index